CHARLES M. SCHULZ

THE ART AND LIFE OF THE PEANUTS CREATOR IN 100 OBJECTS

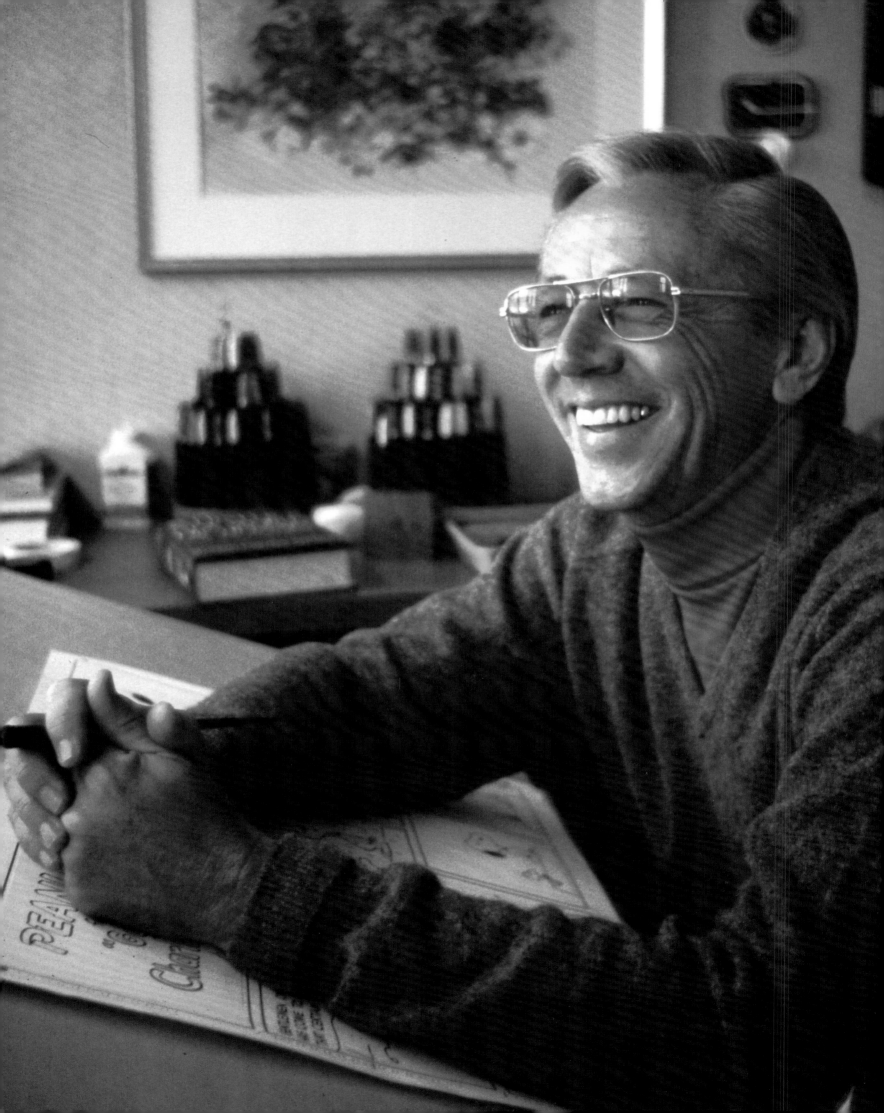

CHARLES M.
SCHULZ

THE ART AND LIFE OF THE PEANUTS CREATOR IN 100 OBJECTS

BENJAMIN L. CLARK, NAT GERTLER,

AND THE CHARLES M. SCHULZ MUSEUM

weldon**owen**

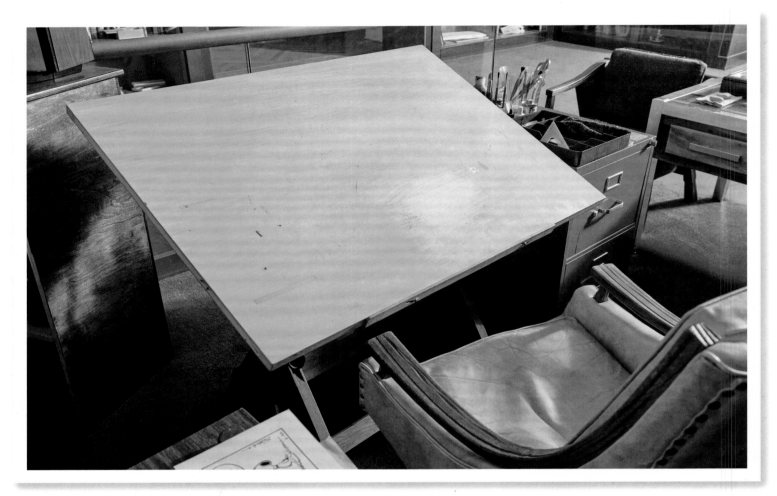

Thirty years of drawing left its mark on Charles Schulz's primary drafting table (Item 74, page 164), on which he crafted ten thousand *Peanuts* strips.

Sparky's table was an old one. It was wood with a particularly well-scuffed patch right in the middle. I was surprised to see that he worked on such a rough surface. Running my hand over his drafting table, I asked, referring to the deeply worn patch, 'What's this from?' And without missing a beat, Sparky replied, 'Hard work.'

—Lynn Johnston, creator, *For Better or For Worse*

CONTENTS

INTRODUCTION

There are many ways to look at any person's life, and Charles M. Schulz was not just any person. Dozens of biographies have been written about the man, some slight and insignificant, others thick and scholarly. All of them will teach you something (occasionally something erroneous); none of them will tell you everything.

One could certainly try to understand Schulz through his work—through the many thousands of strips and cartoons he created over more than half a century as a cartoonist. Indeed, he himself recommended getting to know him that way, and if you try reading the entire fifty-year run of *Peanuts*, you will both know him and have read a lot of entertaining work by the most respected creator of humorous newspaper strips. It will be time well spent.

The Charles M. Schulz Museum and Research Center in Santa Rosa, California, offers another perspective, sharing with you both examples of his work and pieces of his life beyond the strip in a very physical and very immediate form. It's an excellent place to visit, but you can't carry it home with you.

For this book in celebration of the centennial of Charles Schulz's birth, we've taken a similar but more portable tack. Benjamin L. Clark is the curator of the Schulz Museum, and as such he has access

to thousands of pieces of original Schulz art, to decades of correspondence, to archives of photographs, and to many physical objects, from common household items to awards of great prestige. From these, he was charged with selecting one hundred special items that would tell the tale of the man, the life, and the work. We reached out to dozens of people to comment on the selected objects: Schulz's family, his friends, his comrades in cartooning, those he worked with, and those who have been touched by his work.

We hope that within this unique collection you will find your favorites, you will discover surprises, and, at least in some form, you will find Charles Schulz.

—Nat Gertler
co-writer

FOREWORD
A CONVERSATION WITH WES ANDERSON

Was Schulz a direct influence on your work, and are you intentionally referencing Peanuts; or was the strip's sensibility something you already carried in you?

I don't think I ever deliberately/specifically wanted to overtly allude to "Peanuts" in any of my movies -- but I have always found myself openly stealing from it anyway... Even in the case of using the wonderful music from the Christmas special (on more than one occasion): this was just me using Charlie Brown to try to make my own thing better! Rather than paying my respects. In elementary school, I read the comics in the form of the books, the collections, so I sort of experienced the "Peanuts" evolution as if I had grown up in the fifties. I saw Charles Schulz's hand slowly changing over the years. I always loved these iconic characters, and I always loved the mood of these little stories told in handfuls of frames. I love the author's voice in every way.

Can you speak to the importance of objects in world-building and storytelling and how Schulz's storytelling does (or doesn't) impact your own? Did you have a favorite Peanuts or Snoopy object growing up?

Well, I suppose part of the thing is the simplicity of it. The clarity of how things are shown, the clarity about what will never be shown (such as grown-ups). I think after a certain point in the life of the comic we stop seeing Snoopy's doghouse from any other angle but the direct side-view? He had the greatest ways of expressing emotions in these simplest faces. I always loved that little piano.

There's careful pacing, character composition, and cross cutting in Schulz's strips—do you see a filmic quality to the cartoon strips?

I think this must be why the comic translated perfectly to the TV specials. So many things were already in place. The way the grown-ups speak, the way Snoopy and Woodstock express themselves, the voices of the children: all these seem to naturally and directly come out of these panels of drawings and words. I think the makers of the specials were guided by and channeled the sensibility of Schulz (who contributed directly along the way, too, I think).

Do you identify with any specific Peanuts character(s)? Is it Linus?

I would say I admire Linus, but I identify with Charlie Brown.

If you could own an object from the cartoon world of Peanuts, which one would it be?

The Christo doghouse! I love Christo and Jeanne-Claude as much as Linus and Charlie Brown.

—Wes Anderson
filmmaker

1920–1942
GROWING UP

"I can never get it through my head … ," says a young boy in a cartoon Schulz drew for the 1965 book *Two-by-Fours*, "was Jesus a grown man or was he a little baby?" We normally view Charles Schulz as a grown man creating all of those *Peanuts* strips. That grown man was created by a little boy—a little boy who loved the comics pages, who played the games and went to school and felt the insults and slights of adolescence, all of which would flow throughout *Peanuts*. An only child growing up in Minnesota in the 1920s, young Schulz had a very Middle America, middle class life. He showed his creativity and love for cartooning at an early age, and he also had a love of sport. None of this would ever leave him because Charles Schulz was never one to leave the past behind.

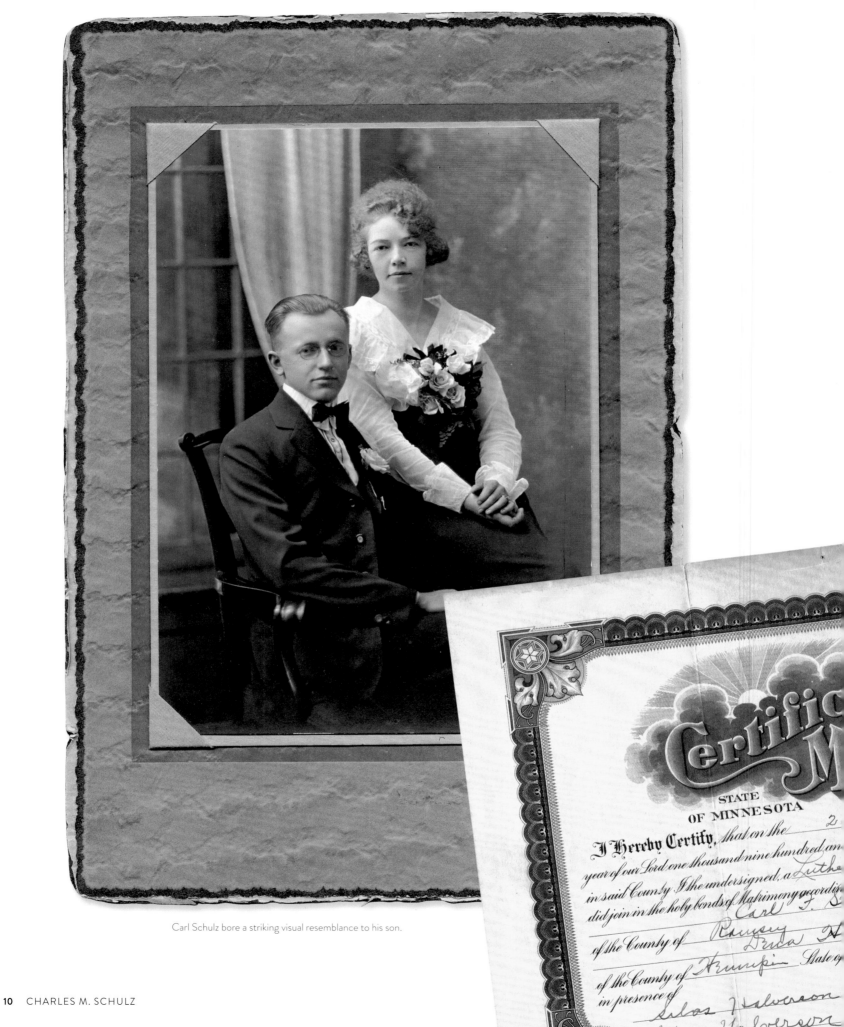

Carl Schulz bore a striking visual resemblance to his son.

01 | CARL AND DENA SCHULZ WEDDING PHOTO

German-born Carl Frederick Schulz ate breakfast each morning at La Belle Home Pastry Shop. Waitress Dena Halverson knew from experience that he would order Cream of Wheat to soothe his troublesome stomach. The two hit it off, as this May 1920 wedding portrait will attest. Before too long, they would have a child with much of Carl's looks, much of Dena's love, and his own temperamental stomach.

Like his father, Charles Schulz would come to have a regular breakfast request that the servers would know to bring him. In his case, it was the people working at the Warm Puppy Cafe in the Redwood Empire Ice Arena, and the requested substance? Grape jelly... and *only* grape jelly.

> My grandmother had a sly sense of humor; so did my mother and my aunts. That was the Norwegian side of the family. Dad's side, the German, was more serious.
>
> —Charles M. Schulz

02 | POSTCARD BIRTH ANNOUNCEMENT

This postcard, sent back in 1922 when for a penny your note could reach its destination with neither a street address nor the not-yet-invented zip code, let Dena's uncle Lars Borgen know that she had given birth. The lad had been born on Sunday, November 26, the day before the card was postmarked (and given that mail would not be processed on a Sunday, it could well have been dropped into the mailbox on the day he was born). Carl, who wrote the note, took the time to mention the baby's weight; at nine pounds, he was larger than most babies, so would likely not be fragile. That was apparently more vital to announce than the baby's name, which goes unstated.

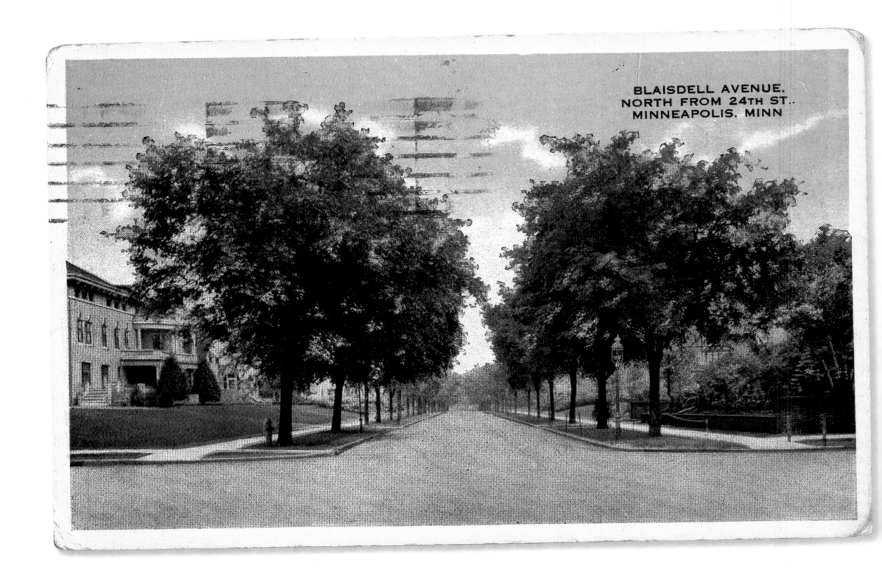

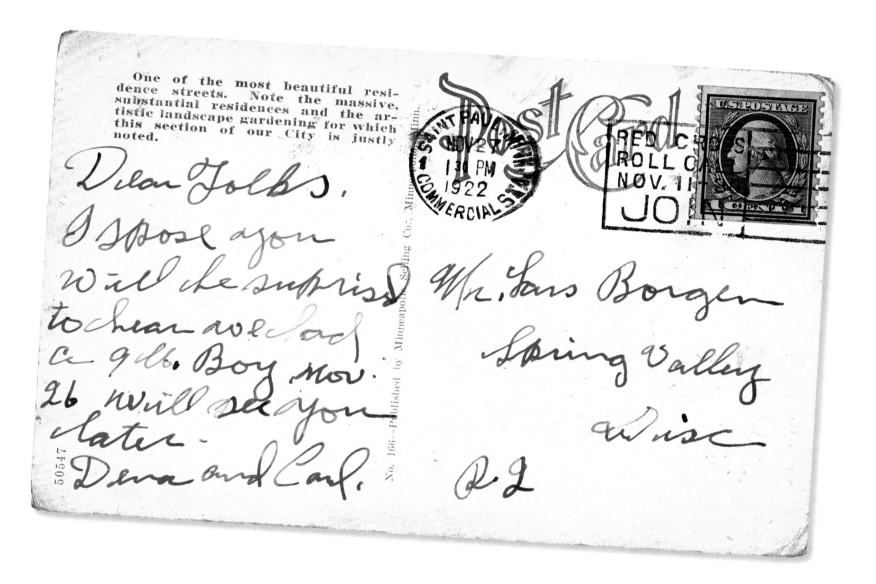

One of the most beautiful residence streets. Note the massive, substantial residences and the artistic landscape gardening for which this section of our City is justly noted.

Dear Folks,
I spose you
will be surprised
to hear we had
a 9 lb. Boy Nov.
26 will see you
later.
Dena and Carl.

Mr. Lars Borgen
Spring Valley
Wisc
R 2

03 | SPARK PLUG FIGURE

Carl and Dena's baby did have a name—Charles Monroe Schulz—but he was very quickly given a second name as well. An uncle suggested calling him Spark Plug, after a cartoon horse in the popular comic strip *Barney Google* by Billy DeBeck. This stuffed doll is just one of a number of licensed Spark Plug items that were produced. Just as Barney Google took to calling his horse simply Sparky, so did everyone take to calling young Charles "Sparky," a nickname he embraced and that would stick for the rest of his life. Charles Schulz's ties to the comic strip world go back almost to his very beginning.

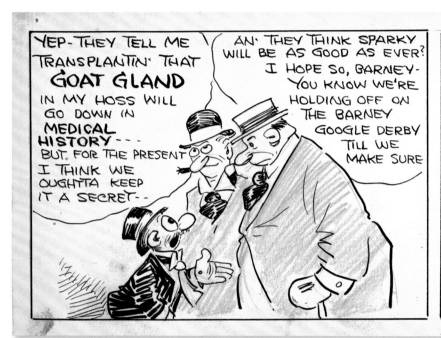

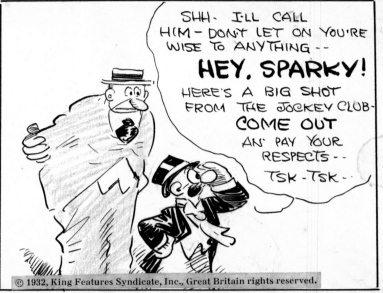

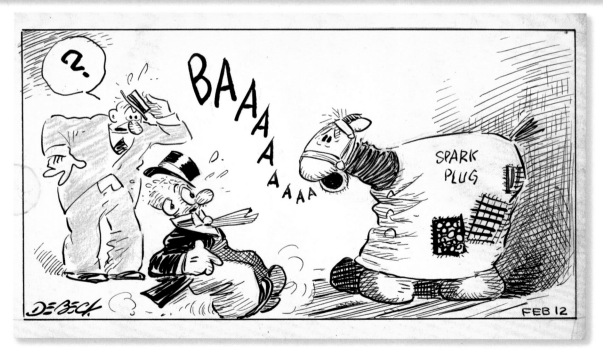

Schulz came to own this original art for the February 12, 1932, *Barney Google* strip. The blue pencil markings indicate where a dot pattern would be placed to create gray.

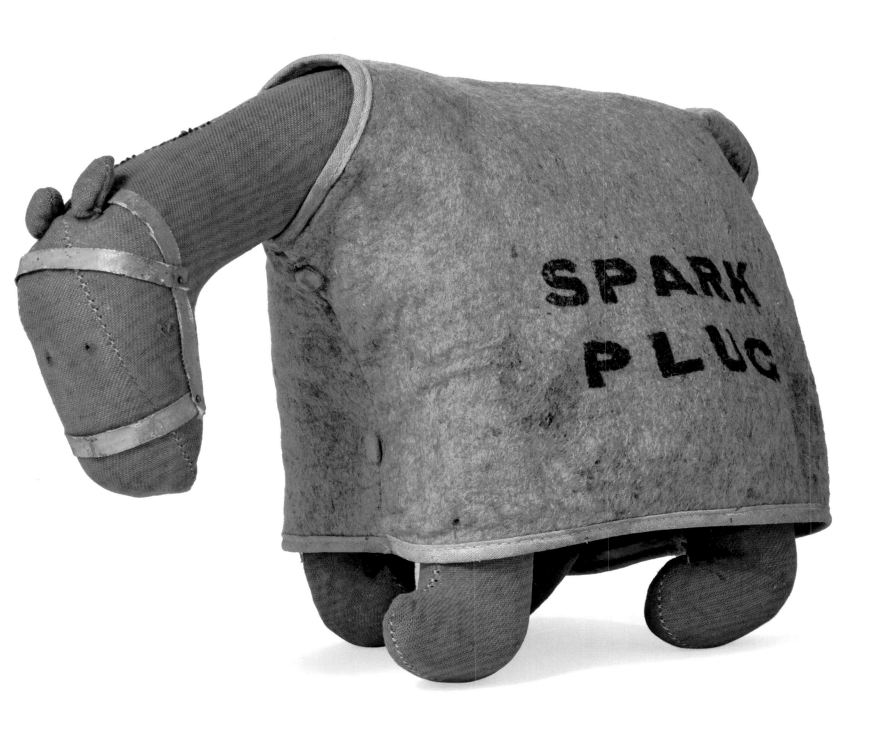

04 | BARBER POLE

In the Schulz Museum's collection is a traditional barber pole, with lights both on top and inside the cylinder. This particular pole was long attached to The Family Barber Shop, a three-chair establishment situated at the intersection of Snelling Avenue and Selby Avenue in Saint Paul, Minnesota. Carl Schulz owned the shop, and for a while, the Schulz family lived in an apartment above.

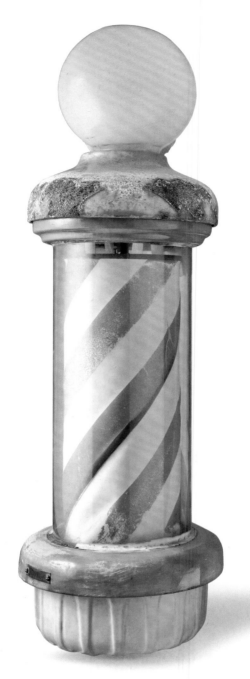

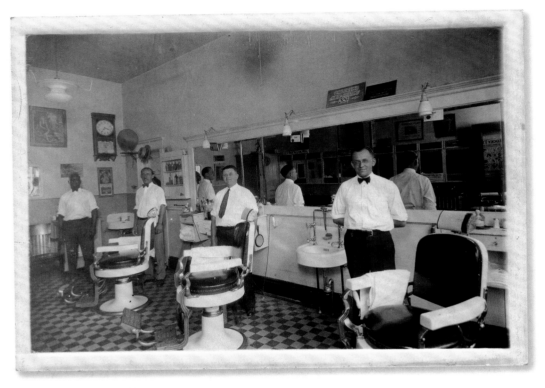

Carl Schulz (right) and his employees in The Family Barber Shop.

 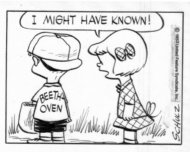

My dad was a barber. I always admired him

for the fact that both he and my mother had only

third-grade educations and, from what I remembered

hearing in conversations, he worked pitching hay

in Nebraska one summer to earn enough money

to go to barber school, got himself a couple of jobs,

and eventually bought his own barber shop.

—Charles M. Schulz

Charles Schulz kept this photo of the intersection of Snelling and Selby on the wall of his studio for many years. If you look closely, you can see the barber pole: in the middle of the picture, there's a streetlight on a corner, and the barber pole is directly below it.

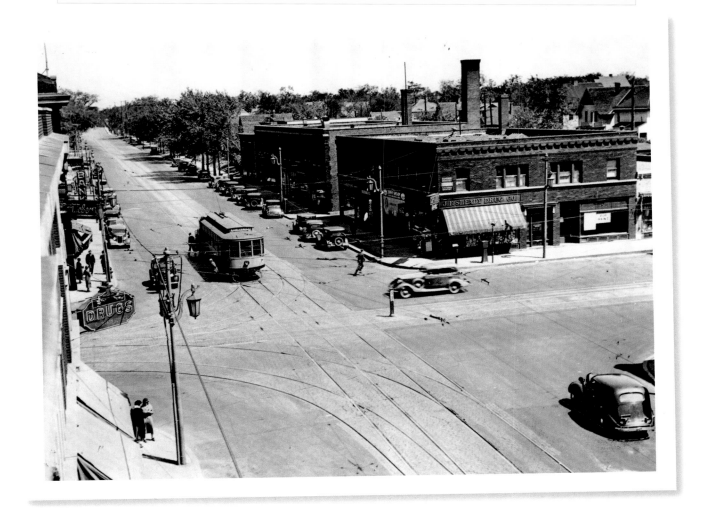

05 | "READ THE STRIP AND KNOW ME."

Charles Schulz had a great imagination. He was able to build a world in which a beagle leads birds on hiking trips, or a young virtuoso plays the works of Beethoven on a piano with black keys that are just painted on. But he also took much of his own world, his own experience, and his own emotions and poured them into *Peanuts*. There is no better example of that than how he drew on his own young life as the son of a barber and gave that life to Charlie Brown, as seen in this March 11, 1960, strip.

Schulz would give elements of himself to many of the *Peanuts* characters. People most often pair him with Charlie Brown, to whom Sparky gave his struggles, his disappointments, and his love of sport. Snoopy, however, was the recipient of Schulz's sense of joy, and also took over as the strip's golfer. Schulz's fascination with the Bible was transferred onto Linus Van Pelt. Fairly late in the strip's run, Rerun Van Pelt began expressing a desire to be a cartoonist, much as Sparky had done in his youth. While Schulz avoided putting adults directly in *Peanuts*, he would sometimes craft strips in which Charlie Brown quotes his unseen dad reminiscences. His father's tales would be about such things as going to the movies with his grandmother or playing cards with friends, and they would be stories based on Schulz's own life.

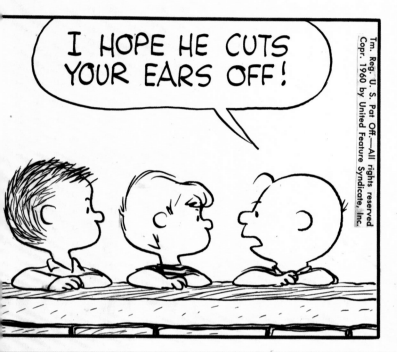

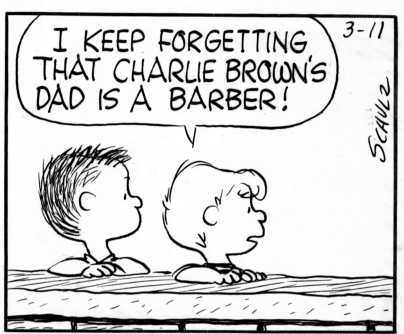

> If you want to know what I am like, all you have to do is read the strip. And if you read a year's batch of strips, you know what I am because those are the things that I normally say in regular conversations.

—Charles M. Schulz

There is plenty of photographic documentation of young Charles Schulz, and the pictures show an ordinary, generally happy life. His family was close, he had friends, he had activities he liked to do. You can see all of these at work in the photo below. At the right is Sparky himself, playing hockey, an activity he would enjoy throughout his entire life. Next to him is his father, Carl, who has made this scene possible by flooding his own property, allowing the frigid Minnesota winter to turn his backyard into an ice rink. With the addition of a couple of stick-wielding compatriots, there was much fun to be had.

Even when the backyard wasn't frozen, love from his family still allowed Sparky to practice hockey. He and his maternal grandmother, Sophie Halverson, would head down to the basement. She'd be goalie, guarding the area under the stairs from the tennis balls he flung at her with his stick. "I like to think she made a lot of great saves," he would later note.

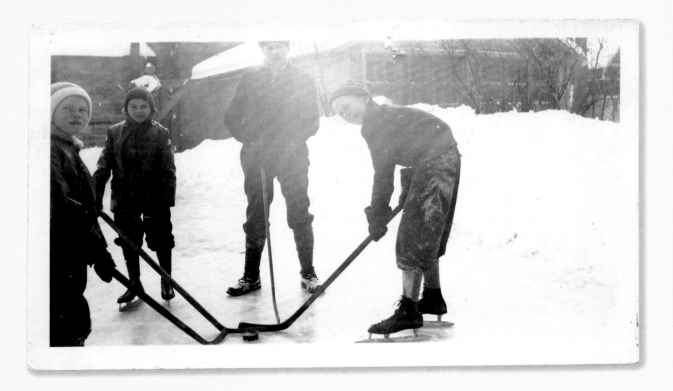

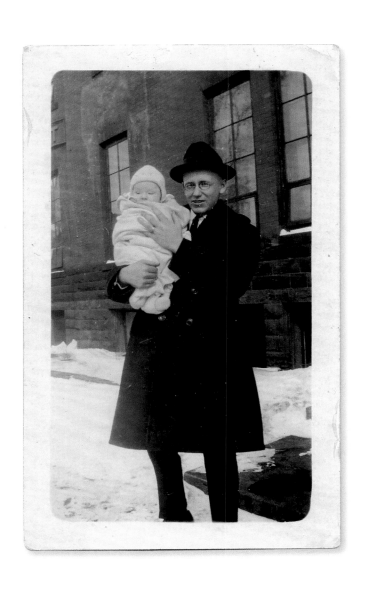

EARLY CHILDHOOD GLASSES

This pair of pince-nez from the museum's collection is just one of various spectacles that young Sparky would wear over the years. He would continue to wear glasses for the rest of his life. Unlike many aspects of his childhood, however, eyeglasses would not be a source of gags for *Peanuts* over the long term. There was a storyline in 1962 in which Linus got glasses (as did Snoopy, whenever he could swipe Linus's pair), but Schulz found that they interfered with the character's facial expressiveness. Cartooning won over continuity. Within months, Linus was no longer wearing glasses in the strip. For Marcie, on the other hand, glasses were a defining feature.

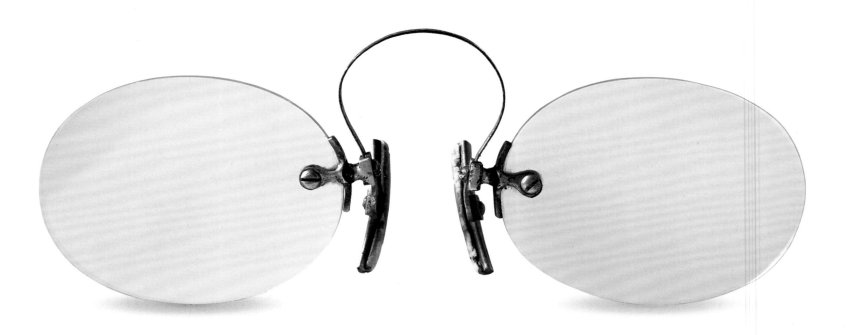

" I am taken with this studio portrait of Sparky as a child,
drawn in by the sweet, earnest face, as serious and grown-
up as his bow tie, round glasses and too-big cap. Looking
at it, I can see the man in the child as, conversely and
in my mind's eye, the child in the man. Sparky was my
stepfather. He came into my life when I was 12 years old. "

—Lisa Clyde

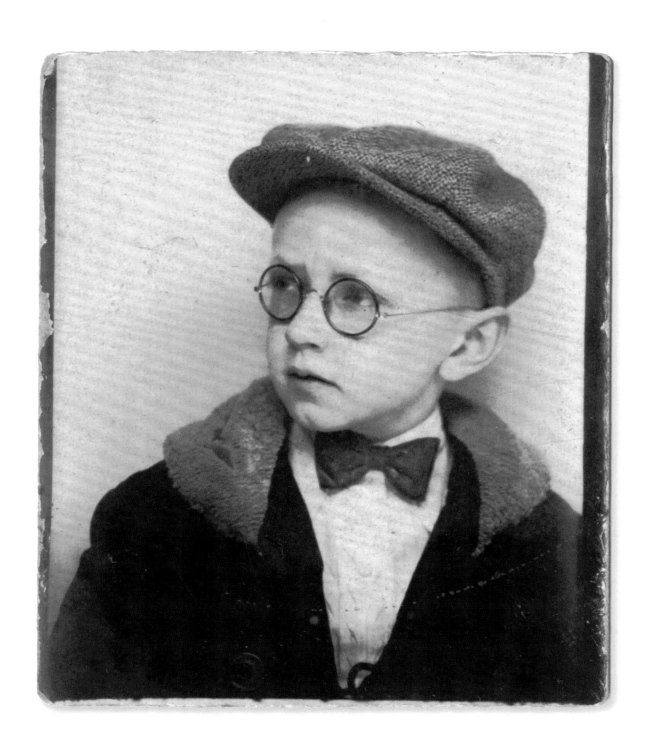

BASEBALL MITT

This baseball mitt belonged to Charles Schulz in his youth. It bears the logo of MW Sporting Goods, which was the private label sold by Montgomery Ward, the mail-order giant that, beginning in the late 1920s, had transformed itself into the nation's largest retail chain. This would have seen use not in some organized league but in makeshift neighborhood games much like the ones in *Peanuts*. "We played on vacant lots with baseballs that had the covers knocked off and had been taped up with black electrical tape," Schulz recalled. "And we used old cracked bats. We played from the early cold days of spring until football season in the fall."

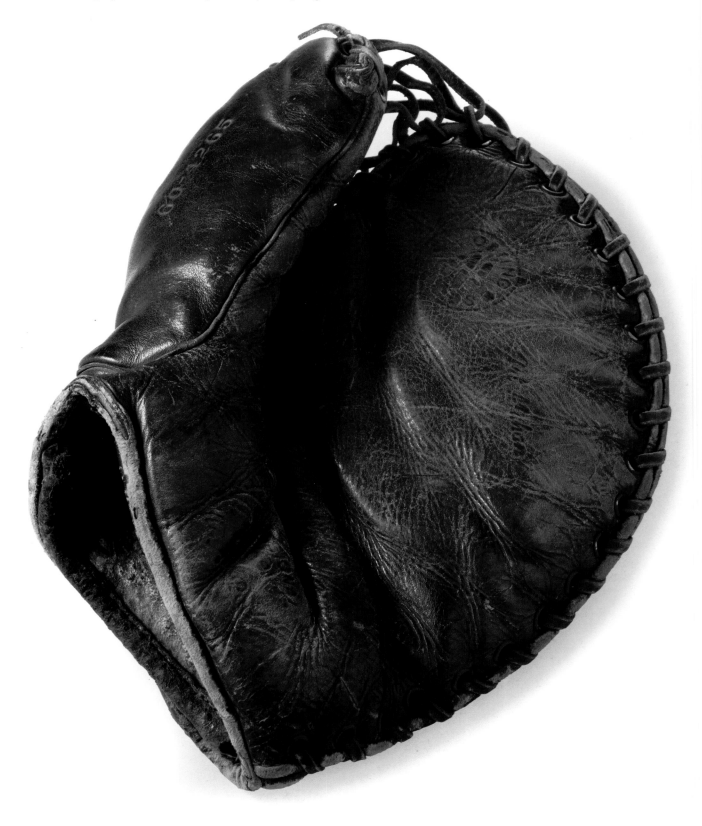

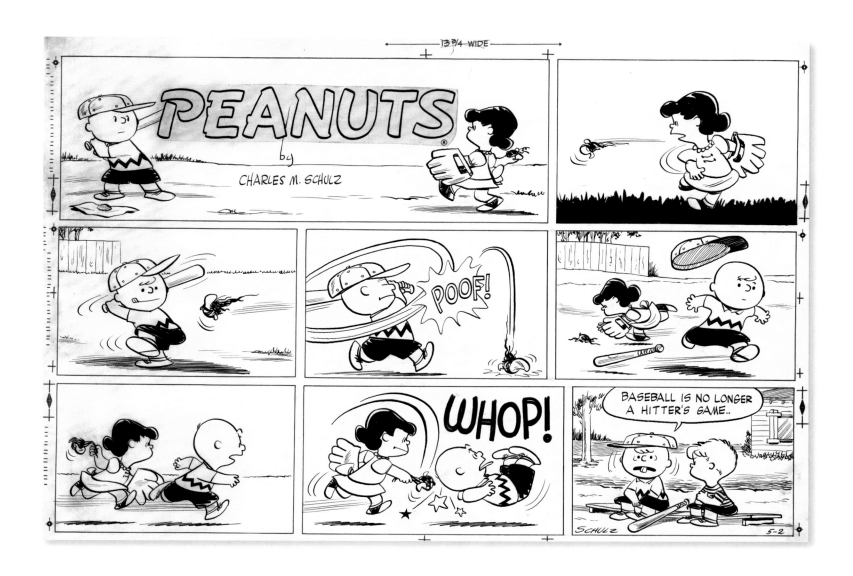

Although he had his favorites, Sparky had a love for sports in general and would gladly take part when he had the opportunity. This football helmet would see a lot of use, as it eventually got handed down to some of his cousins. Still, football came with some sadness. "I remember I was always disappointed when the kids brought the footballs out," he would later note, "because I liked baseball much better than football."

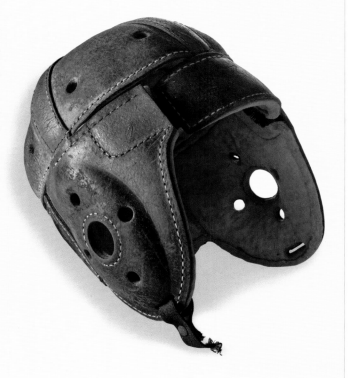

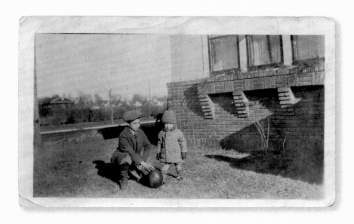

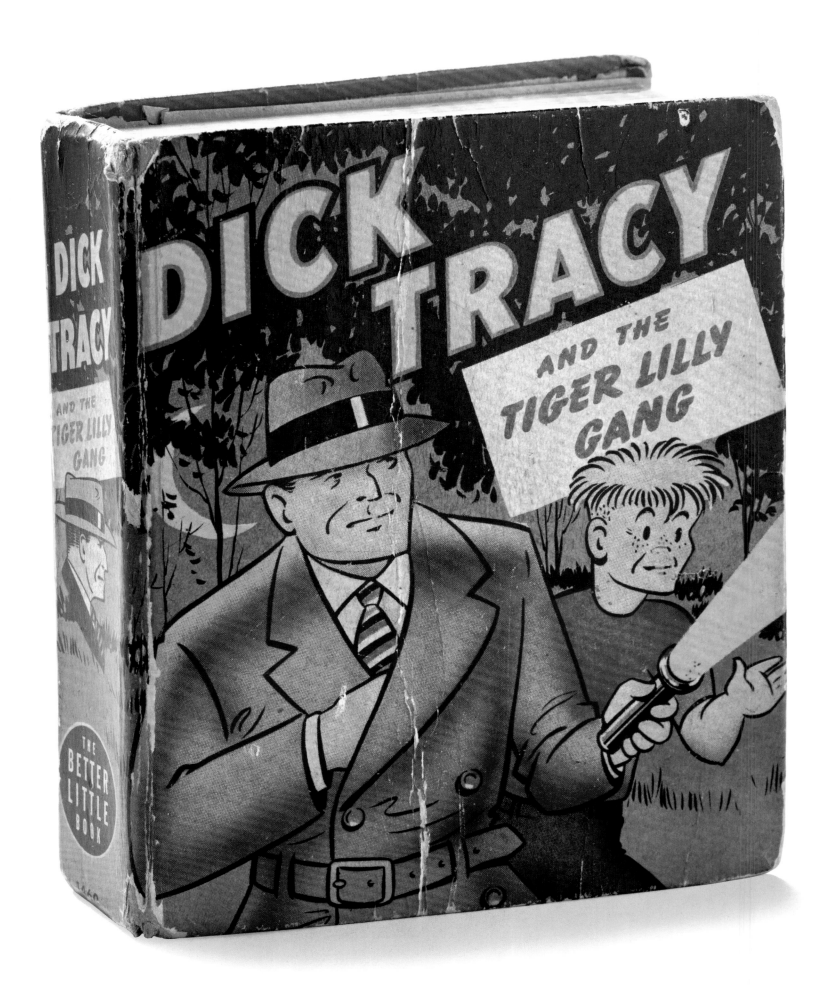

09 | BIG LITTLE BOOKS

Growing up, Sparky was a voracious reader of comics. His father would buy all four local newspapers so they would have more comics to read. He'd read the loosely drawn humor of Percy Crosby's *Skippy,* the precisely penned adventures of *Prince Valiant,* and everything in between. He'd grab what comic books he could, even reading early adventures of Superman, who first appeared while Schulz was in his teens.

He'd also pore over Big Little Books. These cousins of comics were a line of small, thick hardcover books featuring tales of characters from the comics, radio shows, movies, and other popular media. The books, which used a combination of prose and black-and-white pictures, each cost the same dime that a color comic book would cost. Schulz's Big Little Books from his childhood are long since gone, but he collected some again as a nostalgic adult.

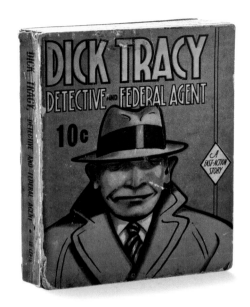

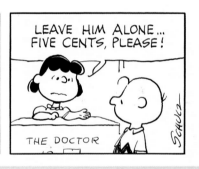

I can remember the first Big Little Book that my
mother brought home for me one day when she went
downtown, called *Dick Tracy: Detective.* And I was always
fascinated by [*Dick Tracy* cartoonist Chester Gould's]
characterizations, his ability to make these things
really seem real and important to the reader.

—Charles M. Schulz

As a child, Sparky read some books on cartooning, but none captured his attention as much as one his mother gave him as a gift on his eleventh birthday. *How to Draw Cartoons* was a 1926 book by Clare Briggs, the cartoonist behind such popular, nostalgia-laden strips as *When a Feller Needs a Friend* and *The Days of Real Sport*. His book was quite different from most cartooning texts, as it didn't focus on drawing technique but on the observational skills needed to find good comic stories, and how different kinds of humor work within a strip. Schulz would point to Briggs as someone who influenced him greatly.

The introduction to *How to Draw Cartoons*, written by *Chicago Tribune* political cartoonist John T. McCutcheon, heaps substantial praise on Briggs. He notes that Briggs had "preserved the boy life of his own youth with ...photographic accuracy," that he had "introduced phrases which have become incorporated into daily conversation wherever English is read," and that "every day millions look at the Briggs cartoon as regularly as they eat their breakfast and almost always get a smile or a pleasant glow in consequence." Schulz not only took inspiration from Briggs but also seems to have matched him in the style of his creative success, as those notes could also apply to Schulz's career.

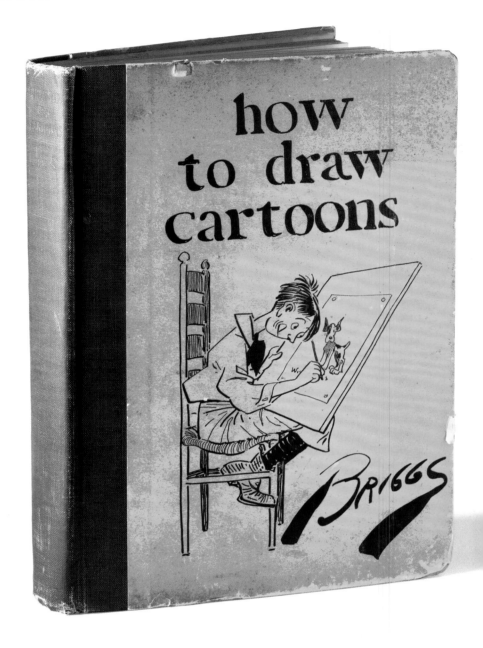

While Briggs and Schulz had different rendering styles, they covered similar themes.

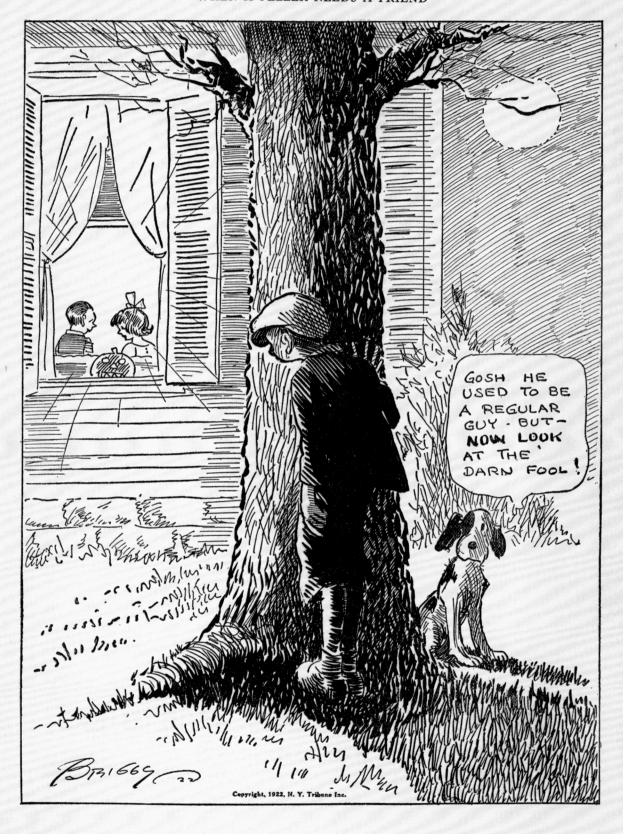

11 | ORIGINAL COMIC STRIP ART

In February 1934, Charles Schulz got an opportunity that would prove quite formative. The Saint Paul Public Library had a display of hundreds of pieces of comic strip art, and for the first time, Sparky got to see the comics not in their slick printed form from the newspaper but with the pencil lines that went into constructing the images and the corrections, smudges, and thumbprints. He could see that works by then-popular folks like Cliff Sterrett (*Polly and Her Pals*), George McManus (*Bringing Up Father*), and Ham Fisher (*Joe Palooka*) were the work of genuine if talented humans. This took him from simply wanting to be a cartoonist to believing that it was possible.

Schulz would later accumulate original comic strip art by a large number of creators, including the original for the November 5, 1916, installment of George Herriman's *Krazy Kat*, seen here. Visitors to his studio would find a hallway lined with framed art from many of the top names in newspaper comics history.

> After World War II, when I came home, *Krazy Kat* became my hero. I had never seen *Krazy Kat* up until then, but it became my ambition to draw a strip that would have as much life and meaning and subtlety to it as *Krazy Kat* had.
>
> —Charles M. Schulz

Krazy Kat, which ran from 1913 until Herriman's death in 1944, was a favorite of newspaper magnate William Randolph Hearst, who made sure that it had a home in his newspapers. It was, however, less popular with those newspapers' editors and with the public at large, and was relatively obscure in its day. The strip gained appreciation in intellectual circles, and is today considered an abstract masterpiece, even as more popular pages from the time are now largely forgotten.

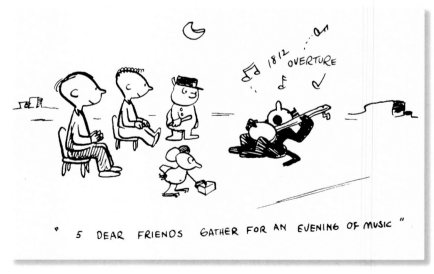

Sparky drew this *Krazy Kat* for friends.

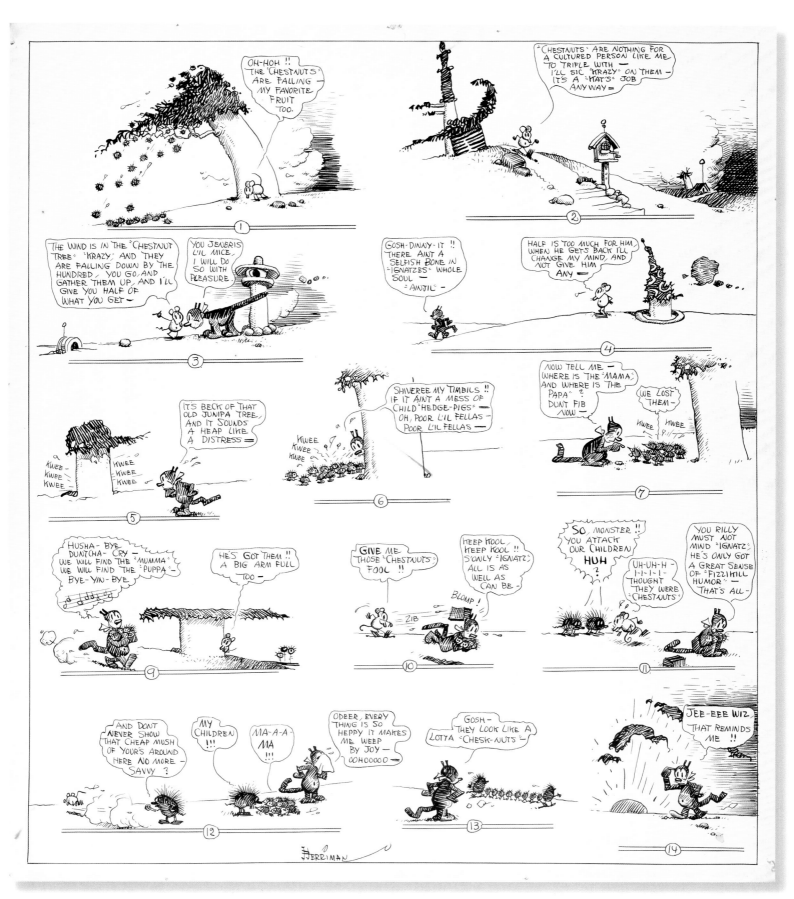

Sparky's George Herriman original.

12 | *PAR FIGHTERS*

When Sparky played his first round of golf in the mid-1930s, he instantly became, in his own words, "a fanatic," despite shooting a maddeningly high 156. ("Two days later I shot 165," he later noted. "The next spring, I started playing again, and within a month or so, I had [shot] a 79.") His interest in golf would continue for more than half a century. Golfing took up a fair portion of his leisure time and was the basis for hundreds of his cartoons, both in *Peanuts* and beyond.

Stewart Wright, another member of the neighborhood sports crew who played on local teams, had also found golf. Working together, Sparky and Stewart generated *Par Fighters*. This homemade golf zine contains two typewritten essays on the topic of golf and three golfing cartoons.

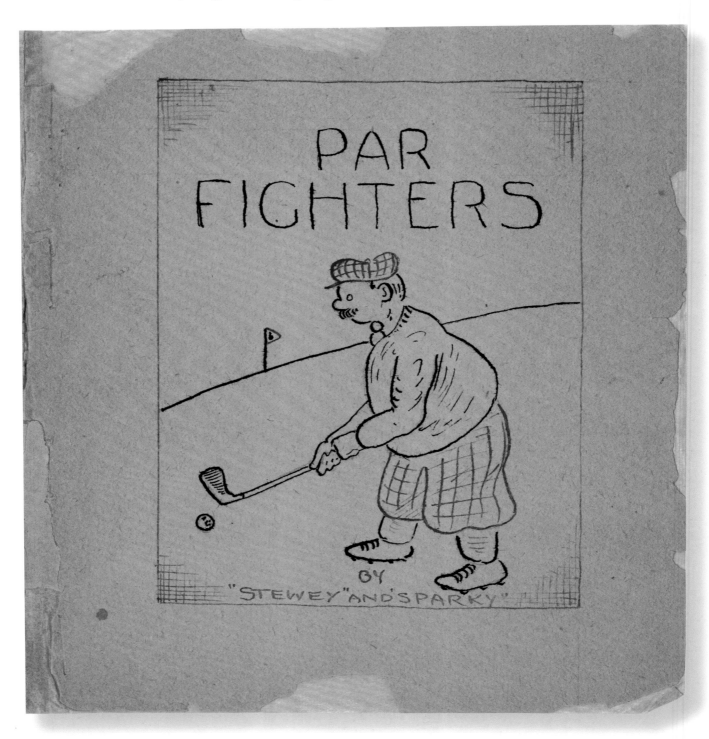

Who would play golf in the snow (or at least swing a club)? Not many people. I can imagine Snoopy doing it, and Snoopy and Sparky were a lot alike.

If you want to be a good golfer, you need to practice somehow during those long Minnesota winters. Sparky loved golf and took a lot of pride in his game. He played regularly in the Pebble Beach Pro-Am tournament. He loved golf so much that the photo on his funeral program showed Sparky on the golf course.

I doubt he was actually hitting balls in the snow photo (they'd be hard to find), but he may have been practicing his sand trap swing with little snowballs. His form is excellent, by the way!

Practicing his golf swing in the snow also strikes me as a whimsical and individual thing to do. He was undoubtedly imagining a warm day with green grass. But the idea of it may well have given him some cartoon ideas. Sparky would later incorporate a lot of golf material in *Peanuts*. The golf course is a great place to think of comic strip ideas, by the way. I remember one of his later Sunday cartoons showed Snoopy playing at Pebble Beach with the waves crashing on the rocks behind him. He was proud of his artwork on that one.

The golfer mostly competes against himself. In addition to a great deal of practice, there's a lot of thought involved and a never-ending desire to be better and better. It's a lot like Sparky's approach to cartooning.

—Kevin Fagan, creator, *Drabble*

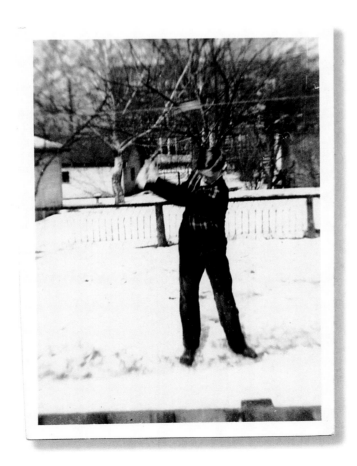

13 | CADDIE BADGE

While in high school, Sparky took his interest in golf and decided to go pro … as a caddie. This badge identified him as someone who was permitted to schlep people's clubs around the Highland Park municipal golf course. It was there that he met a fellow caddie whose last name was "Schroeder." Sparky would borrow the boy's name for his own uses over a decade later.

In 2005, the course where Schulz had once caddied was renovated. Now called the Highland National Golf Course, its signature feature is a bunker on the fifteenth hole that is shaped quite intentionally like Snoopy.

Schulz would take his youthful role as a caddie and bring it into his cartooning, assigning the job to various *Peanuts* characters over the years. Charlie Brown caddied for both Lucy and Snoopy. Peppermint Patty and Marcie trained themselves to be caddies on a local course. Spike caddied for the mysterious beagle known as the Masked Marvel. Even Woodstock got the gig as Snoopy's caddie in the 1980s, although he did find hefting a laden golf bag to be more than a bit of a struggle.

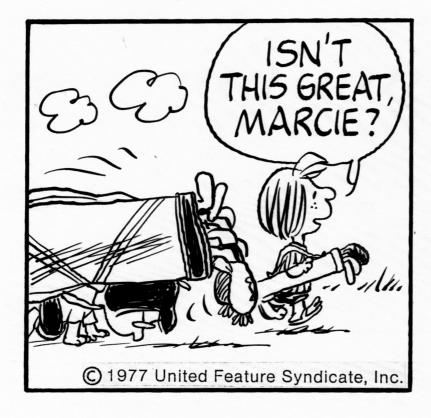

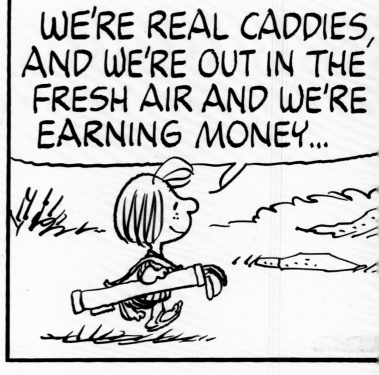

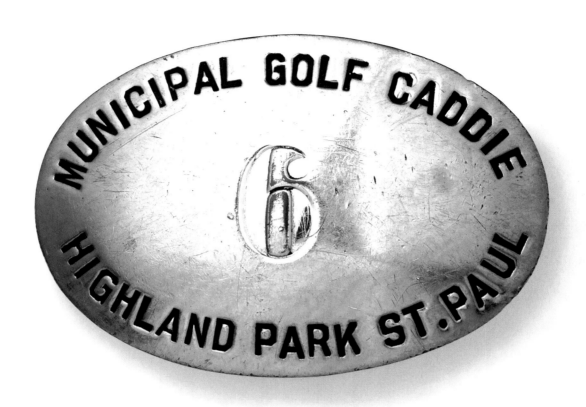

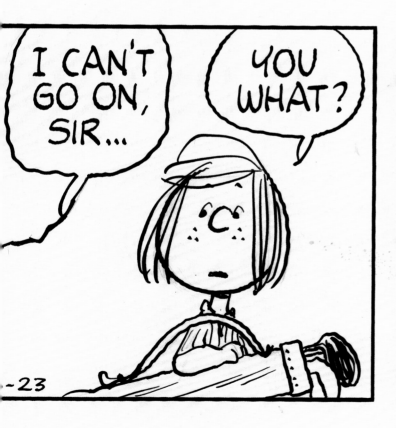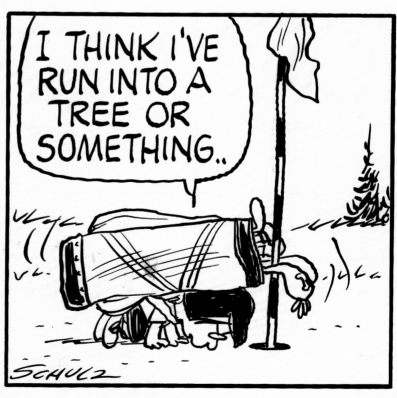

Charles Schulz broke into newspaper syndication when he was only fourteen.

The Schulz family had a dog named Spike who would eat unbelievable things, like razor blades and tacks. The syndicated feature *Ripley's Believe It or Not!* had already spent over a decade showing the world several unlikely or amazing truths each day, making it a lighthearted but informative oasis of art in the newspapers and an obvious place to tell the world about this cool canine. The family wrote a letter to *Ripley's* and included a drawing of Spike by Sparky.

On Monday, February 22, 1937, Schulz's drawing hit the presses throughout the nation.

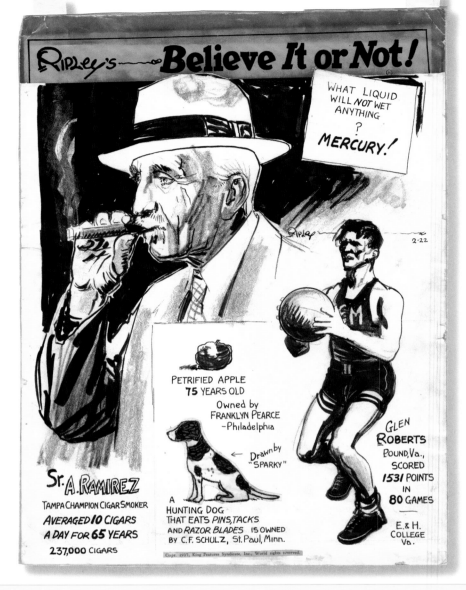

Shermy Plepler, a close friend who lived around the corner, had encouraged Sparky to submit his drawing. Over a decade later, Sparky would name the very first character to speak in *Peanuts* after his childhood pal. Spike the dog would be used in the strip in more than one way: his name would be given to one of Snoopy's brothers, and his appearance would be a key inspiration for the early version of Snoopy himself.

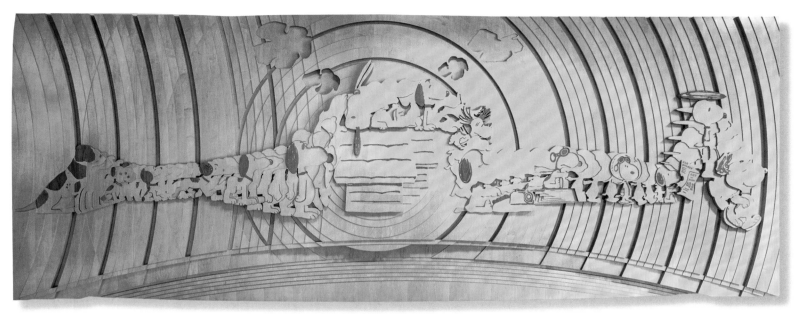

Yoshiteru Ohtani's three-and-a-half ton *Evolution of Snoopy* is mounted on the wall of the Schulz Museum's great hall.

Mr. Schulz's first published illustration has a particularly Snoopy-like appearance, with black spots on its white body, black ears and nose, and a partially black base of its tail. Schulz later drew this puppy in *Li'l Folks*, the prototype for *Peanuts*. In 1997, Schulz and his wife Jeannie commissioned me to create two works for permanent exhibition at the Schulz Museum. After many discussions with Schulz, we decided to create a piece that represented 'the evolution of Snoopy.' Schulz himself showed me this illustration he'd done when he was 14 telling me that it was Snoopy's prototype, the first step in the character's evolution. For 63 years, from 1937 until 2000, when the *Peanuts* series ended, Schulz crafted Snoopy, evolving the character over the course of his life. This illustration was used for the very first image in the *Evolution of Snoopy* sculpture in the Schulz Museum.

—Yoshiteru Ohtani

15 | PAGE OF THREES

In 1938, Sparky was given an in-class illustration assignment that was perfect for a budding cartoonist: he could draw whatever he wanted, but he would have to draw a set of three of each item and all must be on a single sheet of paper. "He couldn't wait for me to stop talking," Minette Paro, the illustration teacher, would later remember. His hands flew over the page as he drew dozens of triads, showing an ability to draw the same thing repeatedly that would serve him well when drawing comic strips. He even signed the work thrice. Miss Paro recognized that the young student's mind was "full of images wanting to get out" and asked him to discuss his drawings before the entire class. She held on to the results for decades, and then sometime around 1965, when Schulz had succeeded beyond what even she had imagined, she sent the page back to her now-famous former pupil.

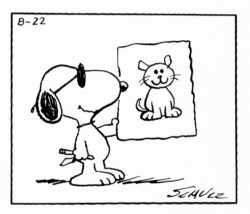

16 | HIGH SCHOOL YEARBOOK

Illustration teacher Minette Paro also oversaw the Central High School yearbook, the *Cehisean*. In Sparky's junior year, she encouraged him to submit cartoon drawings of some of the school activities. He put his energy into the cartoons and was pleased with the drawings, which made him all the more disappointed when the yearbook was distributed, as not a single piece of his art had been included.

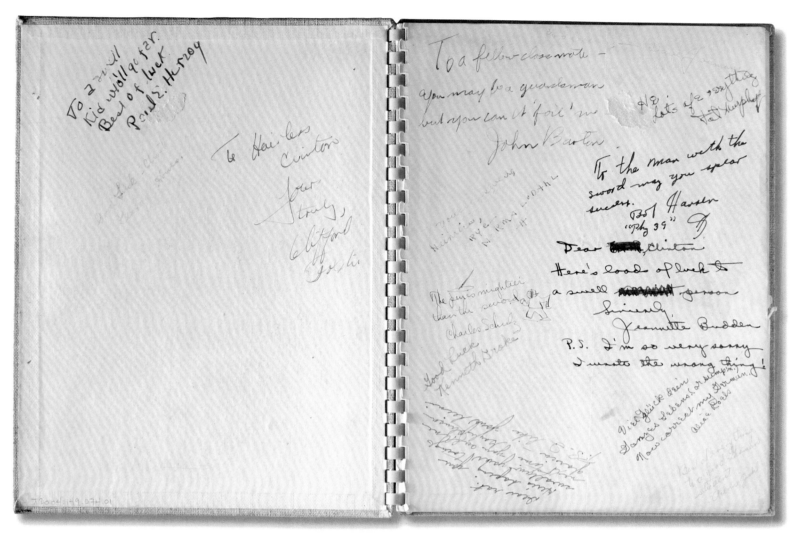

Schulz not only inscribed this copy of the yearbook for a classmate, he added a doodle. His contribution starts about halfway down the right-hand page, next to the spine.

To this day, I do not know why they were rejected.
I have enjoyed a certain revenge, however, for ever since
Peanuts was created, I have received a steady stream
of requests from high schools around the country
to use the characters in their yearbook. Eventually,
I accumulated a stack tall enough to reach the ceiling.

—Charles M. Schulz

· MODERN ·
ILLUSTRATING
INCLUDING
CARTOONING

DIVISION
3

ART INSTRUCTION, INC.
MINNEAPOLIS, MINNESOTA

17 | ART INSTRUCTION COURSE BOOKS

In January 1940, Sparky's mother, Dena, saw an ad for by-mail art classes with Federal School Inc. (which would later be known as Art Instruction Inc.). With her encouragement, Sparky applied, using a sample drawing of the figure that was labeled "Draw me!" in the ad. The course cost $170, which in today's dollars would be about $3,500—a lot to ask from a barber's income. But Carl found a way, and Sparky spent a year and a half going through the school's educational booklets, doing the exercises, and submitting his work to be graded by mail.

That mail didn't have far to go. The school's offices were just across the river in Minneapolis. That closeness didn't make much of a difference when Sparky was taking the course, but it would have a real impact on his life in the years to come.

18 | REPORT CARD

Charles Schulz was such a good student that he skipped two half grades during elementary school. That meant that he entered high school younger and smaller than most of the boys. It didn't seem to hold him back academically in the long term, however. This Central High School report card from his senior year shows him getting nothing lower than a B. When this card was reprinted in the 1975 book *Peanuts Jubilee*, Schulz noted, "This report card is printed to show my own children that I was not as dumb as everyone has said I was."

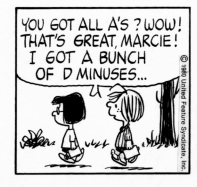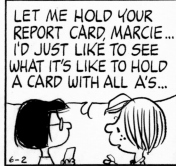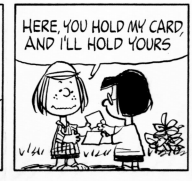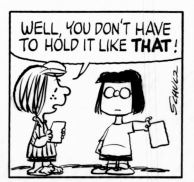

> This impressive report card belies the story Sparky
> often told that 'one semester [he] failed every class.'
>
> —Jean Schulz

H. S. 25---20M 6-38

HIGH SCHOOL

MONTHLY REPORT

Semester Ending ____ June ____ 19 40

Name Schulz, Charles

Enrollment Room 315

Subjects	Room	1	2	3	4	Ex.	Av.	Credits
[1] Econ.	315	A	A	B	B		85	
[2] M. 3	319	a+	a+	a	aa		94	
[3] St.	A							
[4] St.	301							
[5] Com. Law	217	B	A	A	A		86	
[6] M.	319	a+	a+	a	aa		93	
7								
8								
Days Absent		1	1					
Times Tardy			1					

95 to 100 Excellent, AA. 90 to 94, Very Good, A.
85 to 89 Good, B. 80 to 84 Fair, C.
75 to 79 Passing, D. Below 75 Failure, E.

SIGNATURE OF PARENT OR GUARDIAN

1st Mo. Mrs Carl Schulz

2nd Mo. Mrs Carl Schulz

3rd Mo. Mrs Carl Schulz

4th Mo. ____

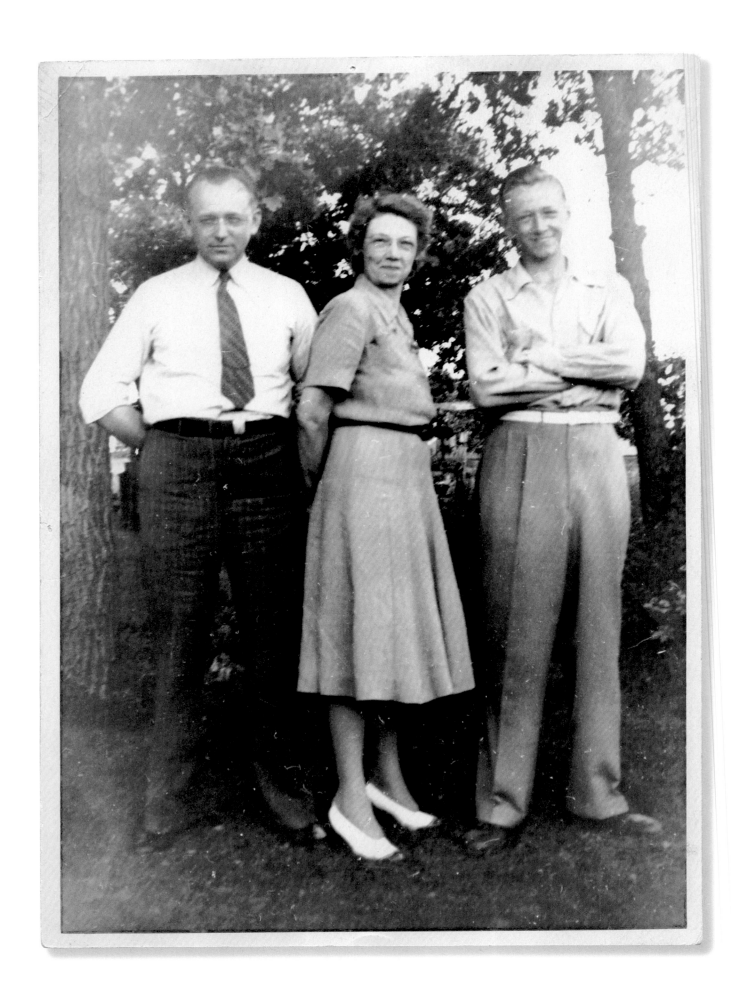

19 | THE LAST FAMILY PHOTO

This photo, circa 1940, is the last known photo of the three Schulzes together. Carl is looking confident, Dena proud, and there's a boyish grin still atop Sparky's now man-sized body. It is a moment of brightness.

But the cancer that will kill Dena is already in her body. The war that will send Sparky thousands of miles away has already begun.

The Schulz family moved to the apartment above the barber shop to be close to the druggist around the corner, to better see to Dena's needs as illness took her. Sparky got his draft notice in November 1942. He returned home from Minnesota's Fort Snelling on a day pass in February 1943, and his mother said what she knew would be her final goodbye to him then.

When Dena died on March 1, Schulz was allowed to delay shipping out with the rest of those drafted at the same time so he could attend her funeral. Many of those he would have gone with ended up in the D-Day invasion force, a vital effort that cost many American soldiers their lives. In 1998, his wife, Jean, would ask him if he thought his mother's death might have saved his life. He replied, "I think about it every day."

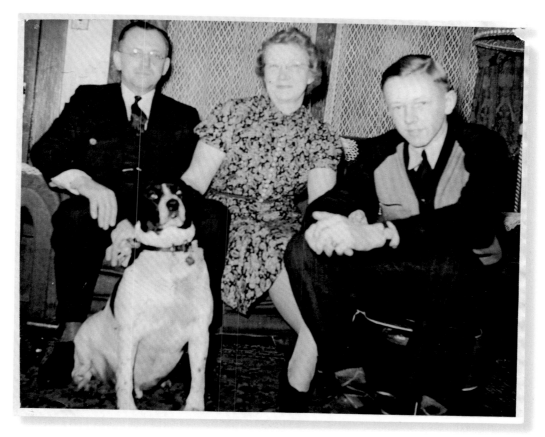

This somewhat earlier photo includes the important fourth member of the household, Spike the razor blade–eating dog.

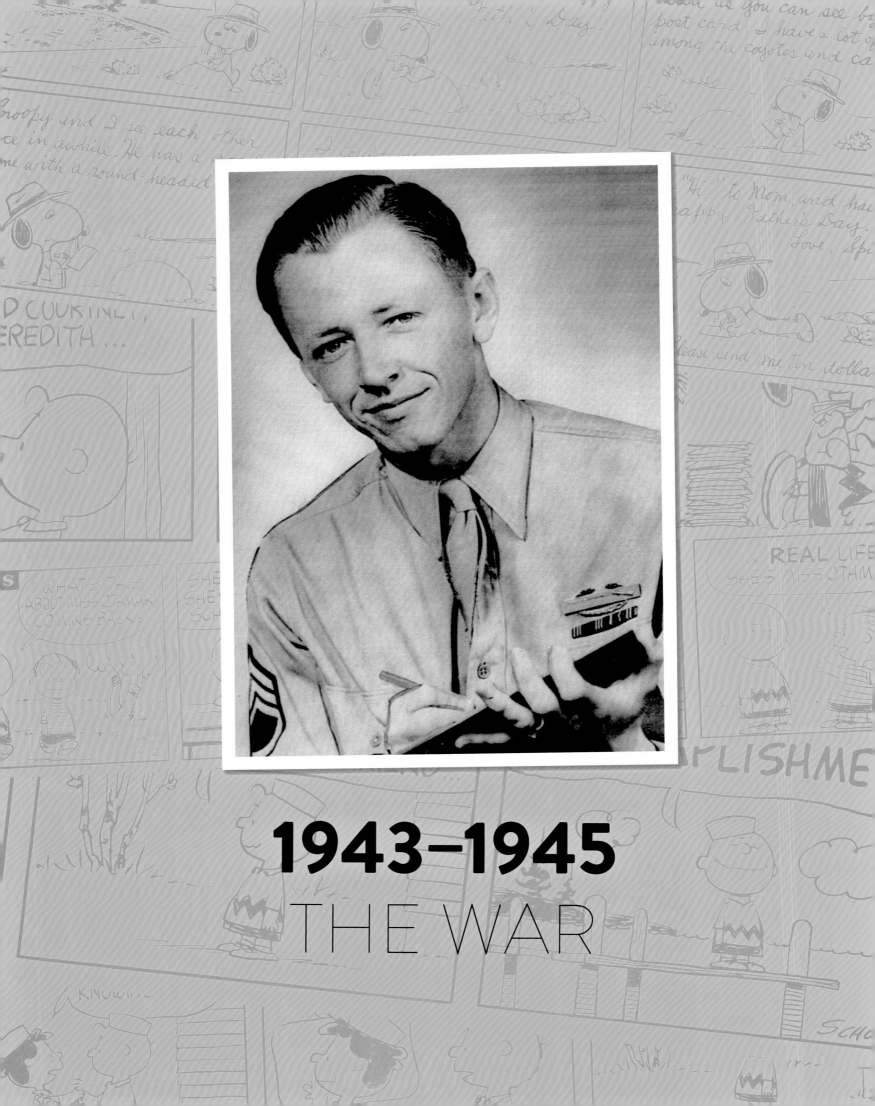

1943–1945
THE WAR

With the Japanese attack on Hawaii's Pearl Harbor naval base in December 1941, the United States was dragged into a world war. Millions of young Americans were pressed into service, drafted to fight a war in distant lands and to keep it from returning to US shores. Schulz was drafted in 1943. He trained in Kentucky at Camp Campbell (renamed Fort Campbell in 1950) to become a soldier but was not sent to fight in Europe until the war was in its final stretch. By the time he returned home in 1946, after the war was over, he had seen far more of the world than he had ever expected, had been handed responsibilities he could not have imagined, and had grown and been reshaped in many ways. When he died over a half century later, his grave marker would carry no reflection of all that he'd achieved in those intervening years. It would identify him simply as "Charles M. Schulz, Sgt. US Army, World War II."

AN INSPIRING EXPERIENCE

Schulz's cartooning always drew upon his life, and his military experience proved a rich vein. While he did little in *Peanuts* to directly address World War II until relatively late in the strip's run, it was his basic training experience, rather than any actual childhood camp experience, that gave him the base for many of the strips about the kids going to summer camp. The World War I Flying Ace's cursing of the war and concern about the "blighters" fighting in the trenches are born of a soldier's experience in the reality of war. Schulz could see how a powerful cartoon could make a deep connection with people even regarding something as dark as war, and he reflected his admiration for Bill Mauldin's World War II cartoons about soldiers Willie and Joe both by name-checking Mauldin repeatedly and by making Willie and Joe two of the few adults to appear in *Peanuts*.

> I was not a tough guy, but I was good at sports. When I was 15, I became instantly a good ballplayer. I was good at any sport where you threw things, or hit them, or caught them, or something like that. It wasn't until I came back from the war that I really had self-confidence, because I went into the Army as a nothing person, and I came out as a staff sergeant, squad leader of a light machine gun squad. And I felt good about myself, and that lasted about eight minutes, and then I went back to where I am now.
>
> —Charles M. Schulz

 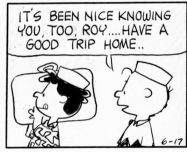 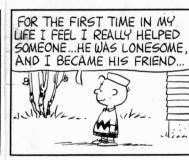

Remembering back to how much it mattered to him that someone befriended him.

> Another reflection of my emotions are all of the summer camp ideas which I have drawn. They are a result of my having absolutely no desire as a child to be sent away to a summer camp. To me that was the equivalent of being drafted. When World War II came along, I met it with the same lack of enthusiasm.
>
> —Charles M. Schulz

> I'd visited France long before that, during World War II,
> when my squad got off the troopship in 1945 and
> I was stationed briefly at a château near Rouen—Château
> Malvoisin, which means 'house of the bad neighbor.'
> I used to think and dream about that building all
> the time. It was gray stone, with a stone wall around
> it forming a paddock where my squad set up camp.
> A few years ago I went back to the château, and there
> I got the idea for the movie *Bon Voyage, Charlie Brown*, where
> Charlie Brown and his friends go to France as exchange
> students. Naturally, they spend a night at the château.
>
> —Charles M. Schulz

Schulz would dip into his wartime experiences when writing the screenplay for the 1980 feature film *Bon Voyage, Charlie Brown (and Don't Come Back!!)*. Much of the film is set at the Manoir de Malvoisine in France, a location where Schulz and his unit had been billeted for six weeks during their war service. *Bon Voyage* was followed by the 1983 TV special *What Have We Learned, Charlie Brown?*, in which the kids reflect on war while visiting battle sites. They saw the Belgian city Ypres, where battles were fought in World War I, and Omaha Beach, the location of World War II's D-Day invasion, in which Schulz did not take part but to which he would repeatedly pay tribute.

21 | TWENTIETH ARMORED DIVISION PLAQUE

Just after Dena's funeral, Sparky was shipped off to Camp Campbell in Kentucky. He was pulled into the Twentieth Armored Division as it was being formed. The division was in training for almost two years before finally being sent to Europe in early 1945, not long before the Germans surrendered and victory in Europe was declared. This plaque, designed by Rich Mintz for the Schulz Museum as a variant of one he crafted for the National Museum of the United States Army, commemorates the newly trained soldiers' most pivotal effort: taking part in the liberation of the Dachau concentration camp, where tens of thousands of civilian prisoners had been worked, starved, and abused to death. Staff Sergeant Schulz would later talk of seeing the emaciated survivors walking in the road, hugging American tanks. He and the half-track machine gun squad he commanded would continue on to Munich as they had been instructed.

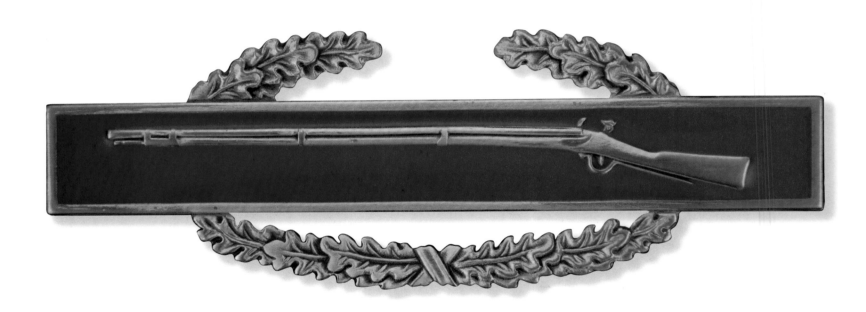

For his service in Germany, Schulz was awarded the Combat Infantryman Badge, a recognition of his having served satisfactorily in active ground combat. It was an achievement in which he took much pride throughout the rest of his life.

20th ARMORED DIVISION
(1943 – 1946)

"BEWARE THE IDES OF MARCH"

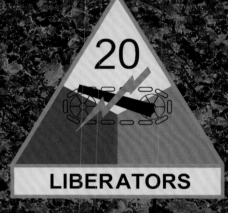

LIBERATORS

CENTRAL EUROPE CAMPAIGN

Entered ETO at Le Havre, FR
Rhine & Danube, GER
Salzburg, AUS

Spearheaded the Battle of Munich

Co-Liberated
Dachau Concentration Camp

When Private Schulz reached Camp Campbell, he was in an emotionally tough position: far from home, knowing nobody, and having just lost his mother to cancer. Corporal Elmer Hagemeyer saw this struggling younger man and befriended him, even bringing him to his home on a furlough. It was then that Sparky met Elmer's wife, Margaret, and she became his friend as well. Their friendship would last long after their military service had ended.

When Elmer Hagemeyer sent letters home to his wife, Sparky would augment them, covering them with cartoons about life at the army base. They would be used to display things like the fresh addition of the staff sergeant "rocker" to the uniform stripes or the attempt to get a finicky radio to work. Margaret Hagemeyer cherished the envelopes as well as the messages within.

> " In 1974 Sparky and I attended a Company B reunion in St. Louis and we stayed with Margaret and Elmer Hagemeyer. It was at that reunion, and in conversation with the unit historian, and discovering that some in the unit had travelled back to Malvoisin, that Sparky decided he would like to go back to that same place where they had stayed for six weeks in 1945. "
>
> —Jean Schulz

Schulz would pay tribute to the Hagemeyers in the same way he did many other friends: by borrowing their name to use in his cartoons. When Miss Othmar, the teacher whom Linus adored, got married in a 1961 storyline, she ended up as Mrs. Hagemeyer.

There was nearly a much larger honor. In the 1950s, Sparky tried developing another comic strip, doing a number of sample strips. Not only was an "Elmer Hagemeyer" a lead character of the strip, but the strip's working title was *Hagemeyer*.

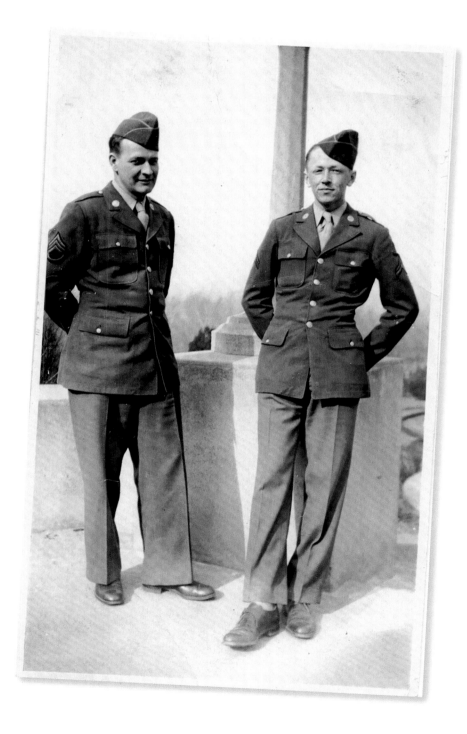

TO: MR. C.F. SCHULZ
170 N. SNELLING, APT. 2
ST. PAUL 4, MINN.

(CENSOR'S STAMP)

PASSED BY 50303

SEE INSTRUCTION NO. 2

FROM
S/SGT. CHARLES SCHULZ, 37550187
CO. B 8th A.I.Bn. APO. 444
c/o POSTMASTER NEW YORK, N.Y.
(Sender's complete address above)

Dear Dad

Some fellow came up to me the other day when we were away from the chateau, + asked me if my home was in St. Paul. He turned out to be the son of that lady whom you're always talking about. I believe their name is Ramstett, is it not? We didn't talk very long, for you know how hard it is to talk to someone you've never seen before. He is a Pfc. + seems to be a pretty nice kid.

We were given our "European Theatre of Operations" ribbon today so I'm going to mail it home to you as soon as is possible. I hear that we are also eligible for the "American Theatre" ribbon too. That's the blue one. The one we received today is green + brown.

I wrote to Bebo + to Annabelle last night. It takes a full month for letters between Bebo + I to get together.

Well, I'm still as hungry as ever so don't relax on those candy bars. I'll let you know as soon as the first box comes.
Good night,
Sparky

Kiss Spike for me.

HAVE YOU FILLED IN COMPLETE ADDRESS AT TOP?

V-MAIL

HAVE YOU FILLED IN COMPLETE ADDRESS AT TOP?

Fighting a war on another continent requires a large amount of transportation of troops, equipment, and supplies. Efficiency becomes paramount. While any one GI's letter to friend or family may be a very small thing to transport, when the number of soldiers you have serving overseas is in the millions, that's a lot of mail to handle.

Today we would avoid that transport by using email, but during World War II, the US armed forces went with V-mail (the V is for "victory"). Soldiers would write their letters on special paper. The military would check the mail to make sure it revealed no secrets, then photograph it. Film took up a tiny fraction of the space and weight that the physical letter would take. When the film reached the States, the photos were printed out, and the letters were delivered. In this letter from Sparky to his dad, he talks about the ribbons he'd earned and requests candy bars.

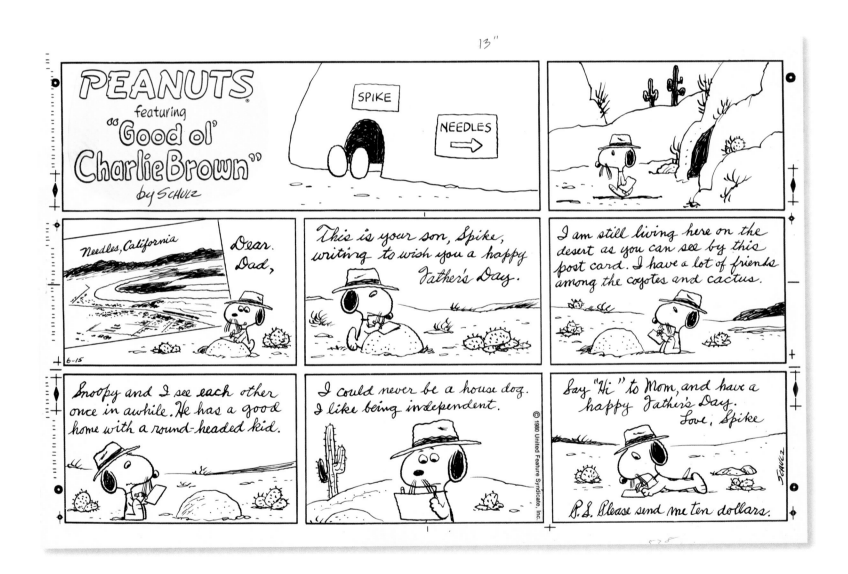

24 | WORLD WAR II SKETCHBOOK

The military keeps a soldier's life very full, even when he is stationed domestically. There isn't much leisure time. Still, the artistic drive is hard to extinguish, and even while serving his country, Sparky found time (mostly on Sundays) to spend with his sketchbook, sketching and cartooning and practicing his craft. This sketchbook, which Sparky titled *As We Were*, kept him in practice as an artist while he was training to be a warrior. He shared his sketches with his fellow GIs, collecting some of their signatures as he did.

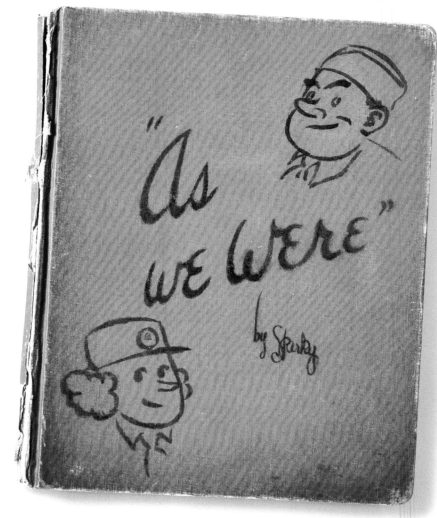

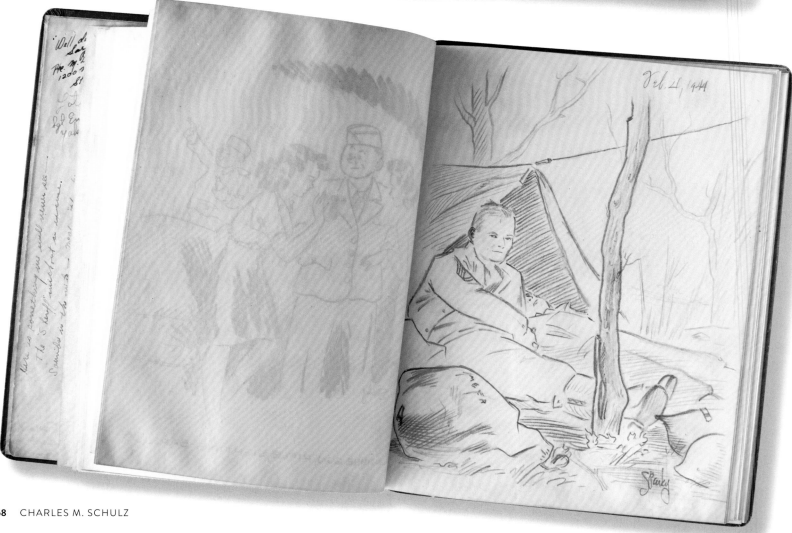

I joined the Schulz Studio in August of 1999. Getting a chance to work with Sparky was somewhere out in the stratosphere, way beyond a dream come true. So, you can imagine how nervous I was the day he offered this red sketchbook to me. I was standing near his drawing board and was intrigued by the cover. He suggested I take the book home so that I could look at it. This was such a generous gesture and of course I was so nervous that something would happen to it while the book was in my care that I let it sit on my coffee table for the better part of the weekend before even working up the courage to look at it. There is something incredibly intimate and personal about viewing another artist's sketchbook. It's like getting a brief glance inside their thoughts, allowing you to view the world through their eyes for a moment. Having Sparky's sketchbook for the weekend is a memory that will stay with me forever.

—Paige Braddock, Chief Creative Officer,
Charles M. Schulz Creative Associates

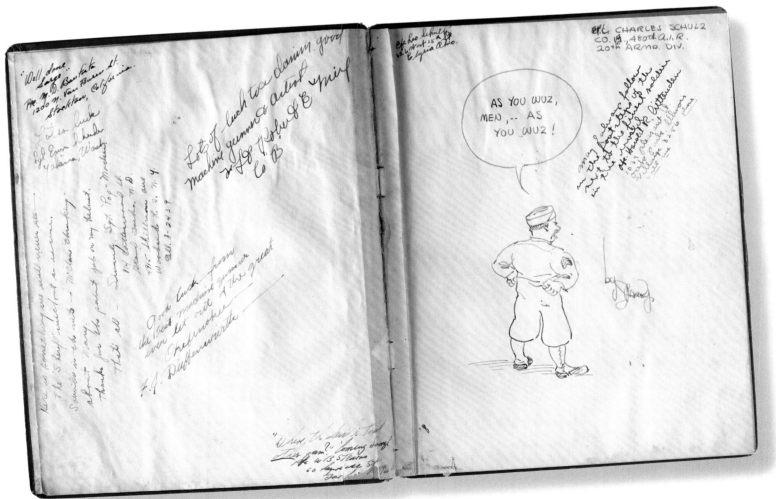

25 | PHOTO ALBUM

Schulz maintained a photo album of his wartime experience. This volume contained not only photographs, but also a map, and a number of articles cut out of newspapers. He was proud of this scrapbook, and would eagerly show its contents to his friends, to his interviewers, and to anyone who had served in the military.

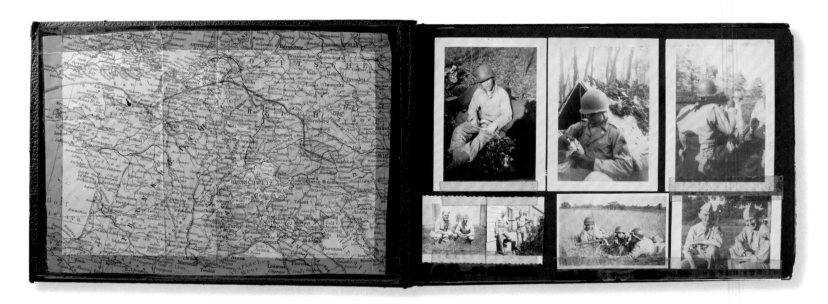

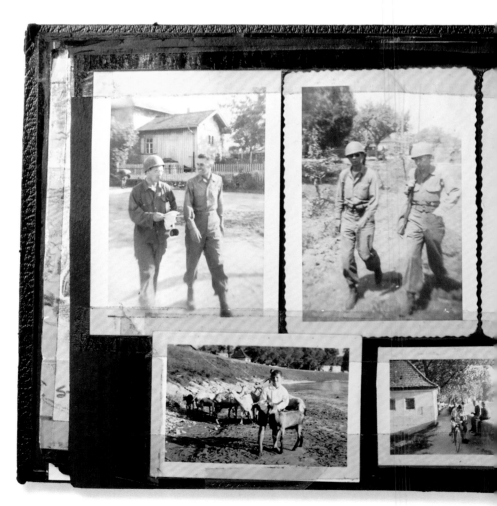

In a very short time, Carl Schulz had gone from being the head of a three-person household to being a widower living alone. Into this life came Annabelle Anderson, a local woman who knew some of the Schulz family's relatives. She kept Carl company and she took an interest in his son, corresponding with him while he was serving his country far from anywhere that he had known as home. The romance continued, but Carl determined he would not remarry until Sparky himself was married. Annabelle and Carl married in 1951.

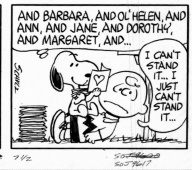

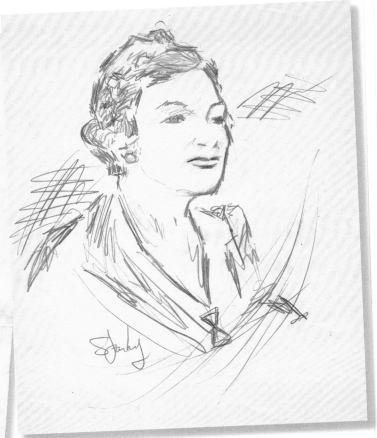

While Charles Schulz is known for his cartooning, he did take occasions to practice other types of illustrative art. His attempts to capture a person's likeness without playing on broad caricature are not often seen. This pencil drawing of Annabelle is one such example.

UNITED STATES ARMY

Nov. 26, 1944.

Dear Annabelle,

How did you ever know that Angel-food is my favorite cake? You certainly couldn't have sent anything any better. I also received the money, and it went for a steak a foot long this evening.

Thank you very much for everything.

This has been a very quiet birthday. I went to the show this afternoon, and saw "Meet Me

2) **UNITED STATES ARMY**

In St. Louis", a really enjoyable picture all done up in technicolor with lots of music.

We have been living out in the field for the past week so because of the cold + inconvenience, I haven't written to anyone.

Let me thank you again for your thoughtfulness, Annabelle. Thoughtfulness + Angel-food cake make a fine birthday present.

As ever,
Sparky

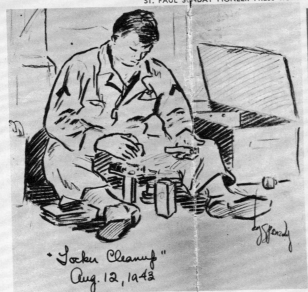

"Locker Cleanup"
Aug. 12, 1943

'As We Were'

Army memories will be kept vivid in a rather unusual manner for Corp. Charles M. Schulz, son of C. F. Schulz, 170 N. Snelling. In a medium-size book with red covers are fifteen cartoons of Army life which the Central high school graduate has sketched in "off-duty" hours.

Formerly an employe of Northwest Printing and Binding Co. in St. Paul and later of the Associated Letter Service, the corporal always has liked to draw. He has an especial fondness for the comic strip style, working with pencil, pen and ink.

Since entering the Army ten months ago, he has been stationed at Camp Campbell, Ky. Typical of his work are the drawings in this series. He plans to continue making sketches of Army life as he sees it.

Driver of the Guard
Oct. 20, 1943

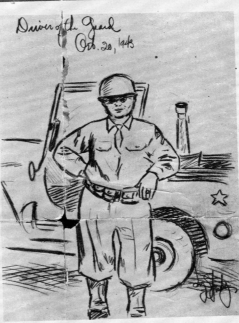

Lockers

usually are the first place the men straighten in the rush preceding inspection, the corporal says.

Humorous Ribbing

of the sighting bar range is depicted in this cartoon. Proficiency with the sighting bar, a wooden training aid, nets no medals or decorations but the term often deceives civilians.

"000...MACHINE GUN, RIFLE, SIGHTING-BAR....."

Driver of the guard makes his rounds of the post in a "peep", as "jeeps" are called by the armored divisions.

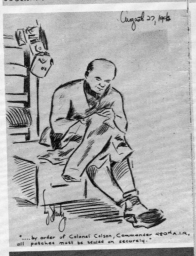

"....by order of Colonel Colson, Commander 480th A.I.R., all patches must be sewed on securely."

Mending and patching clothes is a job not exactly a favorite with the soldiers.

"No reveille on Sunday morning"

Forty Winks extra are obtained each Sunday morning, the one day reveille is not sounded. "We miss break-fast—but it's worth it," the corporal believes.

"Flophouse" (simulated)

Day Is Done and the soldiers flop on their bunks for well-earned rest.

27 | ST. PAUL PIONEER PRESS CLIPPING

During World War II, America's newspapers loved to run articles about (and sometimes by) soldiers from the local area. This practice gave the readership the feeling of being involved in the war effort.

On Sunday, January 9, 1944, the *St. Paul Pioneer Press* ran a page of drawings in its magazine section taken from hometown boy Charles Schulz's sketchbook. Titled "As We Were," after the sketchbook from which the drawings were taken, the page shows examples of the young corporal (as he had become) capturing the quiet moments around Camp Campbell—along with the occasional gag. This would be the first time that Schulz got a humorous cartoon into the papers. It would certainly not be his last.

> " I always get teary when I think about Sparky's entry to the army. Here is this sensitive, naive teenager on his first trip away from home, while his mother was sick, going into the army. The bleedin' army. He must've been so lost. And then to lose his mother... . "
>
> – Brooke Clyde, stepson of Charles Schulz

PORT: SCHULZ, CHARLES

1946-1949
BUILDING A CAREER

With victory in Europe achieved, American forces returned to the United States. Japan's surrender spared Schulz from taking part in the planned invasion known as Operation Coronet. And so, on January 6, 1946, Staff Sergeant Schulz became a civilian once again. Like so many other draftees, he came home with no job waiting for him but equipped with whatever skills he had gained in his years in the service. He had a goal of building a life for himself and a dream of being a cartoonist.

Despite a tough job market for returning GIs and discouraging struggles and setbacks, Sparky worked tenaciously to get his foot in the door of a cartooning career. By the end of this period, he was being taken seriously by national syndicates, and stood on the cusp of the career that would carry him for the rest of his life.

When Sparky was growing up, the Schulz family followed its Lutheran faith rather vaguely. As Dena was dying, Carl found some support from Reverend George Edes of a local church affiliated with the Anderson, Indiana-based Church of God. He began attending the church, and when Sparky returned from the war, he joined his father there. It was at this point that Sparky started developing a deep interest in the Bible. While his specific theological views and choices of religious practice would vary over the years (he went from attending a church that expected him to spread the word on street corners to having no "desire at all to try to influence anyone in my own beliefs or thoughts"), his fascination with the text never waned. In his later years, he would lead Bible classes at a local Methodist church, where he was less interested in teaching a right answer than in helping people find their own. "My class is all discussion and speculation and searching for truths that I want each individual to decide for himself." Biblical tales and teachings would figure heavily in *Peanuts*. This copy of the Bible, inscribed with his own address and the address of his church on June 10, 1948, is an edition published by the New York office of Oxford University Press.

While the content of the Bible was a great influence on Schulz, the physical format of this edition appears to have also had its impact. Starting in 1956, Schulz did a series of single-panel cartoons about teens called *Young Pillars* for the Church of God's magazine, *Youth*. In a 1965 installment, a teen complained that "the zipper on my Bible is stuck!" The same fate befell Linus in a 1990 *Peanuts* strip. In 1998, Linus's brother, Rerun, had the identical thing happen to his copy of the holy book.

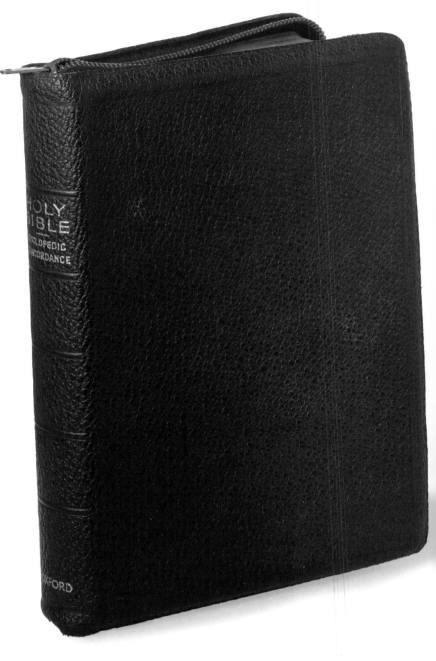

 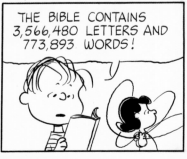

I picked this item because I wanted to choose something that: 1) Sparky spent a lot of time with. 2) Had an impact on the man God created. 3) Would explain his incredible human qualities. 4) Would help us understand where he got his beautiful outlook on life, and 5) Why this comic strip was much more than a comic strip. Charles Schulz was a man of faith and, as we all know, incredible quality. He constantly gave of himself to allow our world to be a much better place, just because he was in it. His God-given talents were shared to bring people together, and allow them to see themselves in his work.

—Scott Hamilton, Olympic champion figure skater, author/speaker, and humanitarian

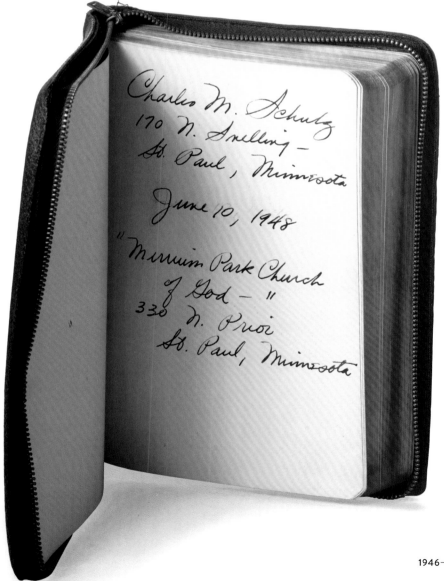

C-70040-26 -3- May 10, 1948

Miss Virginia Russo

It was a real pleasure to see the manner in which you handled the drawings of these
children. With this knowledge firmly established in your mind you should be able to do
some fine work with the problems that are still before you.

Sincerely yours,

ART INSTRUCTION, INC.

Charles M. Schulz

Charles M. Schulz, Instructor

CMS:iab

29 | ART INSTRUCTION HOMEWORK FEEDBACK

The art training that Sparky had received from the Federal School served him well in multiple ways. It improved and focused his skills, and it also helped him get a job—at the very school he had learned from. As an instructor there, he would evaluate the assignments that students sent in by mail, such as this one from Virginia Russo for an assignment on "drawing children," a topic that Sparky himself had once gotten a middling C+ on. The blue pen marks on the assignment are Sparky's, checking the student's proportions and suggesting improvements. The accompanying note gives the student details on any concerns that needed them, and encouragement.

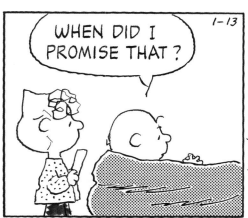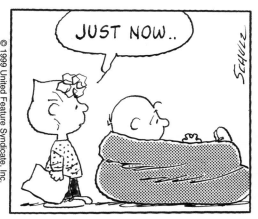

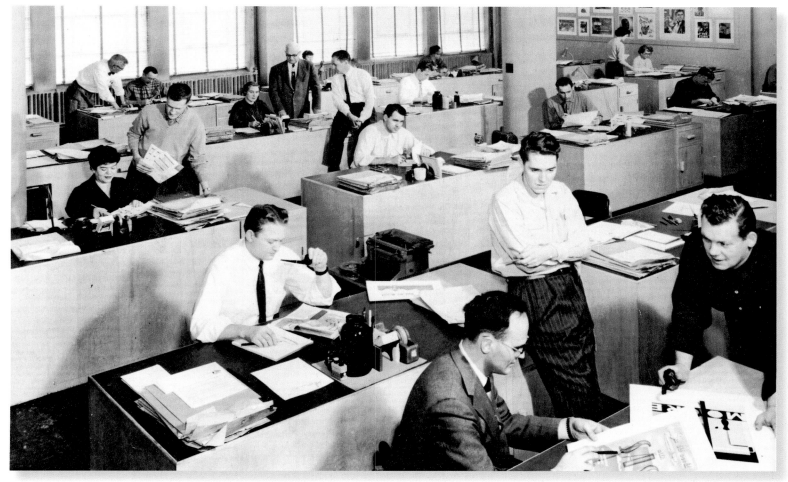

Sparky (seated on the desk in the upper center of this picture) enjoying the camaraderie encouraged by the open office layout at Art Instruction.

30 | THE INITIAL DRAFTING TABLE

When Sparky started working as a full-time art instructor, his salary was thirty-two dollars per week, not exactly a princely sum even in its day. But he was a single man sharing an apartment with his father, so expenses were under control. With his very first paycheck, he invested in himself, spending twenty-four dollars of it on the first of only two drafting tables he would have in his life. He turned what had been his mother's room in the apartment into his studio. Although he would eventually get a second table, this one, made by Anco Wood Specialties under its Anco Bilt brand, would remain with him for the rest of his life, staying in his home when his new table was in his offices. In this photograph from the late 1950s, you can see Schulz posing as if he's drawing a Sunday strip, though the fact that he's holding a pencil while the strip has already been fully penciled and inked makes it clear that it's just a pose.

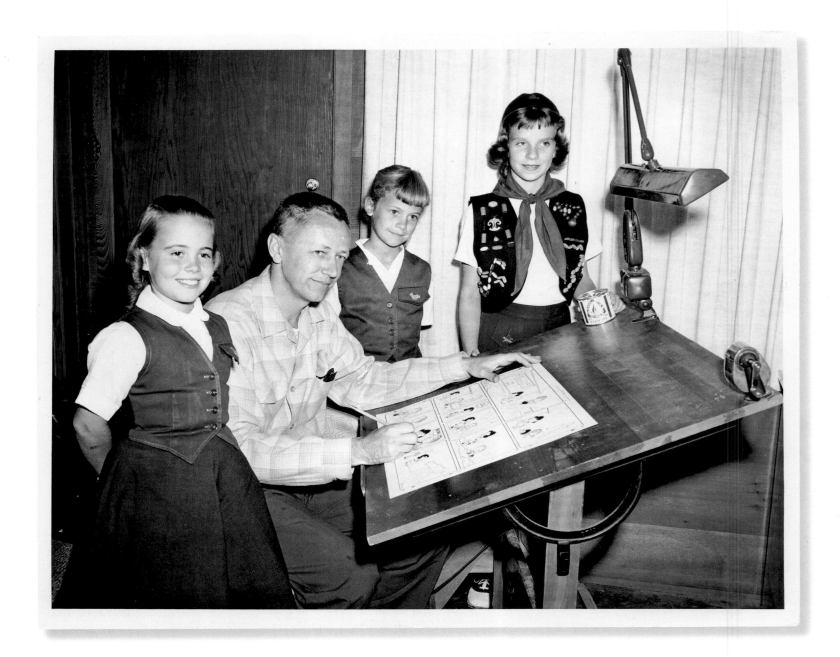

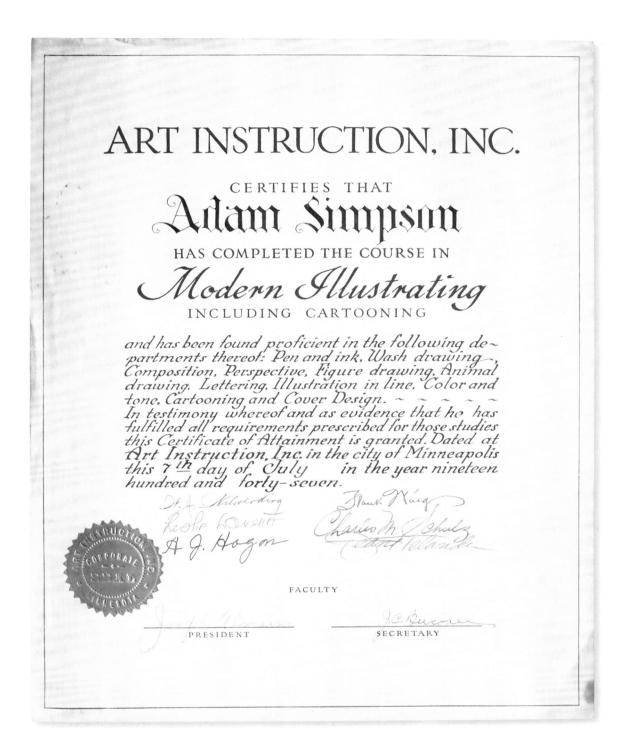

ART INSTRUCTION, INC.

CERTIFIES THAT

Adam Simpson

HAS COMPLETED THE COURSE IN

Modern Illustrating

INCLUDING CARTOONING

and has been found proficient in the following departments thereof: Pen and ink, Wash drawing, Composition, Perspective, Figure drawing, Animal drawing, Lettering, Illustration in line, Color and tone, Cartooning and Cover Design. ~ ~ ~
In testimony whereof and as evidence that he has fulfilled all requirements prescribed for those studies this Certificate of Attainment is granted. Dated at Art Instruction, Inc. in the city of Minneapolis this 7th day of July in the year nineteen hundred and forty-seven.

FACULTY

PRESIDENT SECRETARY

Adam Simpson's diploma, marking the completion of his mail-order illustration course in 1947, is signed by his instructors, including Charles M. Schulz. The name above Schulz's is Frank Wing, who had graded Sparky's own assignments when he was taking the course. Wing, with a storied history as an illustrator, would show Sparky a lot, even though they had differing opinions on cartoon art.

Sparky found much camaraderie at Art Instruction, befriending folks like Dale Hale and Jim Sasseville, who would continue working with him after he left the school. He worked alongside Linus Maurer and Frieda Rich, whose names he would borrow for *Peanuts* characters.

There was also a colleague named Charlie Brown, whose name Sparky would immortalize.

31 | ESTERBROOK 914 RADIO PEN NIB

To an ink artist, a pen's nib is a very delicate machine. Small differences in nib design can make large differences in the line they draw. Finding a nib that lets artists do their best work is vital.

Charles Schulz tried the Esterbrook 914 Radio pen nib when he was given one for signing Art Instruction diplomas. "I discovered that it was a very strong point that could make a nice fine line when held in one direction but could also hold and stand the pressure of making a very broad line without the pen point being too flexible," he would later say.

Esterbrook got out of the dip pen business before closing in 1971. When Schulz learned that the nib that made the round dots of Lucy's eyes and the thin lines of Linus's hair would soon be unavailable, he boldly ensured the consistency of *Peanuts*: he bought out every remaining 914 Radio pen nib that Esterbrook had, and he used them up until his final strip.

> When I was young, we would visit my grandpa at least four times a year. My favorite thing to do was to watch him draw. I was an aspiring artist, captivated by the craft, and he recognized that. He drew so effortlessly, no doubt the reward after years of perfecting his craft daily.
>
> His sketches held a lot of knowledge that I could learn from, and I tried my best to copy his line work. One visit, as we were sitting around the dining room table sketching, he went back into his office and grabbed one of his Esterbrook nibs. Of course I had to try inking my sketches as he did, dipping the pen in the ink and trying to control the flow of the ink as I traced around my pencil marks.
>
> It's very difficult; I don't think I will ever be able to call myself a master penman. I know he took great pride in his craftsmanship skills as he hand lettered and hand drew all eighteen thousand strips.
>
> To me, these pen nibs always symbolized his dedication to his craft. The secret to his drawing skills wasn't the nibs themselves but the thousands of hours practicing and perfecting the art of cartooning.
>
> —Brian Johnson

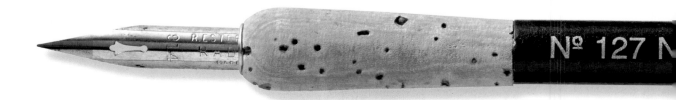

'It was his line, not his storyline.' This is how I would usually try to explain, especially to other artists, the expressive qualities and exaggerations of human emotions and activities that Sparky created through his minimalized black-line pictorial constructions, which initially captured the way I see. The visual articulations of these beautiful black strokes, in his early work, were created with a brush, but its evolution grew increasingly as he began to work exclusively with a two-prong split sharp-ended quill 914 radio pen-point squeezed into an R. Esterbrook pen-staff. With the pressure and pulse of hand, the ink fattens and thins with the spreading and closing of its thin, extremely flexible metal pen nib. It bites and glides across his smooth Strathmore three ply, high surface Bristol paper, leaving a meaningful expression through which the personality of the artist within the cartoonist is present.

It's no secret that when they stopped making the 914 pen-points, Sparky warned that he would stop creating Peanuts when his points were gone. Naturally, he soon had millions. I was extremely fortunate to have been gifted, by his generosity, with over 100 of his pen points that I have looked on for over 40 years. Additionally, it has been an enormous pleasure passing them on to his grandchildren who study art.

In discussing how important the marks resulting from his pen-point, Sparky has been quoted to say, "Far more important than most people think. The drawing must charm, interest. But most importantly you must draw funny."

—Tom Everhart

I remember looking at the dip pen laying in the pencil tray by Sparky's drawing board. This is like seeing Paul McCartney's Fender bass or Robin Hood's bow. As someone who uses dip pens, brushes, and ink, I am keenly aware of the importance of this instrument as the go-between from your hand to the paper. You, the pen, the ink, and the paper are very intimate at that moment. So for me, Sparky's pen is as close to a religious relic as I can get. But for Schulz, it was the means for taking his ideas and characters and putting them out there for people to read every day. This pen changed the world.

—Jeff Smith, creator of *Bone*, *RASL*, and *Tüki* graphic novels

'Uh, Mr. Schulz...what kind of pen do you use?' He smiled and told me it was the Esterbrook Radio Pen nib. 'Only they don't make it anymore.'

Over the following years, we would meet and talk shop—Sparky loved everything about cartooning, including long discussions of discontinued art supplies. I regaled him with stories of my bidding on eBay for vintage Esterbrook radio pen nibs and winning each auction and how I now use them exclusively for my work on *The Lockhorns* comic panel as well as all the Hoest cartoons.

During an NCS Weekend in Washington DC, Sparky and I were leaving the dining area when a young cartoonist glanced at my name tag, stuck out his hand and introduced himself. 'Oh, Mr. Reiner,' he said,' I just want to say how much I enjoy your work. I see your cartoons every day. I just want to ask...what kind of pen do you use?'

Sparky gave me the biggest smile.

—John Reiner, cartoonist, *The Lockhorns*, *Howard Huge*, and *Laugh Parade*

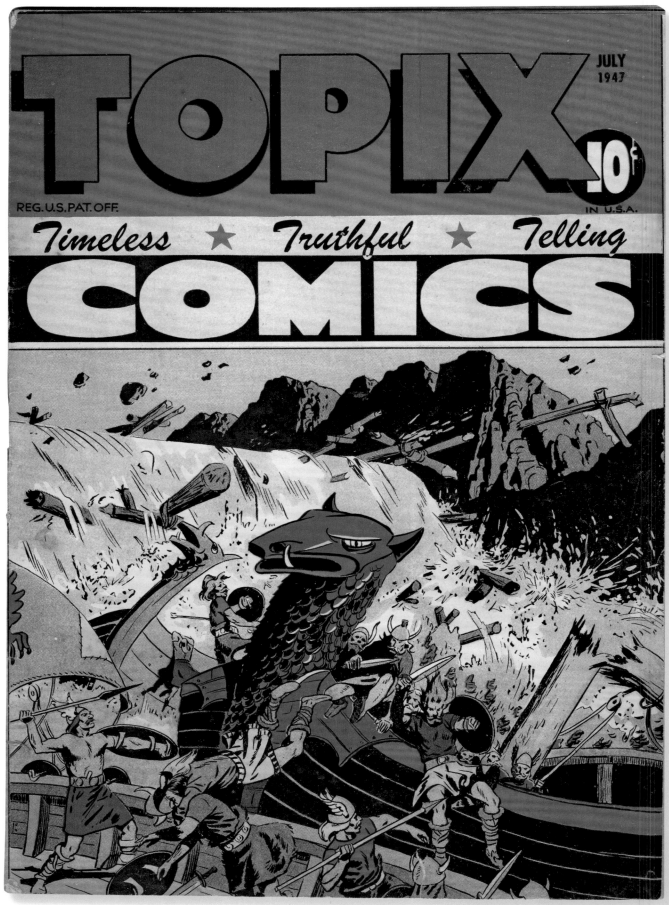

Topix delivered adventure stories, humor stories, Bible retellings, and tales of Church history to Catholic schoolchildren for a decade starting in 1942.

32 | *TOPIX* COMICS

While working as a mail-order art instructor, Sparky was also trying to build his cartooning career. In 1946 and 1947, he worked on *Topix*, a comic book aimed at Catholic school children that featured upbeat and moralistic stories and the tales of Catholic heroes. In traditional comics creation, the effort is often divided among a writer, a "penciler" to draw the story, an "inker" to go over the pencil lines with ink so they reproduce well, a "letterer" who draws all the text, and a "colorist" who places the color. Schulz was working as a letterer on these books, lettering stories not just for the English language edition but also for the Spanish and French editions. This was not the sort of work he truly desired to do, but he felt that any professional credentials would help him in the long run.

Most comic strips are credited to a single creative soul, but the reality is often different. Many newspaper cartoonists have used a range of assistants to help with all aspects of the strip. Sparky, however, famously did all of the steps on the *Peanuts* strip himself, not asking others for gags when he was feeling dry, nor getting someone else to ink his lines when his hands had grown shaky.

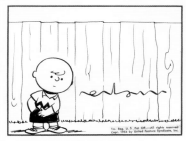

33 | *IS THIS TOMORROW*

In 1946, the Catechetical Guild Educational Society, publishers of *Topix*, decided to move beyond its usual lineup of comforting comics for Catholic kids. The result was *Is This Tomorrow*, a stark anti-communist one-shot comic book. A tale of communists sowing strife in America by fomenting labor strikes, anti-Semitism, and racial conflict and then using the discontent as a way to take control, this 48-page story was an unsubtle depiction of a dystopia. The issue, which came out in late 1947 and went through a number of printings, received support for its message from such groups as the American Legion but faced criticism for its lurid nature as well. It was banned for sale in Detroit, Michigan, as authorities there felt it had images "devoted in the main to scenes of violence and crime."

A large work for a publisher that usually dealt in short stories, the artwork was handled by a number of artists, including an eager-to-get-comics-experience Sparky, who drew some panels in addition to lettering.

Panel detail from daily strip, June 16, 1980.

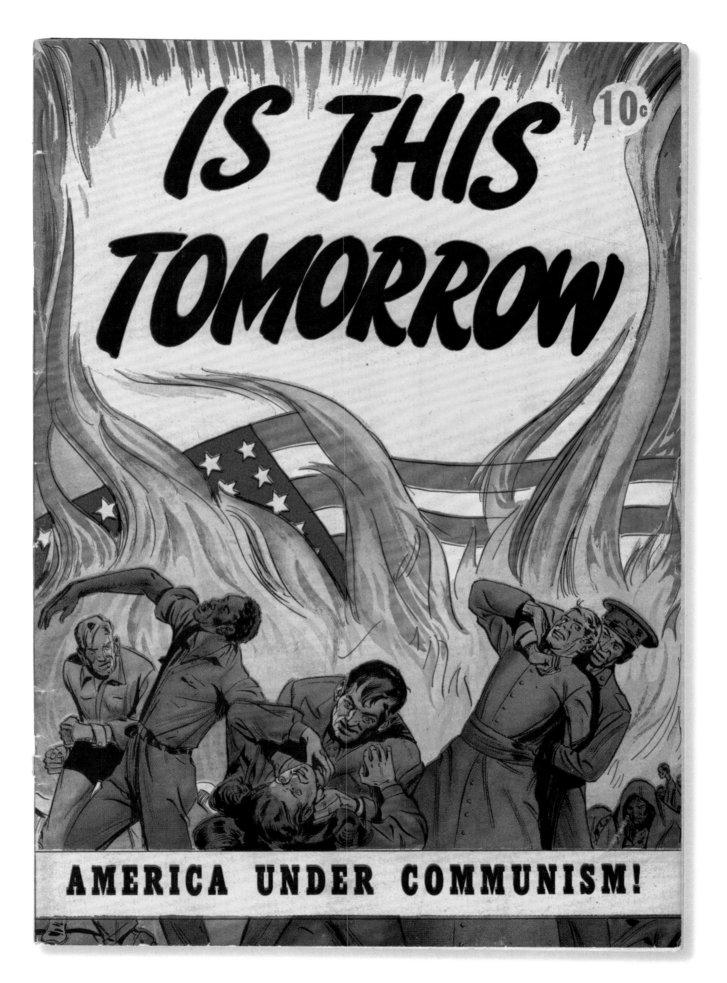

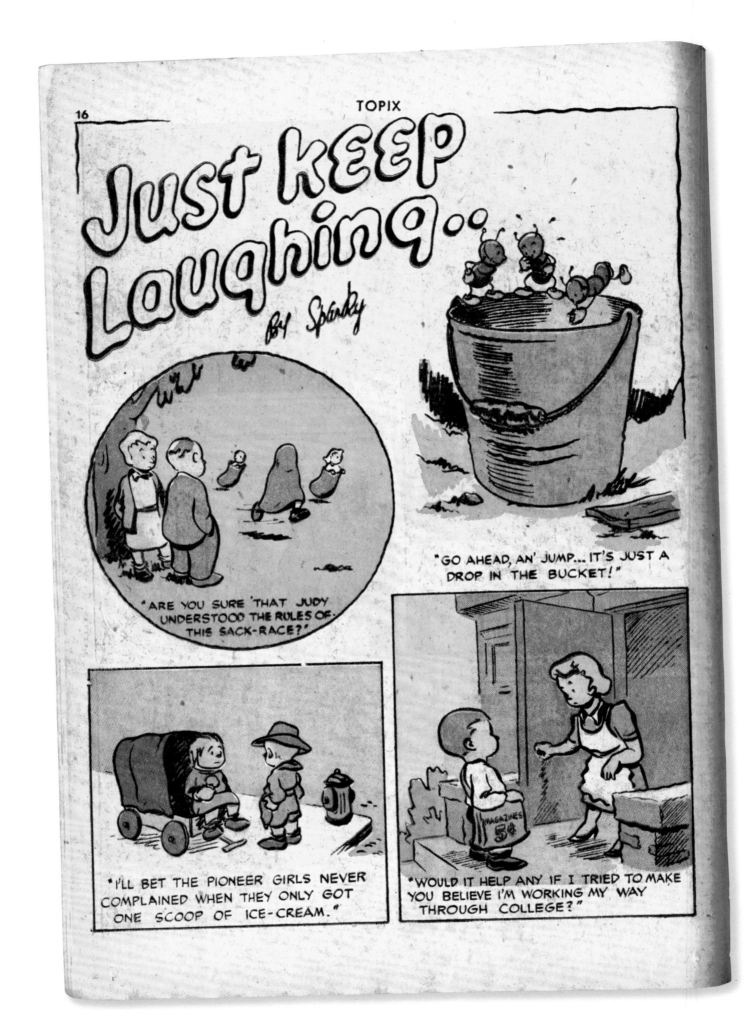

34 | "JUST KEEP LAUGHING.."

Between his day job at Art Instruction and his side gig for the Catechetical Guild on *Topix* and other projects, Sparky was kept busy. When he handled a rush job on a special order, the publishers thanked him by publishing a page of his cartoons. *Topix* volume 5, issue 5, published in February 1947, included a page of single-panel gag cartoons under the title "Just Keep Laughing." Some of them featured kids, in what would come to be Schulz's cartooning focus, but not all did.

The feature ran another installment, two issues later, and that was it for "Just Keep Laughing." Schulz would soon be finding both larger and more regular outlets for his single-panel gags.

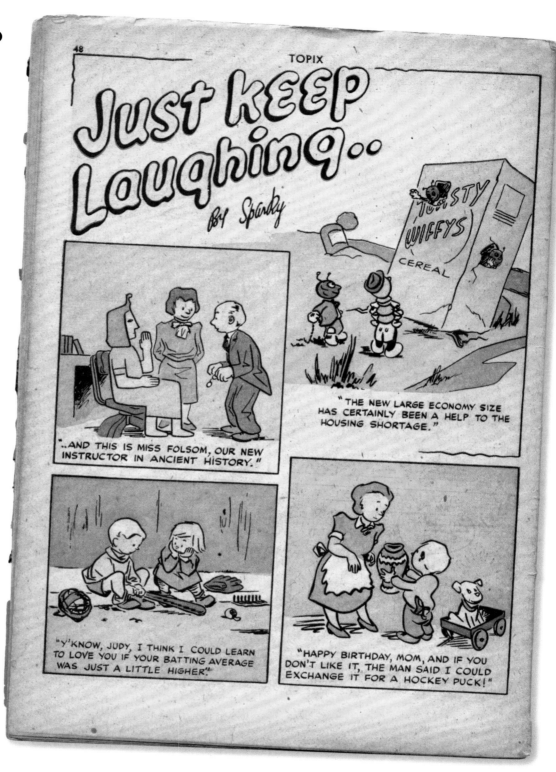

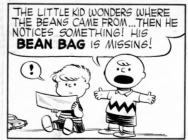

35 | *LI'L FOLKS*

In June 1947, Schulz took the basic concept of the "Just Keep Laughing" pages and moved it into the newspapers—if only one newspaper at a time. *Sparky's Li'l Folks* appeared in the Sunday *Minneapolis Tribune* for two weeks before Schulz took the feature across the river to the *St. Paul Pioneer Press*, retitling it *Li'l Folks by Sparky*. It ran there until January 1950.

The original art appears to be a page that Sparky used when seeking syndication for the series. It includes redrawn versions of gags that had been published on separate weeks. Still, it makes a good example of what *Li'l Folks* was: three to five single-panel gags per week featuring only kids and an occasional Snoopy-like dog. It had no continuing characters. Schulz used the name of his Art Instruction compatriot Charlie Brown several times in *Li'l Folks* but for visibly different characters each time. There are pieces of *Peanuts* in the work, even gags he would reuse in the *Peanuts* strip, but this is not quite *Peanuts*.

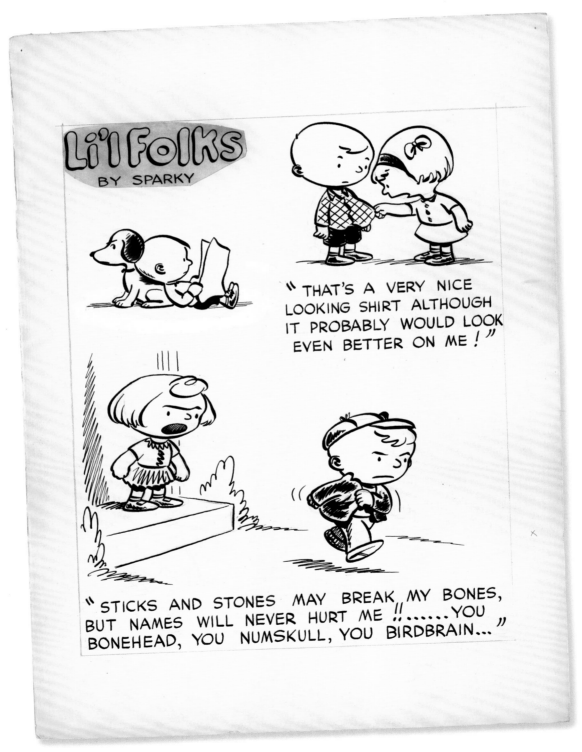

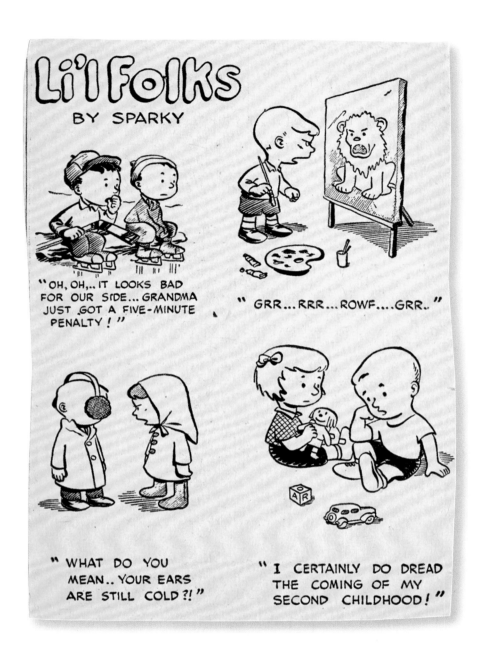

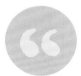

The cartoons are terrific examples of how Sparky was able to draw funny pictures using few, if any words. He does it with simplicity of line that is absolutely beautiful. This is deceptively difficult to do! Sparky, himself, describes it by saying, "I only draw what's necessary." In the cartoon of the boy with earmuffs covering his entire face, we can almost hear an entire monologue coming from the little girl, who is none too pleased by what she is dealing with!

I also love anything of Sparky's with the title *Li'l Folks*, because that is the title he originally wanted for what became *Peanuts*. He always liked "Li'l Folks" as a title more than "Peanuts" as a title. When an editor at United Feature Syndicate originally suggested "Peanuts" as his new strip's title, Schulz' reaction was the same as mine when my editor suggested I call my comic strip "JumpStart": "What does that title even *mean*?"

—Robb Armstrong, creator, *JumpStart*

36 | THE SATURDAY EVENING POST

As a creator of single-panel cartoons, Sparky always had his eye on the highest-prestige, highest-paying market for the works: the major national magazines. He accumulated such a run of rejections that when he finally got an acceptance note—"Check Tuesday for spot drawing of boy on lounge"—he at first assumed it was another rejection, and that he should check the mail for his returned drawing. But this "boy on lounge," which ran in the May 29, 1948, issue of *The Saturday Evening Post*, was just the start. The magazine, which had been published since 1821 and at that point was reaching an audience of millions, would buy seventeen cartoons from Sparky, mostly (but not all) focused on children.

A 1950 *Post* publication of the best cartoons from the preceding five years included two by Sparky, which became the first time his work appeared in a book.

" We're taking up a collection for one of the girls in the office who is not going to get married, or leave, but feels that she is stuck here for the rest of her life."

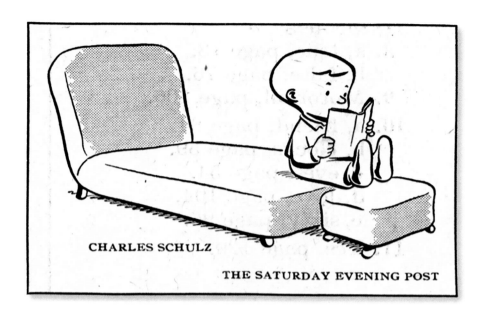

CHARLES SCHULZ

THE SATURDAY EVENING POST

When this cartoon was published, I was one year old. But my parents had subscribed to *The Saturday Evening Post* for years and kept them all. At around age eight, I discovered that this musty stack of old magazines held a hidden treasure: tons of cartoons! I devoured hundreds of them and still remember some, including this one by Sparky. Why? Because like so much of Sparky's work, its allure is deceptively simple. The unfussy artwork effortlessly draws you in; then the sincerity and truth of the gag gently tickles your funny bone. As an eight-year-old, I didn't grasp the sophistication of Sparky's genius, but it left a lasting impression. I thought, 'This looks so easy! I could do this!' I'm still trying.

—Greg Evans, creator, *Luann*

170 N. Snelling, Apt. 2
St. Paul4, Minnesota
July 10, 1949

Dear Frank,

It was really good to hear from you again. I am
always flattered that you remember me.

So you have taken to sculpting ? A very worthy
endeavor, I must say, and there is no doubt in my mind
that you have distinct possibilities if this snapshot
of the plaser cast is any indication. Splendid modeling
of form. What beauty, what design, what depth of feel-
ing, what do I know about it ? I liked your crack about
rather being a singing art teacher than a painting
music teacher. Pretty clever. Maybe you better try
wielding the pen. Or don't you and cross-hatching get
along ?

I was pleased to hear that you have spotted a
couple of my Post cartoons. I get them in so rarely
that I am always amazed when someone stumbles upon one.
There should be another in any issue now. I guess they've
bought about ten of them. Three of these, remarkably
enough, have been reprinted in other publications.
One in Czechoslovakia, one in Milwaukee, and one in
London. The last time I wrote I guess I was headed
for a syndicate contract. I got as close as a person
can possibly get without getting it. They had sent me
the contract, I had signed it, and had already mailed
them enough features to start the thing going for six
weeks, when they suddenly changed their mind. Now I'm
right back where I started, drawing for the St.Paul
paper once a week, and selling to the Post whenever I
can think of anything funny. I'm working on some other
angles, however, so will make it yet. That's the secret,
Frank. Always have an iron in the fire. Always have
another angle ready to go.

A few months ago I bought me a huge Zenith combin-
ation with the new long-playing record attachment built
in. This has given me many many hours of enjoyment. It
has also cost me a minor fortune, for I have been buying
symphonies and concertoes like mad. I've got all of
Beethoven's symphonies but the third, plus other works
by Haydn, Mozart, Brahms, etc. Ever since you taught me
"Summertime" I have been moving steadily upward. I've
often thought how pleased Mac Clane would be to hear
this, for I was always one of the staunchest opponents
of classical music. (It seems to me that I tell you this
everytime I write. Forgive me. I must be getting old.
All infantrymen are old. There are no young men in the
infantry.)

all the old buddies
ot. It doesn't seem
se to a group of
a long time, and now
itely certain that all
really a 'Bonbaden' ?
number two ? Was there
there such a place as
really live at the
And how about Morville
e Autobahn ?

d to stop yesterday, but

advance copy of this week's
h I spoke above is in it.
interested, ol' buddy, pal

appreciate your keeping up
, and not by hand and arm
r writing. I'm expecting
heartedly into this art
you can't outplay them, you

I am no this snaphot of the plaster
cast on my studio wall. studio is one bedroom of the
five room apartment which my Dad and I have. Two of the
walls are reserved for the work of my friends. And so
with the playing of Beethoven's sixth symphony in the
background, I leave you.

Your ol' buddy,

Sparky

P.S. In another envelope I am enclosing an advertising
form that Art Instruction Inc. sends out. In it are the
pictures of a few of the male instructors. In the little
magazine you will find pictures of some more of the staff
plus the same picture that I believe I once sent you,PLUS
an article on the world's most unknown cartoonist. Read
the whole thing with tongue in cheek, an take it with a
grain of the proverbial salt. It may be at least half-
ways interesting to you. At least it will help pad my
otherwise short letter.

THE DIEFFENWIERTH LETTERS

The camaraderie needed by soldiers serving together does not always fade away when the battle is over. These letters from Sparky to Frank Dieffenwierth, who had served on Staff Sergeant Schulz's machine gun squad, feature Sparky dishing about what was up with some of their mutual fellow soldiers, including Elmer Hagemeyer.

He also discusses plans to have his *Li'l Folks* cartoons syndicated by the Newspaper Enterprise Association (NEA). The NEA had indeed signed a contract with Sparky for syndicating *Li'l Folks* in its existing form, as a once-a-week gathering of several cartoon panels, but they had then pulled out of the deal. No cartoons got distributed, and Sparky got a one-hundred-dollar kill fee. It was a disappointment at the time, to be sure, but had that agreement not been terminated, he might have ended up with a reasonably successful series of single-panel gags with no continuing characters, and might never have developed the multi-panel *Peanuts* with its beloved cast.

> "The letters to Dieffenwierth, his army buddy, describe a maturing man making many discoveries about life and longing to share them with a friendly ear.
>
> —Jean Schulz

170 N. Snelling, Apt. 2
St. Paul 4, Minnesota
July 17, 1948

Dear Frank,

You can't possibly imagine how glad I was to hear from you. It is only too bad that you won't be able to cast your vote for Harold E. Stassen. However, my writing now should prove that I have more than just his interests in mind.

It is good to hear that you still are in quest of the finer things of life. Art and music are too often not on everyone's list of likes. It will probably come as somewhat of a pleasant surprise to you that I hereby revoke all my past views on art. From here on in I am a full fledged modernist. I didn't know what I was talking about before. In fact I represent person that I now so deeply despise that I couldn't see anything in the drawing " business, but since then the abstractionists, impressionists better than the conservatives. We all means go to your water color ing, however,... You cannot distor true form.

The comic business is rollin very surely for me. I am enclosing from the ST. Paul Pioneer Press th ested in. This has been running we and recently N.E.A. Service invite plane trip to Cleveland in order possibilities. They have agreed to shoihd start fairly soon although are. In the meantime I have been "Post" with the result that they Amazing, eh ? I also enclose one checking. It's quite a thrill to such an outfit, but of course itb money is also quite good.

We may not be still in the we both belong to the Book of the I have been buying books and recor have long ago overflowed both of m am now in the market for a record fifty record albums. All bought since the honorable discharge too. I have not only turned modernist in art, but am now a lover of classical music. Boy, what a change. They'll never know me in the next war.

Tonight I am going down to the ST. Paul Auditorium to the first Pop concert of the year. This is 'In OLd Vienna' night, and I'm anxious to hear 'Die Fledermaus.'

(2)

Soon after we all got home, and were all busy getting reconverted I got a letter from Scott. He told me then that among other things he was an 'agnostic' That I am glad to say is not what I have turned out to be. I wasn't a steady church goer when you knew me, but I did believe in God. My lack of formal religion was do merely to not knowing better. Now, however, I am right where I belong. I am a firm believer in Jesus Christ.

I am also a firm disbeliever in Henry Wallace.

I was down to Chicago about a year ago to see some syndicate outfits, and stopped in to visit Crittenden. He and his wife now have a very fine littl are getting along

The comic business is rolling along slowly, but very surely for me. I am enclosing a couple of clippings from the ST. Paul Pioneer Press that you might be interested in. This has been running weekly for over a year, and recently N.E.A. Service invited me to a free airplane trip to Cleveland in order to discuss syndiaction possibilities. They have agreed to take it on, and it shoihd start fairly soon although you know how such things are. In the meantime I have been sending some to the "Post" with the result that they have bought a few. Amazing, eh ? I also enclose one of these for your checking. It's quite a thrill to get an acceptance from such an outfit, but of course itbsoon wears off. The money is also quite good.

No revielle tonight.... I mean retreat. What's come over me ?

38 | MUSIC COLLECTION

As he noted in a letter to Frank Dieffenwierth, Sparky became much more interested in music after coming home from the war. Between his friends at Art Instruction and those at the Church of God, he was exposed to ever more music and developed a real love for it. He particularly liked classical music, and before 1948, recorded music wasn't really satisfying for those who loved Bach, Brahms, Beethoven, and so on. But then the long-playing (LP) record was developed, and those 33⅓ revolutions-per-minute disks could play a composition up to twenty-two minutes long without an interruption, more than four times as long as previous disks. By 1949, before *Peanuts* was launched, Sparky had invested in a modern turntable and LP records.

He even started composing music—at least that's what he said in a letter to Church of God friends. "What do you think of this for a melody? Ta ta te ta ta da da te da da da da te te ta ta."

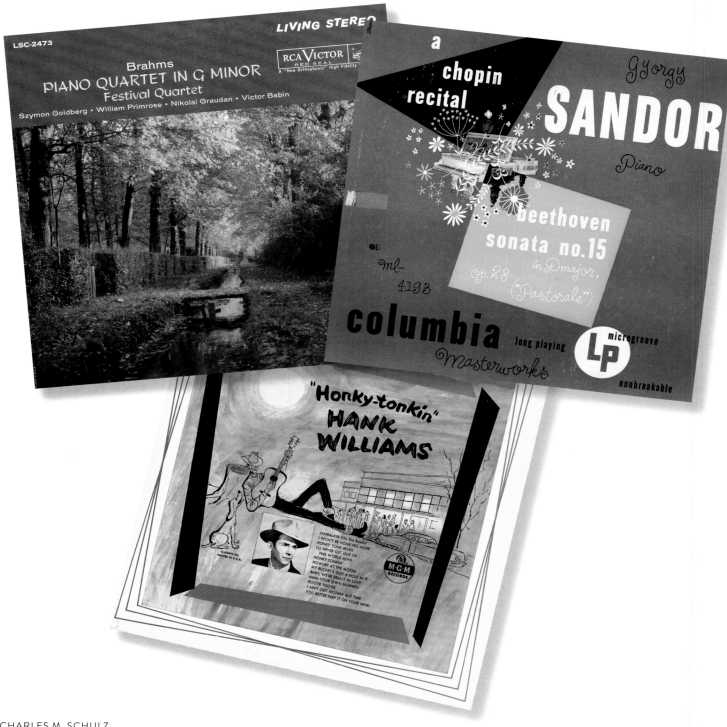

Schulz took music seriously, even when he was dealing with it humorously. Whereas other, more efficient cartoonists would indicate music playing with some waved lines and perhaps a couple of quarter notes, Schulz would transcribe whole passages, with the staff, the clef, the notes, and all the notation. As seen in this cover for a 1953 publication by and for students at the University of Colorado, the full notation helps the reader sense the fullness of the music, even if they can't read sheet music.

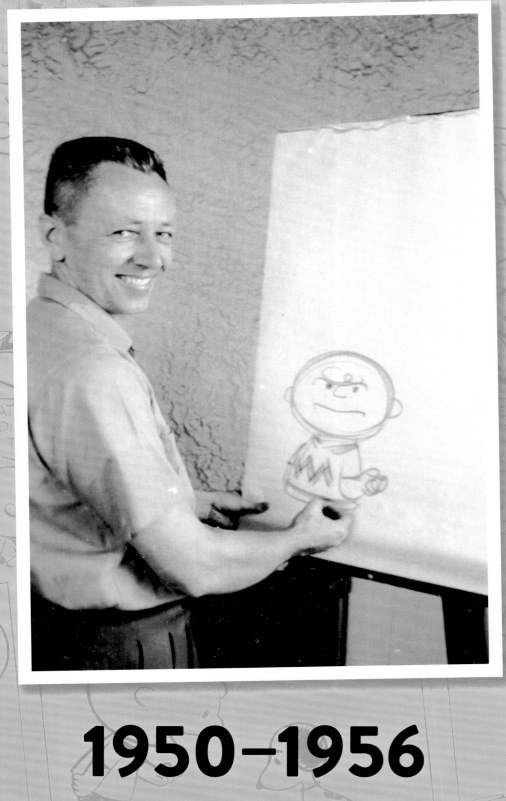

1950–1956
PEANUTS BEGINS

Going into 1950, Charles Schulz was a single man eager to get on with his life and a struggling cartoonist eager for success who had just lost out on a syndication deal and was about to quit *Li'l Folks*, his one ongoing cartooning gig. And he was still living in the town where he was born.

By the end of 1956, he had married and was four kids into forming a very full family. The family had moved from Minnesota to Colorado and then found their way back to Minnesota again, where their fifth child would be born.

As for being a struggling cartoonist, he would have not one but two nationally syndicated comics. He had won the highest award that American comics had to offer. And he had launched *Peanuts*, the project that would define the rest of his life.

39 | EARLY SYNDICATE CORRESPONDENCE

Having the NEA syndication deal fall apart would certainly have disappointed Sparky, but it did not deter him. Even after he stopped drawing *Li'l Folks* for the *St. Paul Pioneer Press* in January 1950 (he had wanted better placement or better pay, neither of which the newspaper was willing to give him), he continued to try and find his comics a syndicated home.

He finally had success with New York–based United Feature Syndicate (UFS), a successful service that had taken over syndication of such hits as *Tarzan* and *Fritzi Ritz*, had launched the popular *Li'l Abner*, and had transitioned *Fritzi Ritz* into being a strip focused on Fritzi's niece, *Nancy*. In addition to providing newspapers with comic strips and columns, UFS published its own comic books, mostly featuring characters from the comic strips they syndicated. Sparky and UFS signed a contract in June 1950, ready to make a big hit out of *Li'l Folks*.

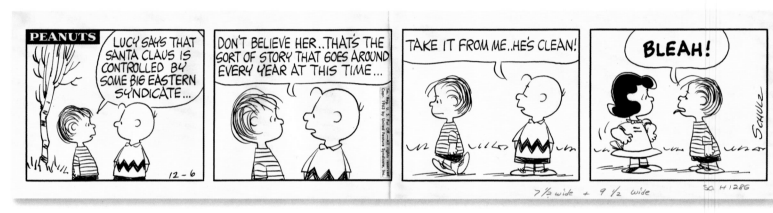

Schulz, like Santa, had given control to a big eastern syndicate.

It's nice to see that even my hero Charles Schulz had to deal with mundane syndicate correspondence and notes from lawyers. Sparky was my first and biggest inspiration as a budding cartoonist and I was honored later in life to be represented by the same syndicate that distributed *Peanuts*, United Feature Syndicate. One day, not long after being syndicated, I drew a political cartoon using Charlie Brown and *Peanuts* as a metaphor. I received a "cease and desist" letter from UFS telling me that by using these characters I was violating copyright. I called my syndicate to see if I was really in trouble and they said not to worry, it was just the legal department doing their job. Not only was Sparky ok with it, he collected original cartoons using *Peanuts*. I was thrilled to add my cartoon to his wall.

—Rob Rogers, syndicated editorial cartoonist

United Press Associations

INCORPORATED IN NEW YORK

GENERAL OFFICES
NEWS BUILDING NEW YORK CITY

RECEIVED.
UNITED FEATURE SYN.
220 E. 42ND ST., N.Y.C

JUN 21 1950 2 03 PM

PAUL PATTERSON
General Counsel
UNION COMMERCE BUILDING
CLEVELAND, OHIO.

June 20, 1950

Dear Larry:

This will acknowledge receipt of your letter of June
16 with which you enclosed a signed copy of the agreement
of June 14, 1950, between United Feature Syndicate and
Charles M. Schulz, producer of the comic strip LI'L FOLKS.
I am returning the copy of this agreement which you sent
me on June 14, 1950.

Sincerely yours,

Joseph R. Fawcett

Mr. Laurence Rutman
United Feature Syndicate
220 East 42nd Street
New York 17, New York

H:5D
encs

This acknowledgement of the contract with Schulz is the oldest correspondence
from the United Features archives. It was sent to United Feature vice president Larry
Rutman, who would become Sparky's strong supporter and advisor.

UNITED FEATURE SYNDICATE

Charles M. Schulz
170 North Snelling Ave
St Paul
Minn

Li'l Folks
Strip
for G. B.
For
release
Ju 11, 1950

40 | PROTO-*PEANUTS* STRIP

The people at United Feature Syndicate wanted *Li'l Folks*, Schulz's series of single-panel cartoons without continuing characters, but they wanted a few things changed, to give it more commercial potential. They *did* want continuing characters, and if possible, they wanted a strip rather than a single panel. Schulz did a number of sample strips like this one, the first multi-panel appearance of Charlie Brown, showing that he could handle the form. Some of the samples were two-panel gags, some three, some four. UFS decided it wanted a strip that delivered four equally sized panels so it could tell newspapers the strip could be stacked horizontally, vertically, or in a square, to fit whatever space was available.

Oh, and that name, *Li'l Folks*, it would have to go too. It was too similar to Tack Knight's 1930s strip *Little Folks*, a title that still had a registered trademark.

Schulz continued to build the daily *Peanuts* strip around that structure of four same-size panels for decades, finally retiring it in 1988. After that, he most commonly did three-panel strips, but he would also do just one big panoramic panel, returning to the single-panel sensibility he had used for *Li'l Folks*.

And then, like syndicate people do, they began to fiddle around with it [the strips]. The sales manager said, 'How about if we make it even broader in its appeal and we have one little kid strip at the top and a teen-age strip at the bottom?' So I thought about it and said, 'Oh, all right, I have to do what they tell me;' so I did that and they really didn't care for the teen-age thing. And then they said, 'we'll just have the kid thing.' And then...they decided that they'd rather have a strip, and right then was when they made this fateful decision that it was going to be a space-saving strip, which I have resented all my life. Now it may have gotten me started, but I'm not sure, so I had to overcome the fact that I was drawing a space-saving strip under the title Peanuts, which was the worst title ever thought up for a comic strip.".

—Charles M. Schulz

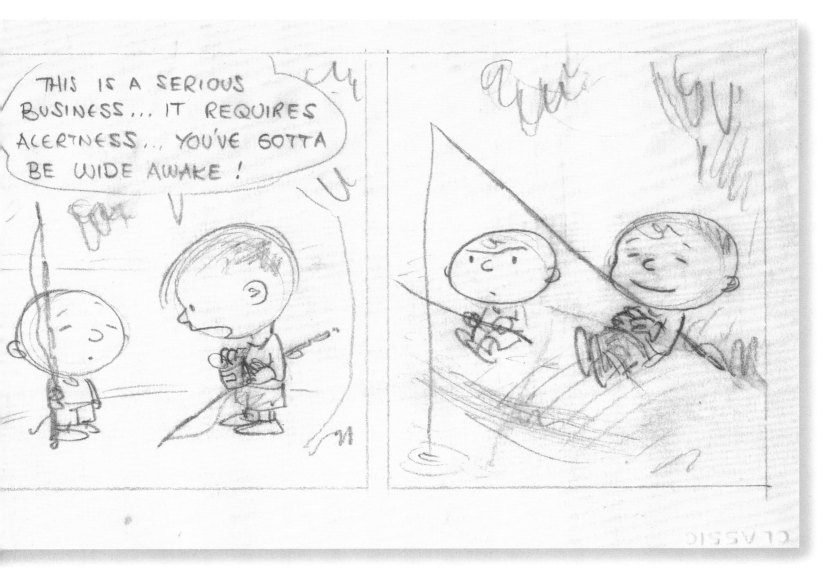

41 | *PEANUTS* FIRST-WEEK PROOF SHEET

This, the first proof sheet for *Peanuts*, was sent to the newspapers that had signed up to carry the strip at its launch, October 2, 1950. There are six strips for the week, as there was no Sunday strip at first. The second sheet notes that the strip is also available in a smaller "3-column" width, as opposed to the four column that most strips ran. UFS promoted the fact that the clean, simply drawn strip would be readable at a smaller size.

These sheets also display the new name for the strip: *Peanuts*. That name had been chosen by the syndicate after some brainstorming. Production manager William Anderson had been thinking about television's popular *Howdy Doody Show* and how the on-set child audience was called "the peanut gallery." He reckoned that it was a good way to refer to kids.

Schulz thought it a terrible title and retained that view even after *Peanuts* had made him a world famous cartoonist. "I wanted to keep *Li'l Folks*. I wanted a strip with dignity and significance," he said. "*Peanuts* made it sound too insignificant."

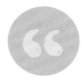

This is where it all starts, the first proof sheets for the first week of *Peanuts* comic strips. The moment of destiny. It was now official. Sparky's boyhood dream of becoming a syndicated newspaper cartoonist came true and here is the proof. These are the baby pictures, the first steps of a journey that will last 50 years. A journey that will go all the way to the moon. Literally. And what a grand debut. From the very beginning, *Peanuts* bravely stood out on the comics page. It was bold, smart, funny, and new. A new type of humor: hip, sophisticated, honest. A new type of art, one having a Zen 'less is more' clarity and spaciousness. A strip that was revolutionary yet totally relatable and lovable—Sparky's magic. These strips ushered in a new era. And, in October 1950, it was all new to its young creator facing the exciting unknown of the blank page. Where will Sparky take Charlie Brown? Where will Charlie Brown take Sparky? The first proof sheet is a tarot card that offers insight to the future. From this point on, Sparky would spend the rest of his life living and breathing *Peanuts*, constantly growing and creating pen and ink panels of truth and art which, to this day, bring comfort and joy to millions around the world.

—Patrick McDonnell, creator, *Mutts*

42 | EARLIEST STRIPS IN THE MUSEUM'S COLLECTION

These pieces of original art from the Schulz Museum collection are for the November 11 and 25, 1950, strips. The thirty-sixth and forty-eighth strips to see print, these are the oldest originals that the Museum has (as of this writing; the Museum constantly seeks to expand its collection.) *Peanuts* was still in its early development. Charlie Brown did not yet have his signature zigzag shirt and Shermy, had still not had his name in the strip. Snoopy had been mentioned, but the name had almost been something different. Schulz had planned on using Sniffy, but when he saw an issue of the comic book *Sniffy the Pup*, he knew that he had to pick again. So he decided to call the little dog Snoopy, a name that his mother had once suggested that they give to the next dog the family got.

While the original art boards for early strips like these are now clearly worthy museum pieces, you can see that at the time they weren't treated like precious works of art. Hand markings of such things as the planned publication date appear on the lower edge. The creases that run between the second and third panels are something that you will find on the daily strips for many years, as the art was folded to make it easier to mail to the syndicate.

43 | THE SUNDAY STRIP

*P*eanuts had launched in 1950 as a "daily," running six days a week. When 1952 began, however, it was finally time for the strip to take its place in the Sunday funnies section. A Sunday installment involved a lot more effort than a weekday one because the strip was not only larger but also had to be colored. This added more time for Schulz, who indicated the colors himself, and more time for the mechanical processes involved in preparing to print for color.

This February 17, 1952, strip is the seventh published Sunday strip and the oldest original Sunday in the Schulz Museum collection. Although the daily strip had already gotten more visually complex in the just over a year that it had been around, the large size of the Sunday strip allowed Schulz room to create much richer imagery.

> Sunday strips had to be written and laid out very carefully in order to be usable in several formats. Although some papers would use the exact layout you see here, others would have to chop off the entire first row of panels, making a shallower strip. Still others would remove just the second panel and stack the following six panels in three rows of two each beneath the large opening panel. In that way, the assembled strip filled a more vertical space. The strip was written to make sense even without the opening panels.

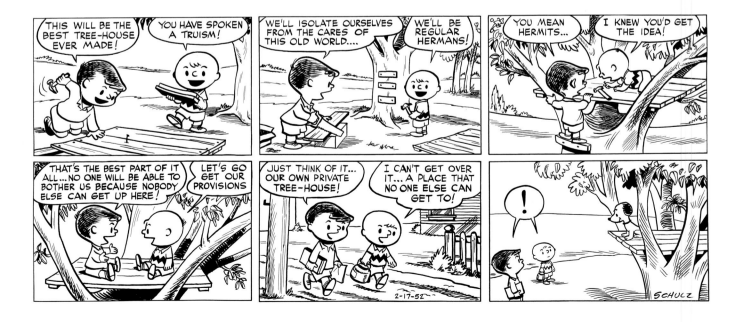

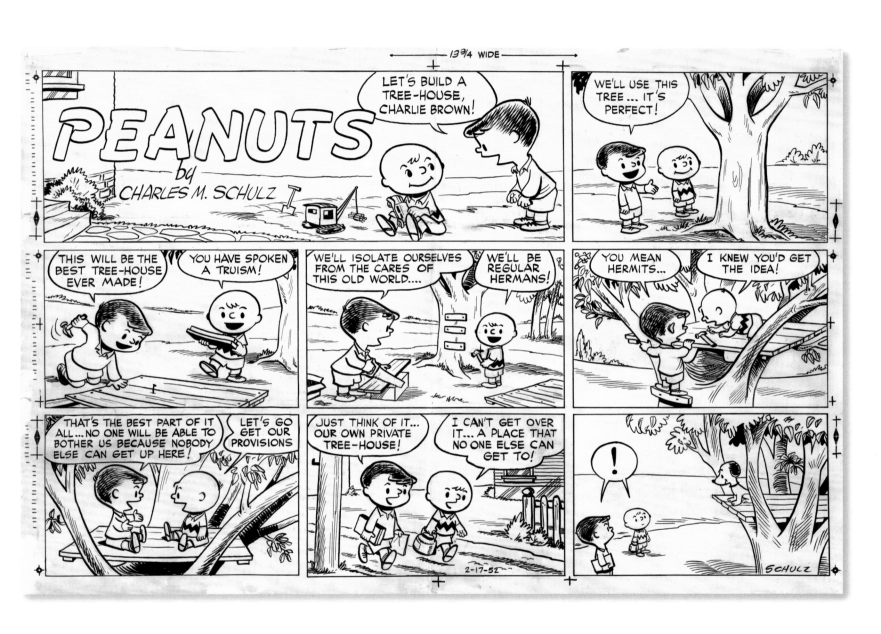

44 | "A DADDY"

Charles Schulz may have been drawing children for years, but he got to know them more directly once he married the former Joyce Halverson in April 1951. He adopted Joyce's toddler daughter, Meredith, as his own. At about the time that Sparky would have been drawing this March 24, 1952, strip, Joyce gave birth to their first son, Monte. The cartoonist acknowledges the experience he had been gaining as a father by signing this strip "A DADDY," a signature he would never use again.

This strip is the earliest appearance of Lucy in the Schulz Museum collection. She was the third major character to be added on top of the original cast, following Violet and Schroeder. And just as Meredith had gotten a baby brother in 1952, so would Lucy, when Linus started appearing in the fall.

> In this letter to the syndicate's editorial director, Sparky discusses the unusual eye design he was using for Lucy in her first strips. He would very quickly adjust to giving Lucy (and later, her brother Linus) just parenthesis to either side of her pupils, rather than a full circle around them.

January 31, 1952

Dear Mr. Freeman,

Just a few lines to answer your questions about the Schroeder page and Lucy.

The only reasons I put the little rings around her eyes are that it gives her sort of a wide starry look which lots of little girls her age have, and also it makes for identification. No one should ever mix her up with any of the others, and I don't think we should worry about realism with these characters.

I feel that a different ending to this Schroeder page would twist it all out of its original purpose. This is a parody on people who talk when they should be listening to what they have been invited over to hear. After Schroeder kicks them out in a burst of anger, he would never feel happy, but rather disgusted and discouraged about the whole thing; thus the anti-climatic finish. I don't think all pages should end with a slam finish if the idea has been in the middle. It's the conversation and attitude of the other two kids here that make up the gag.

Sincerely,

Charles Schulz
"PEANUTS"

Pencil marks
Page —

The Schroeder strip being discussed here appeared on June 15, 1952.

Not long after getting married, Charles and Joyce Schulz (with Meredith in tow) moved to Colorado Springs, Colorado. Life there was not fully to their liking. When they moved back to Minnesota about a year later (with both Meredith and baby Monte), they left behind a nursery wall decorated by Sparky with paintings of characters from *Peanuts* and popular children's books.

Apparently, not everyone who lived in the house after the Schulz family needed a nursery wall, as the mural was painted over repeatedly. The folks who owned the home in 1979, Stanley and Polly Travnicek, literally uncovered this hidden feature, carefully stripping away the multiple layers of paint to reveal the artwork. In 2001, after enjoying this private mural for decades, the Travniceks generously allowed the wall to be surgically removed from their house so it could be transported to California and displayed in the Schulz Museum, which had not yet opened its doors to the public.

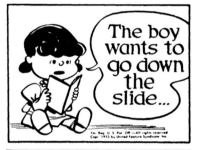
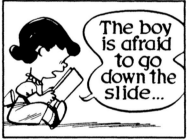
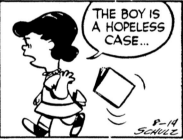

The August 14, 1953 strip is seen here in a square layout from 1954's *More Peanuts*, the first hardcover Peanuts book.

46 | GOOD IDEAS

A comic strip runs on good ideas, but more so, it runs through them. When you're doing 365 strips per year, you can burn through a lot of ideas. Whether they are good ones or bad ones, you always need more—and with *Peanuts*, there were rarely bad ones.

Some cartoonists ask others for ideas, even paying for the ones they use. Not Sparky. As a friendly guy with a popular strip, people would always want to offer suggestions, but he didn't want to hear them. He wanted his own ideas, his own observations on the world around him. Sometimes he'd ask friends for information when he needed some expertise, but the stories and the gags were his. Even when he seemed to be reusing ideas—it's the security blanket again, or Lucy is pulling the football away just as Charlie Brown is about to kick it again—he would actually be building new gags on top of the existing structure.

Folks who knew Sparky would tell you that he may have left his drawing board, but he never left working on *Peanuts*. Whatever he was doing, he still had *Peanuts* somewhere in his mind, hoping to hear something, see something, do something that would give him another good idea for the strip.

Schulz didn't always know if his idea was a good one until he tried to put it on paper. This 1950s strip, which he abandoned mid-effort, clearly didn't make the cut.

I have found that working in the same room is the only guarentee of keeping going. Somehow, a change of scenery makes working more difficult, but sitting down in the same place each day turns on the creativity. I have also discovered, however, that I get a lot of good ideas while driving along in the car, and I can almost be certain that I will think of at least one good idea if I am at a symphony or a ball game or hockey game or something of this kind.

— Charles M. Schulz

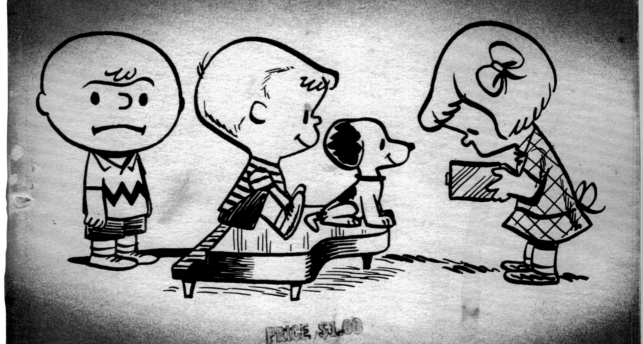

*P*eanuts had its first strip collection when it was less than two years old. That's quite a quick move into book form, but John Selby, editor-in-chief of Rinehart & Company, liked the strip. Released in July 1952, the book, titled simply *Peanuts*, would be a hit, going through three printings in its first year of release, with dozens more to follow. The book was both drawing fans who had discovered the strip in the newspapers and generating new fans who had found it first in the book. Hundreds of *Peanuts* reprint books would follow.

The first book was not a complete reprint, containing only 248 daily strips and no Sundays. Schulz was not comfortable with the book's contents. Even though it had skipped some of his earliest strips, he still felt that his artwork had already gotten better than a lot of the strips that were included. Most of that early work was kept out of later reprint projects, until the launch of *The Complete Peanuts* set in 2004.

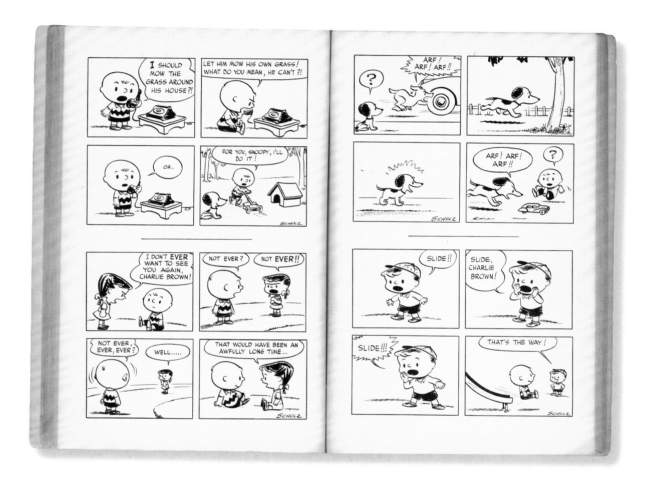

Although dozens of printings of the book exist, Rinehart & Company accidentally made it quite easy for collectors to identify the first printing just by looking at the cover. That's because the publisher made one critical mistake: it forgot to print a price on the cover and had to rubber-stamp every copy near the center of the image. The one-dollar price appeared in place with the second printing, and later editions would actually have the price in two locations on the cover.

PROFESSIONAL ACCEPTANCE

Everyone appreciates a good cartoon, but no one more than cartoonists themselves. The cartooning community can be quick to discover bold, new talent and welcome them into their ranks. Charles Schulz found this out when he was invited to join the National Cartoonists Society (NCS), then and now the premier organization for professional cartoonists. He became a member by 1954, sponsored by Mort Walker, one of his fellow cartoonists at *The Saturday Evening Post* who had broken into newspaper syndication.

In 1954, the NCS members awarded Mort the Reuben Award, their prize for the Outstanding Cartoonist of the [previous] Year. Sparky gave Mort his own prize, of sorts: the original art for the March 11, 1954, *Peanuts* strip, with a personal inscription. The two would remain friends over their long careers, and Schulz became a regular sight at the annual NCS convention.

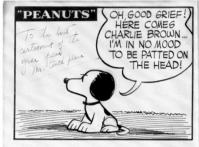 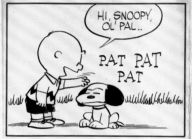 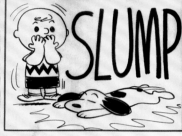 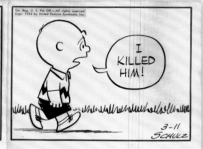

Mort Walker and Charles Schulz had parallel lives and careers. They were both born in the Midwest, ten months apart, and served in World War II. Their strips, *Beetle Bailey* and *Peanuts*, debuted on September 4 and October 2, 1950, respectively. Each of them was recognized as the Outstanding Cartoonist of the Year by the National Cartoonists Society that same decade. When Mort won his award in 1954, Sparky sent him this original *Peanuts* strip with the self-deprecating inscription, 'To the best cartoonist of the year from Mr. tenth place.' Two years later, Sparky won his Reuben. This strip was displayed in Mort's home for many years, and after his passing in 2018, it became part of the permanent collection of the Schulz Museum. A unique example from his early period, it begins with Snoopy using a speech balloon instead of the customary thought bubble and ends on a dark note.

—Brian Walker, cartoonist (*Beetle Bailey* and *Hi and Lois*), cartoon historian, author, and curator

Charles M. Schulz joins fellow cartoonist Mort Walker on stage to present the Reuben Award in 1993.

Schulz frequently wrote little notes on the original art that he gave away. For people whom he didn't know very well, it was usually a simple offering of best wishes, but people he was close to often got a more interesting note. Enough colorful examples of these could be found that the Schulz Museum staged an exhibit of just strips with these notes. Titled "Warmly Inscribed," the exhibition ran from November 10, 2021, to May 9, 2022.

In 1954, you could send a self-addressed stamped envelope—first class postage, three cents—to the *Chicago Tribune*, the *Tampa Bay Times*, the *El Paso Herald-Post*, or any of a number of other papers carrying *Peanuts* and receive *The Peanuts Album* in return. This simple little promotional pamphlet gave Sparky the chance to do richer, more subtle portraits of his cast of characters, allowing him to use shading that the stark black-and-white line art of the comics page did not permit. The original art for these images is in the Schulz Museum collection.

One of the pages was dedicated to a photo of Charles and Joyce Schulz and their kids, and there were now three offspring. Craig Schulz, then a mere baby, would grow up to become the president and CEO of his father's studio and to be part of the three-man writing team behind the 2015 feature film *The Peanuts Movie* alongside his own son, Bryan.

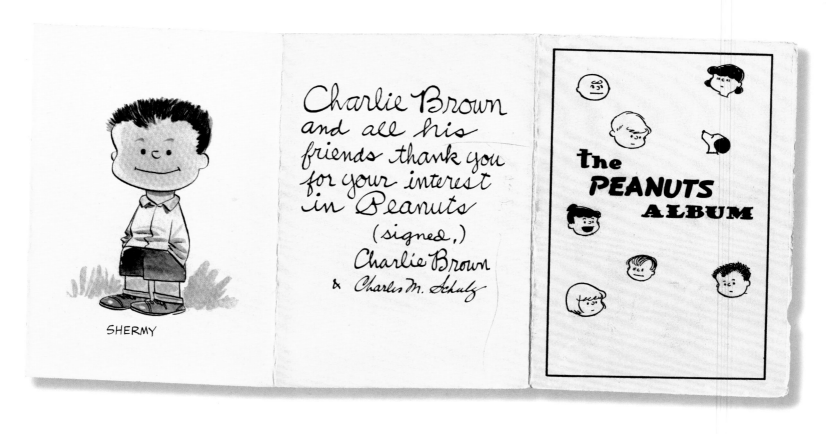

Charles M. Schulz, creator of "PEANUTS," is a resident of Minneapolis. Frequently he gets to his studio at 6:30 A.M. to work on his daily strip and Sunday page. That's to permit a little golf in the afternoon. Golf is one of his two hobbies—the other is bridge.

During World War II, he served as a machine gunner in Europe and, after his three-year "hitch" in the Army, returned to Minneapolis and got down to the serious business of cartooning which eventually led to the creation of "PEANUTS." He is 31 years old.

There are three "Peanuts" in the Schulz home. The photo at the left shows (l. to r.) Craig, Mrs. Schulz, Meredith, Charles, Sr., and Charles, Jr.

'GOOD OL' CHARLIE BROWN

LUCY

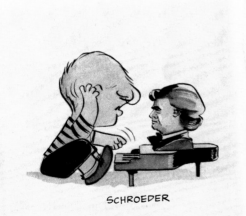

SCHROEDER

50 | THE WEST MINNEHAHA PARKWAY HOUSE MURALS

Sparky and Joyce returned to Minnesota in 1952 with a growing family that called for more home space and the growing success of *Peanuts* that would let them pay for it. They moved quickly from a two-bedroom Minneapolis ranch house to a larger house nearby. Sparky, Joyce, and their children, Meredith, Monte, and Craig, upgraded again in April 1955. This third Minneapolis location, a 5-bedroom, 4,500-square-foot house on West Minnehaha Parkway, still within a mile of their previous two addresses, would be their home for three years.

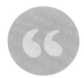

Having grown up in Minnesota myself, the Schulzes' house is less than ten miles from my own childhood home—and only one mile from my wife's childhood house at 4852 Thirteenth Avenue! It always scrambled my brain to think that something as great as *Peanuts* could come out of the same ordinary, humble midwestern town where my family and I lived. I know now that 'glamour' and 'cartooning' don't go together, but seeing the strip in the paper sure did seem like the big time to me.

—Pete Docter, chief creative officer, Pixar Animation Studios

Schulz decorated interior walls of this house with cartoon murals: one of Snoopy, and one that you might take for Charlie Brown if it weren't for the cowboy hat identifying him as Monte, Schulz's eldest son. These images were roughed on the walls in pencil and then finished using poster paint. When a later owner was selling the house in 2014, the Schulz Museum got an opportunity to retrieve these artworks, carefully extracting whole portions of the wall, including lathe wall structure and the plaster covering it. The art was meticulously cleaned and stabilized to protect the fragile poster paint, which had never been intended as a long-term art medium.

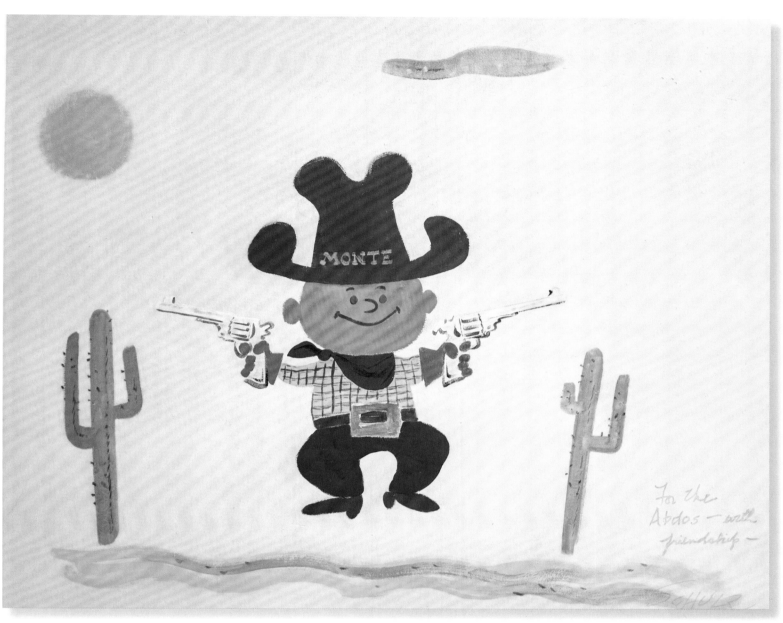

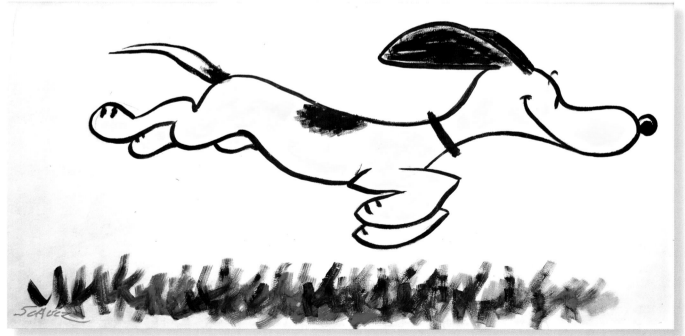

The 1956 NCS convention was held in New York City. Being there allowed Sparky to accept an invitation for a reception and tour aboard the USS *Coral Sea*. The staff of that *Midway*-class aircraft carrier had also voted him their cartoonist of the year.

Schulz getting his 1955 Reuben from Rube Goldberg (bottom) and posing with the 1964 trophy (top).

REUBEN AWARD

Schulz's fellow cartoonists at the National Cartoonists Society quickly went from considering Schulz "one of us" to counting him as "one of the best of us." At the April 1956 annual NCS convention, they gave him the Reuben Award for the Outstanding Cartoonist of the Year 1955. The award, named after noted cartoonist Rube Goldberg, was a statuette based on the sculpture work. This statuette was handed to Sparky by Rube Goldberg himself. To win the award, Sparky beat out other high vote getters, including George Lichty, Jimmy Hatlo, and Herblock. Sparky was not just among his contemporaries but in the presence of some of the very cartoonists who had inspired him when he was growing up.

Almost a decade later, Sparky won an unprecedented second Reuben, for Outstanding Cartoonist of the Year 1964.

CHARLES M. SCHULZ

OUTSTANDING CARTOONIST OF THE YEAR
1964

PRESENTED BY
THE NATIONAL CARTOONISTS SOCIETY

Sparky's second Reuben

1957–1975
PEANUTS GOES EVERYWHERE

While the early 1950s showed that *Peanuts* could gain respect and success as a comic strip in the United States, the years that followed showed that was only the beginning. By the midway run of its fifty-year run, *Peanuts* would become an international hit with strong successes in publishing, television, film, theater, and merchandising. Unlike many of the multimedia successes that we see today, however, the creator of *Peanuts* had a strong personal hand in most of it, writing or at least overseeing the material. Even with all that going on, Sparky did not always limit himself to *Peanuts*. He created other cartoons and collaborated on non-*Peanuts* books through much of this time, ultimately setting those efforts aside to focus solely on Charlie Brown and his friends.

52 | INTERNATIONAL LICENSING

This 1957 book may not seem impressive. It is, after all, merely an abridged, reduced-dimension reprint of *More Peanuts*, a 1954 book that Schulz himself told *Pogo* creator Walt Kelly was "filled with so much bad work." (He was wrong. The book is fine, but Schulz always aspired to improve.) Still, this book marks a new realm for *Peanuts*, as it was the first *Peanuts* book published in the United Kingdom. Issued by the British national tabloid newspaper *Daily Sketch*, this book was an early step down the road to everything from Snoopy Cafés in Japan to *Peanuts* postage stamps in Gibraltar.

The *Peanuts* comic strip has appeared in dozens of languages in newspapers and books across the globe.

International interest in *Peanuts* grew not only beyond English, but beyond licensing, as this unauthorized book of traced *Peanuts* strips from communist-era Poland shows.

53 | IT'S ONLY A GAME

While the *Peanuts* strip was a success, Schulz's early efforts were in single-panel gag cartoons, and he managed to keep a hand in that. One way he did so was doing cartoons for *Youth* magazine, a Church of God publication, from 1955 to 1965. At the end of 1957, he launched a new effort, a newspaper feature of single-panel gags about sports, games, and leisure activities, titled *It's Only a Game*. At the beginning of 1958, he made a major change in the production of the series, switching from drawing the cartoons fully himself to just doing a sketch, which would then be fleshed out by the uncredited Jim Sasseville, his Art Instruction friend who was now also drawing *Peanuts* comic book stories. The series, which was made up of three gag panels and a mini cartoon each week, lasted only sixty-three weeks before Schulz decided to pull the plug. "It hampered my drawing, trying to draw in Sparky's style," Sasseville admitted. "Drawing his 'adult style' for *It's Only a Game* could be frustrating. Much of the time, I thought he conveyed the idea better with his initial sketch than I did with my finished drawing."

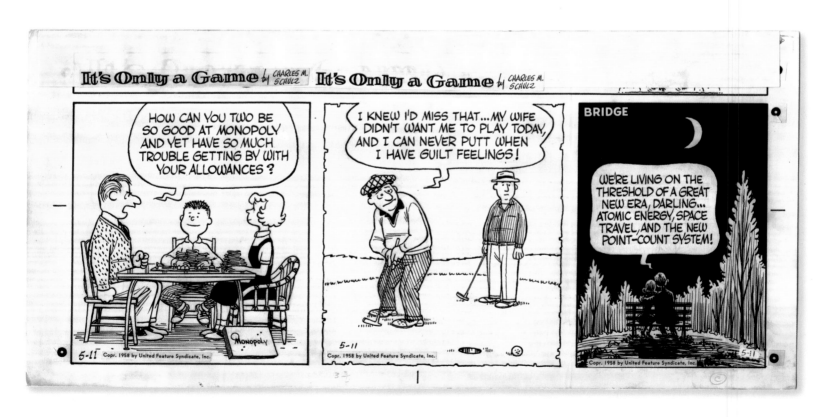

This example of the early *It's Only a Game*, which was fully drawn by Schulz, displays its flexible format. Originally conceived as a feature focused on the card game bridge (of which Sparky was an avid and expert player), the final panel was always a bridge gag. Newspapers could cut off the bridge panel and run it next to their bridge column, with just the first two (or, in this odd case, three) gags running in the comics section. Other papers would run individual panels on three weekdays, rather than using it as a Sunday feature.

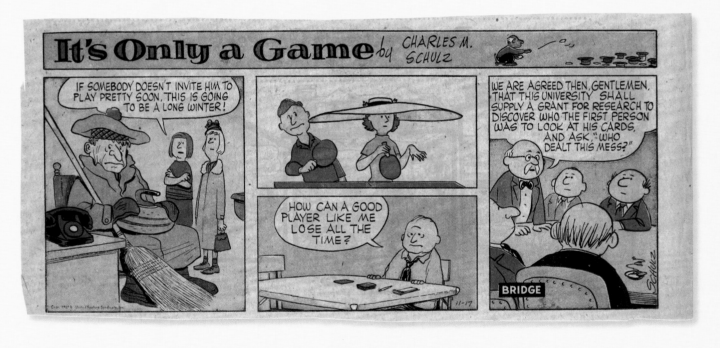

54 | FIVE CHILDREN

I n 1958, Joyce and Charles Schulz's fifth and final child arrived. Jill came into this world in April, joining her older siblings Amy (born in 1956), Craig (1953), Monte (1952), and Meredith (1950).

Being a cartoonist is a full-time job with a never-ending stream of deadlines, but so is being a father. Sparky found ways to do it all, and while his children have noted that he always had *Peanuts* on his mind, they've also noted that he was always open to being interrupted, even by a kid who just wanted to have a little fun. And even when they left him alone, Sparky still had pictures of the kids on the walls of his studio, keeping them in his mind.

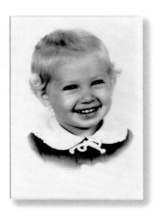 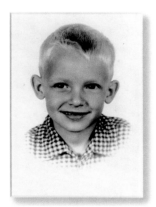 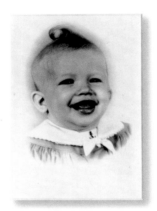 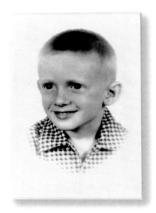

This charm bracelet, a heavy gold chain manufactured in Italy by the Italian luxury house Gucci, carries five charms. Each charm is engraved with the first name and birth year of one of the children. Jill's carries a little more information, her middle name and birth date.

" Our lives together were always sports-oriented. Dad was very competitive, and he once told me if I wanted to be a success, I should concentrate on what I loved the most, and put my heart and soul into it. I began riding horses, and in 1973 was introduced to *mules!* I love mules and eventually progressed from riding my bicycle to riding horses, and then mules. I began my career in breeding, training, and promoting mules. Today, I have a respected career focused on the educational production and promotion of mules and donkeys, also known as Longears. In history, mules are commonly known as an underdog, but they loyally helped to build and expand this great country with their efforts! I am currently known to my numerous fans as 'The Mule Whisperer.'

Thanks, Dad. I love you! Great advice. "

—Meredith Hodges

When this photograph was taken, we'd just recently
come out from Minnesota and all our old family and
friends were still alive. Dale and Nona Hale drove out
ahead of us to get the house ready, and Craig and
I rode with Bus and Marion. Grandpa Schulz and
Annabelle planned to come see us, and Grandma
Halverson and Aunt Ruth were soon to visit, too, and our
cousins, the Sheldons, ready to travel out, as well.
Dad was enthused with his new studio and our tennis
court, billiard table, swimming pool, and the gracious
and magical property that was exciting and fresh.
And Dad was young, a wonderful life ahead of him that
perhaps even he could never have imagined in those early
halcyon days of California. I remember the brick barbecue
he built in one of our gardens and the joy he shared in
lunchtime billiards with Dale and Tony and Jim Gray, and
the flash cards he drew for me to teach me spelling. We
had so much fun, it was another age almost, lovely days
of wonder and discovery. Gone now, of course, reconciled
to a past few in our family recall. But they did happen and
they made of Dad, and us, who we were to become. So
that photograph is a touchstone to a life we can never
have back but whose memory to me is precious.

—Monte Schulz

Not long after Jill was added to the family, Charles and Joyce made a big change. They moved from often-chilly Minnesota, where they had their friends and family, to the more moderate climate of Sonoma County, California. They bought a property that was already known as Coffee Grounds, situated as it was on Coffee Lane. They had ample land for raising their ample family, although they were now far from their Minnesota relatives and friends.

They soon set to making the most of the land. They built a new, larger house, turning the original house into Sparky's studio. They added a tennis court, swimming pool, and a small baseball diamond. There were stables and animals and plants aplenty. In some ways, their new place was less a home than a personal resort.

The family would eventually move out of Coffee Grounds, but not far. Sparky would live the rest of his life in Sonoma County.

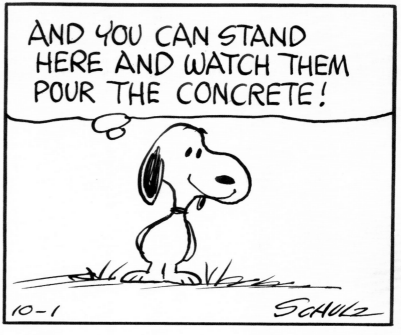

The American comic book was originally built around reprinting newspaper comic strips, and that was the way that *Peanuts* had entered the field. Since 1952, reprinted *Peanuts* strips had been appearing in comic books, mixed in with the adventures of other United Feature Syndicate characters. When Dell Publishing took over the *Peanuts* comic book rights, however, they had other ideas. From 1958 to 1963, original *Peanuts* comic book stories appeared not only in *Peanuts* titles but also as supporting features in other comics, such as *Nancy and Sluggo*. While Schulz supplied original covers for these issues, he wrote and drew only a handful of the stories himself. He had brought Jim Sasseville and Dale Hale, a couple of his comrades from Art Instruction, out to California with him to assist him in his studio at the Coffee Grounds. While they never did any of the drawing on the *Peanuts* newspaper strip, they got to draw many of the comic book stories, with Schulz occasionally lending a hand on a tricky bit.

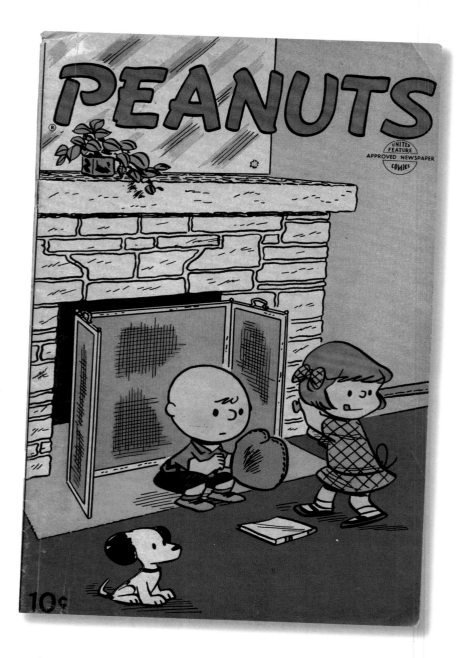

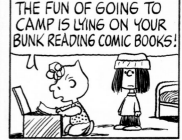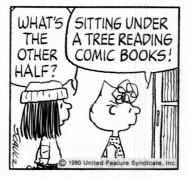

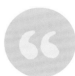

You think I wasn't nervous the first time I
drew Charlie Brown's head with the Master
standing right next to me watching? YIKES!

—Dale Hale, cartoonist on the *Peanuts*
comic book stories

57 | HUNGERFORD TOYS

In 1958, the Hungerford Plastics Corporation took on a challenge that none had dared before: converting the *Peanuts* characters into 3D. Hungerford's initial line of vinyl toys included Charlie Brown, Lucy, Linus, and a black-and-white dog whose name does not appear on the package. This was not a mistake; a company called Elka Toys held the relevant trademark on the name Snoopy, having used it for an unrelated stuffed dog toy in 1955, a conflict that would plague *Peanuts* licensing for years to come. The next character added to the line, Sally, appeared in stores in the same week in 1959 that she first appeared in the strip.

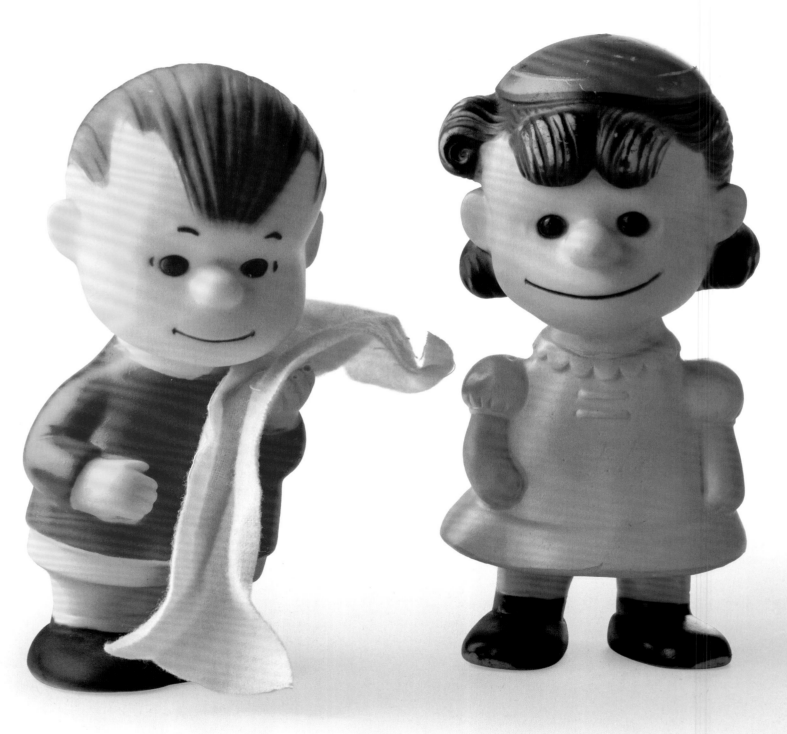

That zigzag on Charlie Brown's shirt has been a fascination since I was a kid. The design is as old as time, of course, appearing in petroglyphs and Egyptian pottery, and in the comics family tree via *Krazy Kat* and others. I use it in *Zits* frequently—on lamps, rugs and pizza boxes—all a sort of quiet nod to Sparky and our forefathers.

—Jim Borgman, editorial cartoonist and co-creator of *Zits*

58 | EARLY HALLMARK DESIGNS

Hallmark, the leading US manufacturer of greeting cards and celebratory products, added the *Peanuts* gang to its line starting in 1960. Schulz himself designed many of the early products, as can be seen in these design sketches. The emotive nature and recognizability of the *Peanuts* characters worked so well in this context that Hallmark became the strip's longest-running licensee. Over sixty years later, Hallmark now offers well over one hundred different *Peanuts* products, with new ones constantly added.

DATE BOOK

The 1962 *Peanuts* date book was the first *Peanuts* item produced by the then-small San Francisco–based company Determined Productions. Founder Connie Boucher had launched into publishing a year before with a Winnie-the-Pooh coloring book that had proven popular. She saw the opportunity to move printed *Peanuts* beyond the realm of mere strip reprints. Determined Productions took an aggressive visual approach. That first date book was a fairly early example of the sort of bold typography that would come to typify the 1960s and the counterintuitive decision not to put the *Peanuts* characters on the cover. The annual date book found a large audience (including Charles Schulz himself, who used them as his own personal calendars), and Determined Productions quickly branched out into a wider range of *Peanuts* products.

Connie Boucher is wearing a Determined Productions–made sweatshirt featuring Schroeder, who is himself wearing a sweatshirt featuring Beethoven.

What made [Boucher] different was the quality
and originality of her ideas. She proposed the date
book in 1961, and now everyone is doing them.

—Charles M. Schulz

Unlikely things have unlikely effects. It was, of all characters, Lucy who set aside her usually fussbudgety nature for the April 25, 1960, strip, hugging Snoopy and declaring, "Happiness is a warm puppy." Those words convinced Determined Productions head Connie Boucher that she needed something besides calendars to sell. She convinced Sparky to create a full, small book bearing that phrase as a title, with each spread noting another thing that "happiness is" accompanied by an original Schulz illustration. Released in October 1962, the book was a phenomenon. The first (but far from the only) *Peanuts* book to hit the *New York Times* Best Seller list, it spent forty-five weeks on the nonfiction list, peaking at number two. It spawned parodies and imitations, changing the look and idea of gift books in ways that are still in effect. It led to a series of similar *Peanuts* books, which are frequently returned to print for new audiences. The phrase itself took hold, ending up in *Bartlett's Familiar Quotations*, a fact in which Sparky took pride. Without this phrase from Lucy, the Beatles song "Happiness Is a Warm Gun" would not exist.

But it was not all-powerful. The month of the book's release, the San Francisco Giants (who would long be Schulz's favorite baseball team) ended up in the 1962 World Series. Every player on the team was given a copy of the book with the special inscription, "Happiness is winning the Series." And yet the Giants failed, losing in the seventh game by a single heartbreaking run. Charlie Brown surely understood how they felt.

While *Happiness Is a Warm Puppy* has been released in many editions and many languages, there is perhaps no edition as special as the one for blind readers. Intended solely for libraries for the blind, these Twin Vision books intersperse the original printed pages with pages in braille and with raised pictures. In that way, a sighted reader could read along with a blind one. California-based Jean Norris conceived of this format, but it took a lot of human effort to build the books. "She had volunteers, and even got some prison inmates involved in this project," explains former volunteer Sylvia Bernstein.

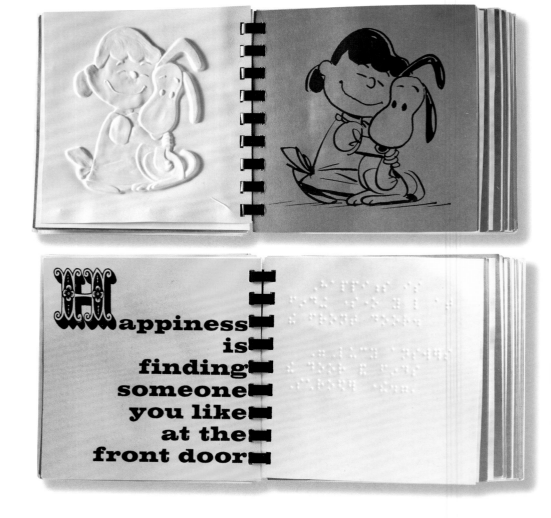

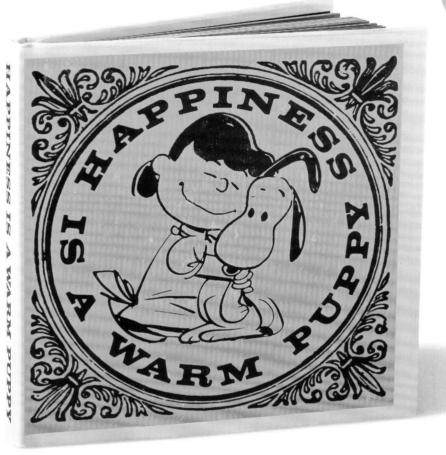

HAPPINESS IS A WARM PUPPY

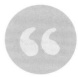

I was an avid *Peanuts* fan from the moment I could read the funnies, and throughout my youth I collected all the *Peanuts* paperbacks that I could find. They were laugh-out-loud entertainment from as far back as I can remember. Charles Schulz was the reason I wanted to be a cartoonist, and the enduring reason I've been making my living at it for 34 years now. This print was on a pink throw pillow on my bed from the age of 8 until after I graduated from college. I slept on it, I hugged it, I cried on it. It was a prized possession.

—Jenny Campbell,
creator, *Flo & Friends*

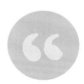

Sparky spoke in a measured, witty way that reminded me of the dialogue in his strips. To me, that showed just how much the strip emanated from within him. Cartoonists were in awe around him and that made some of us hesitant to try to get to know him, so at a cartoonist convention, Sparky brought up one of my recent editorial cartoons that included his *Peanuts* characters wearing baseball caps, claiming the caps were drawn incorrectly. I summoned up my courage and told him I drew them that way to bug him. I made that up, of course, but he thankfully laughed. Sparky's legacy lives on in so many ways, including through our youngest daughter, who we named, 'Lucy.'

—Mike Luckovich, *Atlanta Journal-Constitution* cartoonist

The beloved 1965 television special *A Charlie Brown Christmas,* with its message about putting the true meaning of Christmas above the commercialization of it, was created as a commercial of a sort. Soft drink giant The Coca-Cola Company wanted a Christmas show to sponsor and asked if a *Peanuts* special might be created. Schulz, working with producer Lee Mendelson and animator Bill Melendez, pulled together a special that brought both the full spirit of the characters Schulz created and a substantial quote from the Bible that fascinated him. This opening page of the script shows pre-word processor text-editing techniques, such as crossing out words (note the change of title from *Charlie Brown's Christmas* to *A Charlie Brown Christmas*) and cutting and taping. The closing exchange about Pig-Pen making a "git" list is not in the final special.

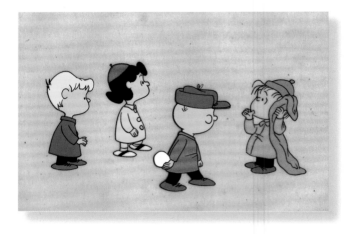

Part of the genius of Charles M. Schulz was knowing precisely why he was creating something. So when he decided to team with producer Lee Mendelson and animator Bill Melendez for the 1965 classic *A Charlie Brown Christmas*, he told them the network special had to be about something. If not, he said, 'Why bother doing it?' The mission soon became: What is the true meaning of Christmas? Once that purpose was planted like a golden spike, everything emanated from there. Painting a melancholy mood set against the assault of neon commercialism. Capturing the trappings of the season amid the icy whites and slate grays of a midwestern winter. And building to Linus's Biblical reading ('for unto you is born this day in the City of David a Savior, which is Christ the Lord') that Mendelson once told me was 'the most magical two minutes in all of TV animation.' Study the special's brilliant cels and what resonates as timeless is the visual focus on what is beautiful and joyful and true in the yuletide spirit—the collective sense of meaning that adults can too easily lose track of. Yet out of the mouths of babes—those as small as the humblest Christmas tree—blooms the resilient reason for the season. Merry Christmas, Charlie Brown.

—Michael Cavna, comics and animation columnist, *The Washington Post*

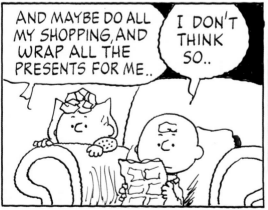
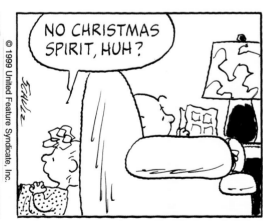

EMMY AWARD

A Charlie Brown Christmas was not a guaranteed success. The pacing was slower and more casual than that of the prime-time animations of the day. The line readings by the children, most of them untrained actors, portraying the voices of the characters were at times awkward. A jazz soundtrack was not what people expected for either animation or for Christmas. Some at the CBS television network were ready for a flop. While Schulz, Mendelson, and Melendez had already started planning *Charlie Brown's All-Stars* and *It's the Great Pumpkin, Charlie Brown*, studio executives said they would not be ordering any more *Peanuts* specials.

That changed instantly when the show aired on Thursday, December 9, 1965. The special was the second-most-watched show of the week, beaten only by the highly popular *Bonanza*. And the viewers were not disappointed. They would tune in again and again over the years, with the show now having aired in prime time on network television every year for more than half a century. The Television Academy recognized the special with two Emmy Award nominations, and it won the category of Outstanding Children's Program, beating out such long-running favorites as *Captain Kangaroo* and *Walt Disney's Wonderful World of Color*.

Front row (left to right): Lee Mendelson, Charles Schulz, Bill Melendez. Back row: Emmy, Emmy, Emmy, Emmy.

> *Peanuts* isn't really a children's strip in the first place. My audience ranges from the very young to grandmothers. It isn't about children: it's about people and their foibles, and we use kids to make it work, to make a point.
>
> —Charles M. Schulz

This would not be the only Emmy for *Peanuts*. On May 27, 1974, Schulz won the category Outstanding Individual Achievement in Children's Programming for writing *A Charlie Brown Thanksgiving*. For Schulz, this was a simultaneous honor and slight. The honor is obvious. The slight comes both in the fact that this was the first time that the academy chose to announce some of the winners the day before the big televised awards ceremony, rather than at the ceremony, and because Schulz never thought he was creating specifically "children's" work. *Peanuts* was about children, of course, but Schulz always saw his audience as wider and more heavily adult.

Still, it proved that the Emmy awarded to *A Charlie Brown Christmas* was no fluke. As of 2021, *Peanuts* specials have won five Emmy Awards and earned over thirty nominations.

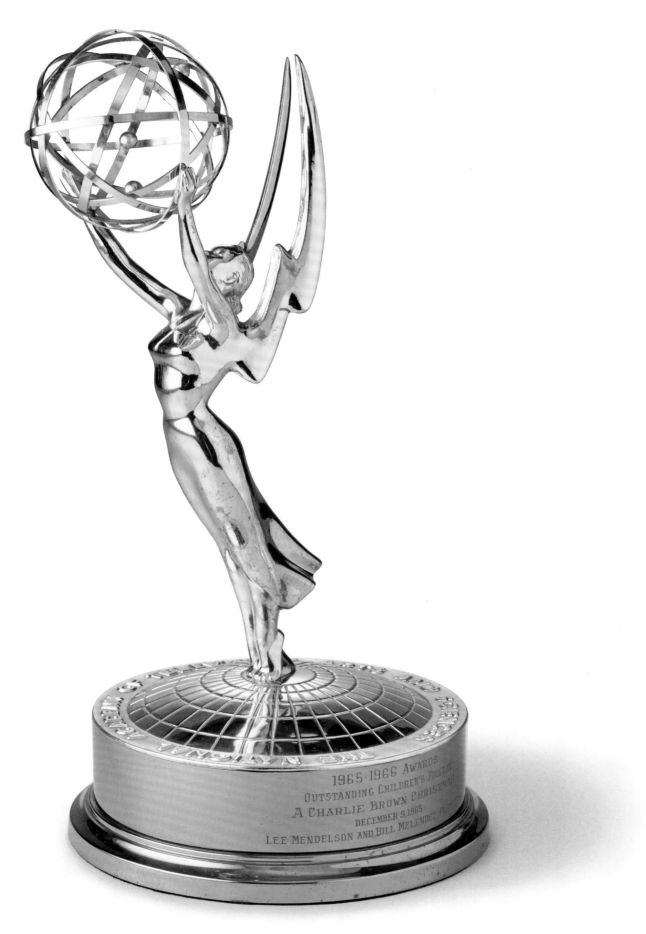

The Emmy statuette was originally named an "Immy" after the image orthicon camera used in early television production.

While the Emmy Award is selected by those within the television industry, the George Foster Peabody Awards, which honor excellence across a range of media, are chosen by a panel of scholars, critics, and media professionals who convene annually at the University of Georgia. *A Charlie Brown Christmas* was recognized in 1966 as an excellent children's program. As the Peabody website explains, "Gentleness is a quality that is seldom understood by television's writers or directors," but *A Charlie Brown Christmas* was a "notable exception."

Producer Lee Mendelson attended the Peabody Award ceremony in New York and brought along the original art for a *Peanuts* strip, signed by Schulz, as a gift to a special *Peanuts* fan. The fan? Lady Bird Johnson, wife of President Lyndon B. Johnson, who was presenting the awards that evening. Her television special, *A Visit to Washington with Mrs. Lyndon B. Johnson on Behalf of a More Beautiful America*, was also honored.

The Peabody jurors would recognize *Peanuts* again in 1983, for the television special *What Have We Learned, Charlie Brown?*

Mr. Johnson
White House

Dear Mr. President,

I am starting a collection of famous marriage proposals. I need to have when you proposed to Mrs. Johnson and what you said. It doesn't have to be the exact words.

A loyal fan,
Eleanor K.
Bangor, Maine

P.S. If you forgot, ask Lady Bird.

Schulz had referred to his fellow Peabody honoree Lady Bird Johnson in one of his illustrations for the 1964 book *Dear President Johnson*. This book, compiled by Bill Adler, featured children's letters to President Johnson, with plenty of Schulz illustrations. This was just one of several non-*Peanuts* books that Schulz illustrated. He provided spot cartoons for two books collecting tales from the "Kids Say the Darndest Things" segments of the show *Art Linkletter's House Party*. He also co-wrote (with Kenneth Hahn) and provided cartoons for *Two-by-Fours*, a book on the topic of preschool children and the church.

64 | *IT'S THE GREAT PUMPKIN, CHARLIE BROWN* ANIMATION CELS

Once the success of *A Charlie Brown Christmas* became apparent, CBS rushed to lock in more *Peanuts* specials. The next to air was the baseball-themed *Charlie Brown's All-Stars*, but it was still less than a year after the first special that *It's the Great Pumpkin, Charlie Brown* was broadcast.

In the comic strip, the *Peanuts* characters are almost always seen from only a few different angles. In animation, however, characters have to move and turn through poses that Schulz never drew. By the time of this special, animator Bill Melendez and his team (credited unusually on the *Peanuts* specials as providing "graphic blandishment") had been animating *Peanuts* for years, first for a series of ads for Ford automobiles and then for an unaired documentary before the first *Peanuts* special. In *Great Pumpkin*, the team had brought Snoopy's World War I Flying Ace persona and his hunt for the Red Baron to life for the very first time.

For over four decades, across stage, screen, television, tennis courts, golf links, and ice rinks, through friendship, loyalty, and creativity, the special and synergistic partnership between our father, producer Lee Mendelson, animator Bill Melendez, and *Peanuts'* creator Charles M. Schulz, Charlie Brown and his gang were magically brought to life on network television. Starting with the Emmy winning *A Charlie Brown Christmas* on CBS-TV Thursday night, December 9, 1965, it became the first of many iconic animated memories such as *It's The Great Pumpkin, Charlie Brown* along with many more Emmys and accolades. We have been so blessed to have our father work with "Sparky" and Bill to create something that has been loved by so many people for so many years.

—Jason and Glenn Mendelson, Lee Mendelson Film Productions, Inc.

"YOU'RE A GOOD MAN CHARLIE BROWN"

©United Feature Syndicate, Inc. 1966

65 | *YOU'RE A GOOD MAN, CHARLIE BROWN*

In 1966, if you were looking for *Peanuts* songs, you couldn't avoid the smash hit "Snoopy vs. the Red Baron" by The Royal Guardsmen. Getting far less attention was a concept album called *You're a Good Man, Charlie Brown*, with *Peanuts*-themed songs written by Clark Gesner. Those pieces got their spotlight in 1967, when they were used as the base of an Off-Broadway play. This playbill from the opening of the original Theatre 80 St. Marks run doesn't credit anyone with the text of the play. That work would later be attributed to "John Gordon," a pen name used to cover that it was a workshopped collaboration by Gesner, the cast, and others involved in the production. The original production ran almost sixteen hundred performances, and the play would have road shows, multiple Broadway runs, both live-action and animated television versions, and countless school and community theater productions that continue to this day.

THEATRE 80 ST. MARKS

80 St. Marks Place 254-9740

ARTHUR WHITELAW and **GENE PERSSON**

present

YOU'RE A GOOD MAN, CHARLIE BROWN

a new musical entertainment

Based on the Comic Strip "PEANUTS"

by

CHARLES M. SCHULZ

Music and Lyrics by

CLARK GESNER

with

Bill Hinnant	**Reva Rose**	**Karen Johnson**
Bob Balaban	**Skip Hinnant**	**Gary Burghoff**

Book	*Sets & Costumes*	*Lighting*
John Gordon	**Alan Kimmel**	**Jules Fisher**

Assistant to the Director	*Musical Supervision Arrangements and additional Material*	*Assoc. Producer*
Patricia Birch	**Joseph Raposo**	**Stanley Mann**

Directed by

JOSEPH HARDY

Show Album on M-G-M Records

Recording Supervised by **Mort L. Nasatir**

A&R **Bob Morgan / Herb Galewitz**

Director of Engineering **Val Valentin**

Chief Studio Engineer **Dave Greene**

CAST
(in speaking order)

LinusBOB BALABAN
Charlie BrownGARY BURGHOFF
PattyKAREN JOHNSON
SchroederSKIP HINNANT
SnoopyBILL HINNANT
LucyREVA ROSE

TIME: An Average Day In The Life Of Charlie Brown

MUSICAL NUMBERS

Act I

"YOU'RE A GOOD MAN, CHARLIE BROWN"	Entire Company
"SCHROEDER"	Lucy, Schroeder
"SNOOPY"	Snoopy, Charlie Brown
"MY BLANKET AND ME"	Linus
"KITE"	Charlie Brown
"DR. LUCY (THE DOCTOR IS IN)"	Lucy, Charlie Brown
"BOOK REPORT"	Charlie Brown, Lucy, Linus, Schroeder

Act II

"THE RED BARON"	Snoopy
"T.E.A.M. (THE BASEBALL GAME)"	Entire Company
"QUEEN LUCY"	Lucy, Linus
"PEANUT'S POTPOURRI"	Snoopy, Linus, Schroeder, Lucy, Patty
"LITTLE KNOWN FACTS"	Lucy, Linus, Charlie Brown
"SUPPERTIME"	Snoopy
"HAPPINESS"	Entire Company

Piano: Ronald Clairmont Percussion: Lou Nazarro

Who's Who in The Cast

[cast biographies text]

It is true that there never was a true script when we created the hit New York musical *You're a Good Man, Charlie Brown*. The cast was given books of previously published *Peanuts* comic strips, which we acted out onstage before the artful eyes of director Joe Hardy, who arranged them in an order that made sense in producing 'a day in the life of Charlie Brown.' We had Clark Gesner's wonderful musical score, which we also incorporated as we went. The rest became history.

One more thing … for those who remember me for *M*A*S*H*, it was *Charlie Brown* that started it all for my career, and I am ever grateful!

—Gary Burghoff, actor

Classical composer Ludwig van Beethoven had an ongoing presence in *Peanuts*, as the young pianist Schroeder loved the man and his work above all. The Beethoven bust that sometimes sat atop Schroeder's piano gave Schulz ample practice drawing the man. In the 1960s, at a "Beethoven's birthday" party the Schulzes threw at the Coffee Grounds (their rural home near Sebastopol, California), Sparky hand drew Ludwig onto sweatshirts for some of the guests. This one in the museum archives was drawn for Peggy Jarisch, a friend of the Schulzes.

When drawing Beethoven, whether for the strip or for these shirts, Schulz didn't just settle for a cartoon figure that you knew from context was supposed to be Beethoven. Just as he took the time to draw out a full musical staff rather than a few cartoon notes that would imply music, he took the time to draw a figure that would be recognizable to any Beethoven aficionado.

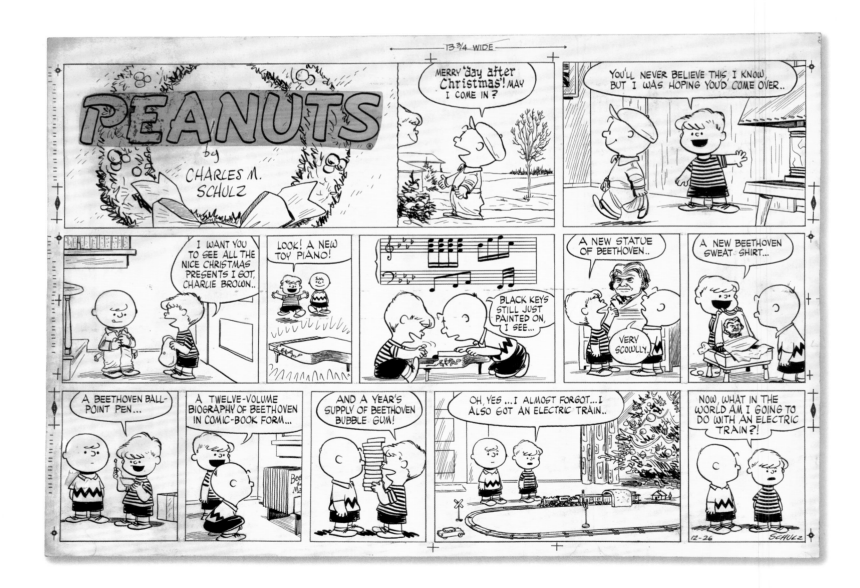

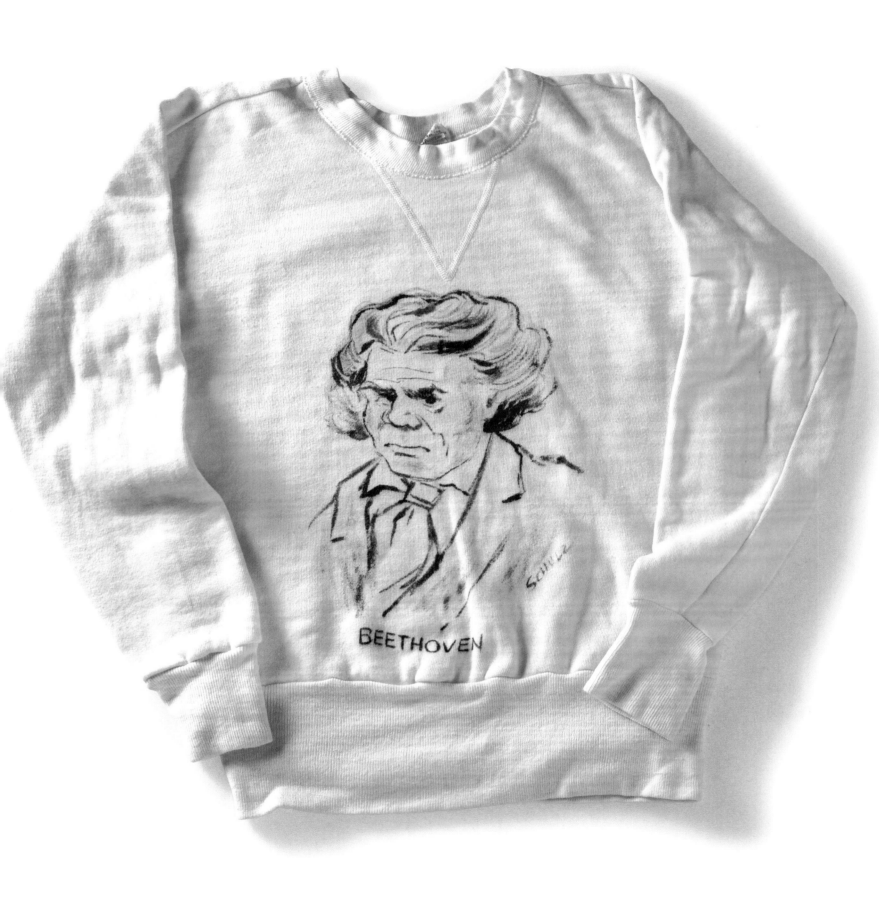

67 | STUFFED SNOOPY

Having had big successes with first their *Peanuts* date books and then the *Happiness Is a Warm Puppy* hardcover and the series of books that followed, Determined Productions did not feel constrained to stick with printed goods. It quickly moved on to such items as pillows in the shape of the characters (pillow dolls). But when the company launched the first proper plush Snoopy in 1968, it created a whole new field for itself. It put out Snoopy in a variety of sizes and with different costumes. You could buy separate outfits to put on your Snoopy. When Snoopy's sister Belle appeared briefly in the strip in 1976, it gave Determined an excuse to produce female beagles and accessories. A series of fashion events followed, with top-name designers making outfits for Snoopy and Belle dolls.

Japan's embrace of *Peanuts* was launched when student Teruko Banno brought a plush Snoopy home from New York. Her father Michio Banno, then head of the manufacturing company Familiar, reached out to the US State Department to help in securing a license to produce *Peanuts* items.

The trademark conflict that had prevented Determined Productions from using the Snoopy name on stuffed dolls led to the Elka Toy & Novelty Manufacturing Corporation filing a lawsuit in December 1967 against United Feature Syndicate, then the owner of *Peanuts*. An agreement was negotiated, and the conflict came to a final and irrevocable end in February 1971, when Elka transferred its trademark to the syndicate.

Birthday presents for children with December birthdays can be challenging. Santa usually brought a doll, but how can we make the birthday special? For birthday number three in 1975, the large, plush Snoopy was the perfect solution. He fit into her arms perfectly and was ideal for snuggling as she went to sleep. Now gray and rather worn, her Snoopy enjoys a comfortable retirement, still dressed in the blue cotton shirt made many years ago by my mother for one of my dolls, which fits him perfectly.

—Lucy Shelton Caswell, a volunteer since the Schulz Museum was in the planning stages, a trustee since its opening

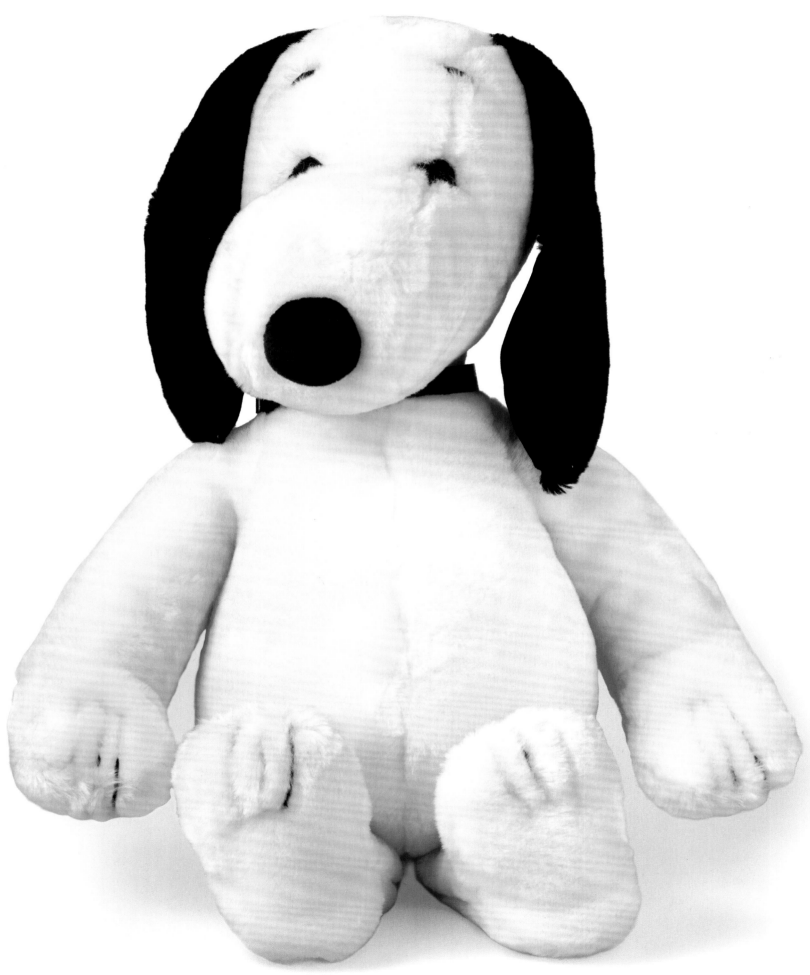

Four-wheeled ATVs were not a thing until inventor George Carter III conceived this groundbreaking, ground-covering peppy yellow vehicle. While it wasn't licensed for street driving, it was indeed licensed to carry the Snoopy name and logo. As part of the licensing deal, manufacturer Coot Industries gave Sparky his own Snoopy Funmobile, and it became another fun toy for the folks at the Coffee Grounds. In time, the little two-seater passed into other hands and was eventually allowed to decay. Then it was found by an automobile restorer named Sid, who with his son, Robbie, spent years on a slow, careful restoration of the car. They also reached out to the Schulz Museum to try to verify that this particular vehicle had belonged to Sparky, and Sparky's son Craig was able to recognize some small customizations he had made. Once it had been fully restored and Sid and Robbie had been able to display and enjoy it for a while, Craig bought the Funmobile back.

Coot also made a red Funmobile with a more powerful engine. What did they call the car that could outrun Snoopy? The Red Baron, of course.

IT'S CALLED 'SNOOPY'—"Peanuts" creator Charles Schultz takes his favorite dog for a ride in Coot Industries' "Snoopy" funmobile. The San

The newspaper that ran this photo flipped it; the steering actually was on the left-hand side, as is standard with American cars.

"This guy who invented off-road vehicles asked Dad if he could put Snoopy on one, to market the cars. In the process, my Dad got a free sample, the yellow Snoopy car. He was going to use that car to commute from the house up to the golf course. He didn't use it very much. Myself and the other kids, we took over the Snoopy car, ended up running the thing into the ground and selling it. After 50 years, it came back to me.

—Craig Schulz, president, Charles M. Schulz Creative Associates

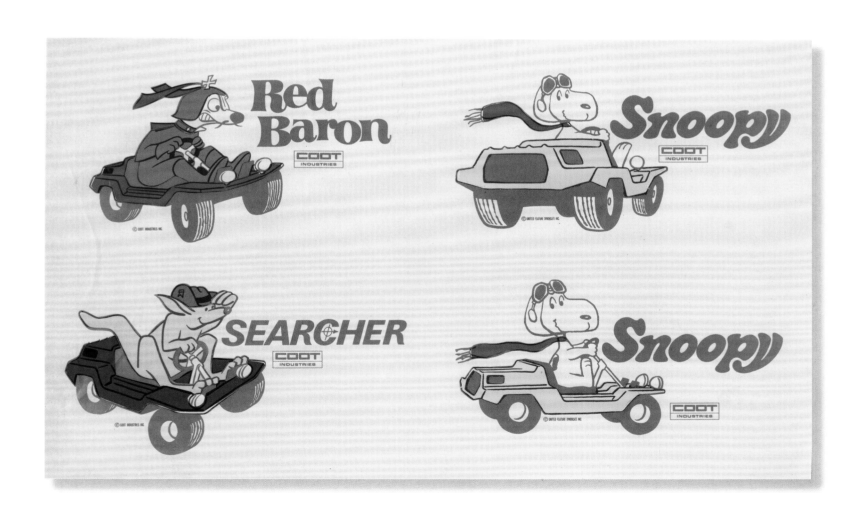

Mrs. Harriet Glickman 4933 Wortser Ave. Sherman Oaks, Calif/ 91403

Mr. Charles Schulz
United Features Syndicate
220 E. 42nd St.
New York, N.Y. 10017 April 15,1968

Dear Mr. Schulz,

Since the death of Martin Luther King, I've been asking myself
what I can do to help change those conditions in our society
which led to the assassination and which contribute to the
vast sea of misunderstanding, fear, hate and violence.

As a suburban housewife; the mother of three children and a
deeply concerned and active citizen, I am well aware of the
very long and tortuous road ahead. I believe that it will
be another generation before the kind of open friendship,
trust and mobility will be an accepted part of our lives.

In thinking over the areas of the mass media which are of
tremendous importance in shaping the unconscious attitudes of
our kids, I felt that something could be done through our
comic strips and even in that violent jungle of horrors known
as Children's Television.

You need no reassurances from me that Peanuts is one of the
most adored, well-read and quoted parts of our literate society.
In our family, teen-age Kathy has posters and sweat shirts...
pencil holders and autograph books. Paul, who's ten and
our Charlie Brown Little Leaguer....has memorized every
paper back book...has stationery, calendars, wall hangings
and a Snoopy pillow. Three and a half year old Simon has
his own Snoopy which lives, loves, eats, paints, digs, bathes
and sleeps with him. My husband and I keep pertinent Peanuts
cartoons on desks and bulletin boards as guards against pomposity.
You see...we are a totally Peanuts-oriented family.

It occurred to me today that the introduction of Negro children
into the group of Schulz characters could happen with a minimum
of impact. The gentleness of the kids...even Luc— —
setting. The baseball games, kite-flying...yea, —
Psychiatric Service cum Lemonade Stand would acco——
the idea smoothly.

Sitting alone in California suburbia makes it all ———
and logical. I'm sure one doesn't make radical ch——
important an institution without a lot of shock w——
syndicates, clients, etc. You have, however, a sta———
———tation which can withstand a great deal.

CHARLES M. SCHULZ
2162 COFFEE LANE
SEBASTOPOL, CALIFORNIA 95472

 April 26, 1968

Harriet Glickman
4933 Wortser Ave.
Sherman Oaks, Calif. 91403

Dear Mrs. Glickman:

Thank you very much for your kind letter. I
appreciate your suggestion about introducing
a Negro child into the comic strip, but I am
faced with the same problem that other car-
toonists are who wish to comply with your
suggestion. We all would like very much to be
able to do this, but each of us is afraid that
it would look like we were patronizing our
Negro friends.

I don't know what the solution is.

Best regards.

 Sincerely yours,

 Charles Schulz
 Charles M. Schulz

June 6, 1968

Mr. Charles M. Schulz
2162 Coffee Lane
Sebastopol, California 95472

Dear Mr. Schulz:

With regards to your correspondence with Mrs. Glickman on the subject
of including Negro kids in the fabric of Peanuts, I'd like to express an
opinion as a Negro father of two young boys. You mention a fear of being
patronizing. Though I doubt that any Negro would view your efforts that
way, I'd like to suggest that an accusation of being patronizing would be
a small price to pay for the positive results that would accrue!

We have a situation in America in which racial enmity is constantly
portrayed. The inclusion of a Negro supernumerary in some of the
group scenes in Peanuts would do two important things. Firstly, it would
ease my problem of having my kids seeing themselves pictured in the
overall American scene. Secondly, it would suggest racial amity in a
casual day-to-day sense.

I deliberately suggest a supernumerary role for a Negro character. The
inclusion of a Negro in your occasional group scenes would quietly and
unobtrusively set the stage for a principal character at a later date, should
the basis for such a principal develop.

We have too long used Negro supernumeraries in such unhappy situations
as a movie prison scene, while excluding Negro supernumeraries in quiet
and normal scenes of people just living, loving, worrying, entering a hotel,
the lobby of an office buidling, a downtown New York City street scene.
There are insidious negative effects in these practices of the movie industry,
TV industry, magazine publishing, and syndicated cartoons.

 Sincerely,

 Kenneth C. Kelly
 Kenneth C. Kelly

KCK/bc

CHARLES M. SCHULZ
2162 COFFEE LANE
SEBASTOPOL, CALIFORNIA 95472

 July 1, 1968

Harriet Glukman
4933 Wortser Ave.
Sherman Oaks, Calif. 91403

Dear Mrs. Glukman:

You will be pleased to know that I have
taken the first step in doing something
about presenting a Negro child in the
comic strip during the week of July 29.

I have drawn an episode which I think
will please you.

Kindest regards.

 Sincerely yours,

 Charles Schulz
 Charles M. Schulz

© 1950 United Feature Syndicate

In 1968, white California housewife Harriet Glickman saw the racial strife that the United States was going through and felt the need to try to make some change. She mailed letters to some comic-strip creators, hoping that they might augment the white denizens of their strips with an African American character, and thus do just a bit to normalize friendly relationships among members of different races.

Schulz responded at first with some reticence. He wouldn't want his efforts to be seen as tokenism. Glickman got Ken Kelly, a Black space communications engineer, to back up her request, and this emboldened Schulz. He added Franklin to the strip at the end of July, a move that drew a lot of attention and some controversy.

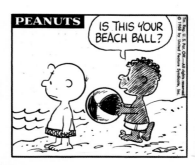 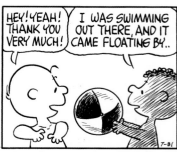 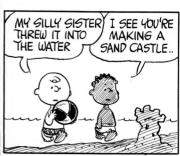 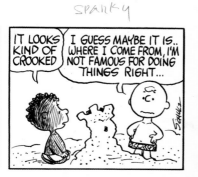

Schulz set Charlie Brown's first meeting with Franklin on a beach in a year when some beaches were just being opened to all races.

When I first interviewed Sparky, it was for the 50th anniversary of *Peanuts*. Besides the opportunity to be able to sit down with one of my heroes, I would finally get the chance to tell him not just how much the strip meant to me but what Franklin represented. As an amateur cartoonist growing up in Queens, I read the strip every day in the *Long Island Press*. Up until 1968, I never saw anyone who looked like me in the comics. And then, in 1968, we met Franklin. Franklin's debut was a low key first meeting on a beach with Charlie Brown, in keeping with the tone of the strip, but it rocked the world of comic syndication. And it was all because of this letter from Harriet Glickman. It made strips like Morris Turner's *Wee Pals* more acceptable to newspapers and changed the staid, conservative works of daily comic strips for ever and made kids like me feel more accepted.

—Al Roker, Weather and Feature Anchor, *Today* and Co-Host of 3rd Hour, *Today*

70 | APOLLO 10 ASTRONAUTS

At the far right of this June 17, 1969, photo is Charles Schulz. The figure on the far left is Ronald Reagan, then governor of California (and Schulz's occasional correspondent). Between them are Eugene Cernan, Thomas Stafford, and John Young, three men who had taken Charlie Brown for a rather long ride the previous month. In this case, "Charlie Brown" was not the round-headed kid but the call sign for the command-and-service module of the Apollo 10 spacecraft that had done a test run to the moon. Once Charlie Brown got in orbit, Cernan and Stafford transferred to "Snoopy," the lunar module, to test the landing systems that would actually put humans on the moon in the Apollo 11 mission two months later.

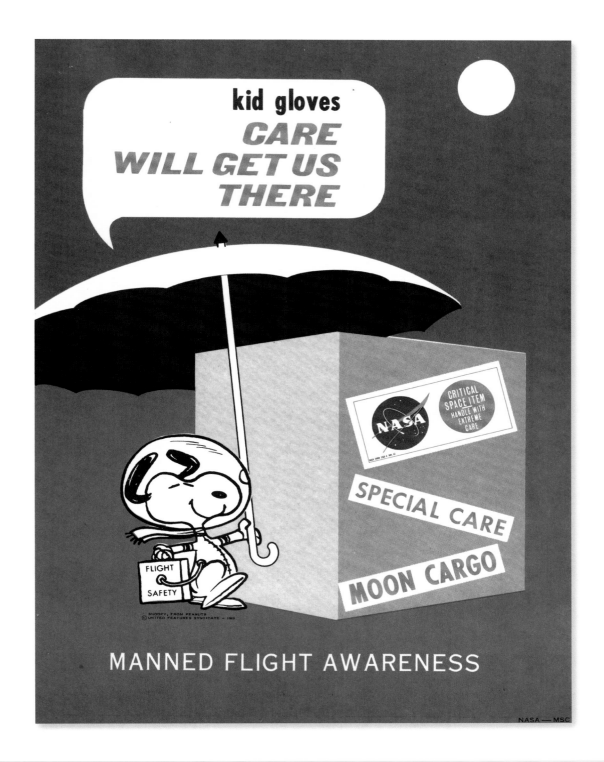

Peanuts and NASA have had a long relationship that continues to this day. Some of it is informal, like referring to an astronaut's under-helmet gear as a "Snoopy cap" because its white dome and dark sides makes the wearer look like a certain beagle. Some of it is very formal and organized, like the NASA partnership to produce STEM (Science, Technology, Engineering, and Mathematics) content including the animated TV series *Snoopy in Space*.

When Gene Cernan returned to space on Apollo 17, the last Apollo mission to the moon, he and geologist Harrison Schmitt had the chance to do what explorers have long had the right to do: name the things they've found. That is why there is a crater on the moon named "Snoopy."

71 | SILVER SNOOPY AWARD

Apollo 10 was not Snoopy's first trip into space—nor his last. He heads upward with many a NASA mission, in the form of a bag filled with Snoopy lapel pins. These pins, though small, carry a powerful purpose: they are given to NASA contractors and employees in recognition of efforts to improve the safety and success of space missions. Each one is delivered by an astronaut and is accompanied by a certificate noting on which flight the pin had been flown. Charles Schulz received his own pin. It was given to him by Wally Schirra, commander of Apollo 7, the low-orbit test flight on which the pin had flown.

Schulz provided the design for the Silver Snoopy pin,
and later used the space-helmeted Snoopy in the strip.

My grandmother, Ova Marvel, took me into the farms of Indiana in October 1957. We saw *Sputnik 1*, the first artificial Earth satellite, fly overhead, and my love of space and the sky began. (*Sputnik* is Russian for 'Fellow Traveler.') In 1967 NASA public affairs director Al Chop asked Sparky if they could use Snoopy as their safety mascot. Sparky loved the Silver Snoopy Award Program. I met Sparky at the opening of the Redwood Empire Ice Arena on April 28, 1969. One of our first conversations was about Apollo 10, scheduled to launch on May 18 of that year. The lunar module named Snoopy was to get within nine miles of the moon. Its job was to snoop around!! Sparky and I talked about the space program so often. He even made a phone call once when I was in his office. He said, 'Hi, this is Sparky Schulz. How many golf balls are there on the moon?' I asked him to whom he had been talking. He said, 'NASA.' He had such a love of the space program and we shared that for all of his years. Snoopy was proud to be invited to a Silver Snoopy award ceremony for Jim Furr at the Kennedy Space Center. I was honored to be invited to the ceremony for Tom Erkenswick at Houston's Johnson Space Center. I love this award and I love the space talks I had with Sparky as a 'fellow traveler' I miss him so much.

—Snoopy, aka Judy Sladky

onoma County, California, is a lovely place to live, thanks in good part to its mild climate. However, that climate does not lend itself to skateable ponds in the winter. When the sole ice rink in Santa Rosa, the county seat, closed down due to structural problems, Joyce and Charles Schulz saw an opportunity to give back to their town. In 1969, the Redwood Empire Ice Arena opened its doors, providing skating space, a hockey arena, and a performance venue, all in grand style. The gorgeous 45,000-square-foot building included advanced heating and dehumidification features that allowed it to stay at a comfortable 68 degrees Fahrenheit (almost 20 degrees warmer than the old ice arena) while keeping the ice frozen. The 15,700 square feet of ice could quickly be covered and seating brought in, so 3,700 people could watch whatever entertainment was presented.

Interior of the Ice Arena's Warm Puppy Café shortly after opening in 1969.

Joyce Doty drives a grader at the Ice Arena's construction site, 1968.

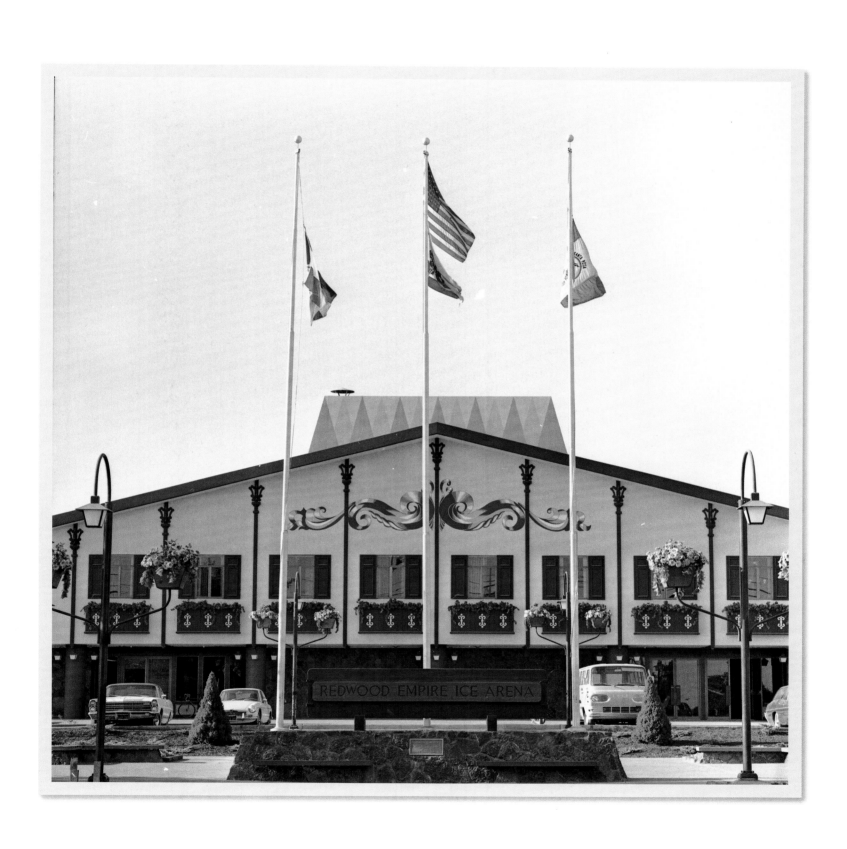

73 | A NAPKIN

"The story of this napkin comes in three chapters," explains Jean Schulz. "Chapter one, circa 1970, before I met Sparky, in the Redwood Empire Ice Arena: I had taken my daughter, Lisa, and neighbor, Mary Jo Anderson, to their skating lessons. Mary Jo's father, Edwin, knew Mr. Schulz (which Mary Jo told us frequently) so I asked her to get Mr. Schulz's autograph on a napkin. (Which he did often for fans.)

"Chapter two, in 1973 Sparky and I married. A few decades later, I opened a drawer in the dining room buffet, saw the napkin, and showed it to Sparky. He was amazed to see it and to hear that I had asked Mary Jo to get it for me."

"'I can't believe you still have this,' Sparky said. 'You should put it in a museum.'

"Chapter three, 2016: I noticed the napkin again, and I realized it *DID* belong in Sparky's museum. After 35-plus years it is where it should be."

The Snoopy doodle that I received from Sparky when I was in college was a cherished item of mine back in the early '70s. The postcard sketch hung on my bulletin board above my drawing table and kept me inspired on my drive to someday becoming a syndicated cartoonist.

—Jeff Stahler, creator of *Moderately Confused* and syndicated editorial cartoonist

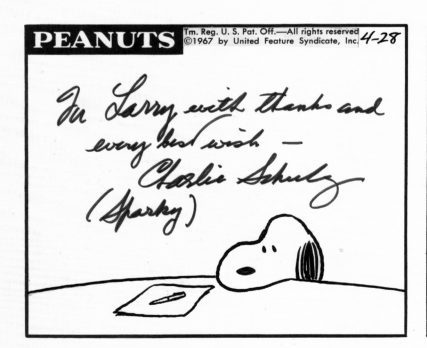

The text in the first panel of this April 28, 1967 strip is an inscription Schulz put on the original art when giving it away.
Snoopy is not actually adding illustrations to a note from Schulz, however it may appear.

Drawing Snoopy was the social lubricant that got me through middle school and high school. I became the kid who could draw on binders, and I was responsible for Snoopy occupying about 80 percent of that cardboard real estate at Hamilton Junior High School in South Bend, Indiana.

I continued appropriating Sparky's creations in high school binders and many other flat surfaces. I soon expanded my repertoire to include drawing Woodstock and then creating a four-foot-tall papier-mâché Snoopy being captured by the Red Baron.

When *You're a Good Man, Charlie Brown* came to our part of the country, I was fortunate enough to see the play. Once again, the dog was the character that captured my attention, but the actor playing Woodstock wore an oversized yellow turtleneck sweater that was the coolest thing I'd ever seen. I bought one almost exactly like it and wore it for most of my sophomore year. It took dedication to do that while living in a small town in the Mojave Desert, let me tell you. Who knew the sweaty kid in the yellow turtleneck would grow up to be a cartoonist just like his hero?

—Jerry Scott, co-creator, *Baby Blues* and *Zits*

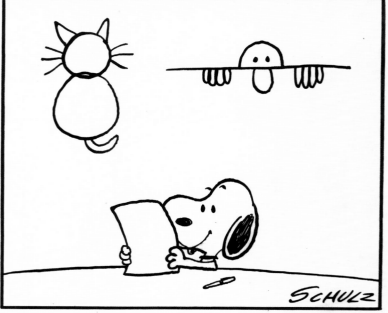

| **THE PRIMARY DRAFTING TABLE**

The Redwood Empire Ice Arena may be known as "Snoopy's Home Ice," but for a while it was pretty much Schulz's home as well. In 1971, Sparky and Joyce were preparing Coffee Grounds, their twenty-eight-acre estate, for sale. With the studio being cleaned out, Sparky needed a place to work until his new studio was built, and so he set up his things, including this, what would become his drafting table, on the arena's mezzanine level. Schulz once told *For Better or For Worse* cartoonist Lynn Johnston that he would retire once he wore a hole through the board, something he never achieved.

For me, Sparky's desk has always been the gravitational center of the cartooning universe. The object around which the rest of us orbit. The closest thing we cartoonists have to a Mecca. For there was no cartoonist who had a greater impact on those of us who followed.

When I had just become syndicated and got to see Sparky's studio for the first time, the one thing I wanted to do was touch that desk. Like it somehow had healing powers. From its unbelievably worn finish (how much does one have to draw to even do that?) to the notion that all the characters I held so dear were birthed right there on that surface, that desk was borderline magical.

—Stephan Pastis, creator of *Pearls Before Swine*

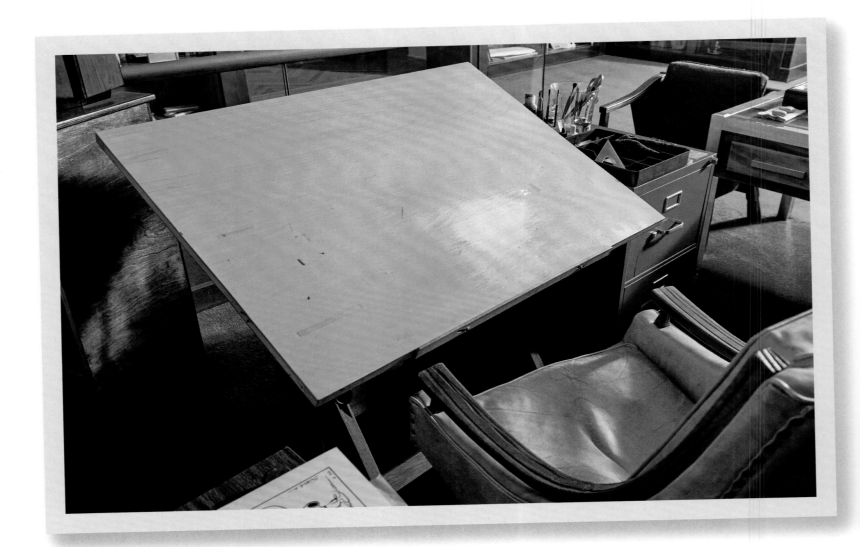

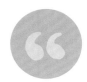

I've visited the Schulz Museum numerous times over the years, and no matter how awestruck I was by the artwork on display, I've always found myself spending the most time in Sparky's re-created studio. I've literally stared at this drafting table, with its smudges and worn-down wood grain, and had something close to a religious experience. Okay, maybe that's a bit extreme, especially in the context of Mr. Schulz's deeply held faith, but it's an experience that has been genuinely moving and emotional for me. It's incredible to be mere inches away from the surface on which so many strips that meant so much to me were created.

But as a physical object, the drafting table itself has been a source of inspiration. Now more than ever, there's a great cultural focus on 'the next new thing,' and it feels like so many of my peers are constantly finding new technological ways of working. As someone who is both a bit of a Luddite and generally change averse, I take comfort in the knowledge that the greatest cartoonist in the world used the same wooden table for decades, and with nothing more than paper, pen, and ink, created one of the true apexes of the art form.

—Adrian Tomine, cartoonist, *Killing and Dying* and *The Loneliness of the Long-Distance Cartoonist*

The first time I was invited into Charles Schulz's studio, I was excited, nervous, and shy. Sparky was welcoming and easy to be with as he showed me around. I was surprised by how homey his area was. The studio building itself is like a spacious bungalow, with perhaps six people working in comfortable, well-lit offices. His family and staff had wanted to do some upgrades, so, at the time, most of the building's interior had been redone. Sparky's private space, however, had been out-of-bounds. He didn't want anything changed, so the room where he worked remained as it had been for many years. He loved being surrounded by familiar things. I wandered about looking at the worn carpet, comfy chairs, family photos, and mementos, not really believing I was there!

The first thing a cartoonist wants to see when visiting other cartoonists is their work space. You want to see the pens they use, the paper, what kinds of pictures they have on the wall, where the lights are, and what kind of drafting table they work at hour after hour! Sparky's table was an old one. It was wood with a particularly well-scuffed patch right in the middle. I was surprised to see that he worked on such a rough surface. Running my hand over his drafting table, I asked, referring to the deeply worn patch, 'What's this from?' And without missing a beat, Sparky replied, 'Hard work.'

I felt a bit foolish, but he was right. After almost thirty years of drawing cartoons on a similar surface, my own drafting table now has a worn patch right in the middle. I'm waiting for a young, new cartoonist to look at it and ask, 'What's this from?' I will say, 'Hard work!' But I'll give Sparky the credit. He knew how to write a good punch line!

—Lynn Johnston, creator, *For Better or For Worse*

75 | HOCKEY SKATES

Schulz never lost the love for hockey he had developed in his early years. In California, he became a fan of the California Golden Seals, a National Hockey League team based in Oakland, from 1967 to 1976. He even designed the team's mascot, a seal who, like its creator, was called Sparky.

Sparky (the human) did not confine himself to the ice arena's mezzanine and café. Those 15,700 square feet of Olympic-grade ice were also a home to him, allowing him to play hockey as he had as a child in his backyard (and, at times, with his grandmother in the basement). These skates that he wore in the 1970s were made by Bauer, who had been making skates in Canada since 1927.

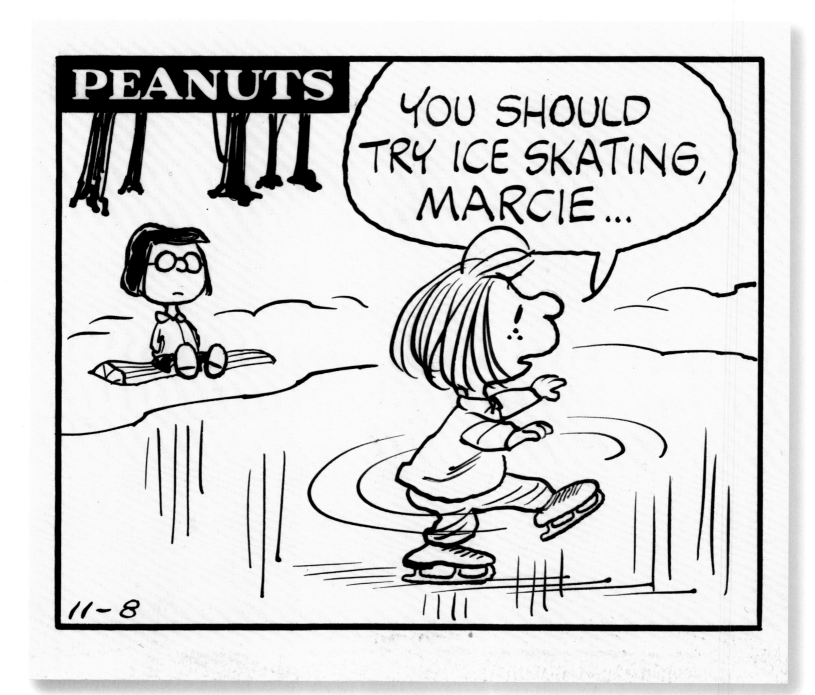

Panel detail from daily strip, November 8, 1974

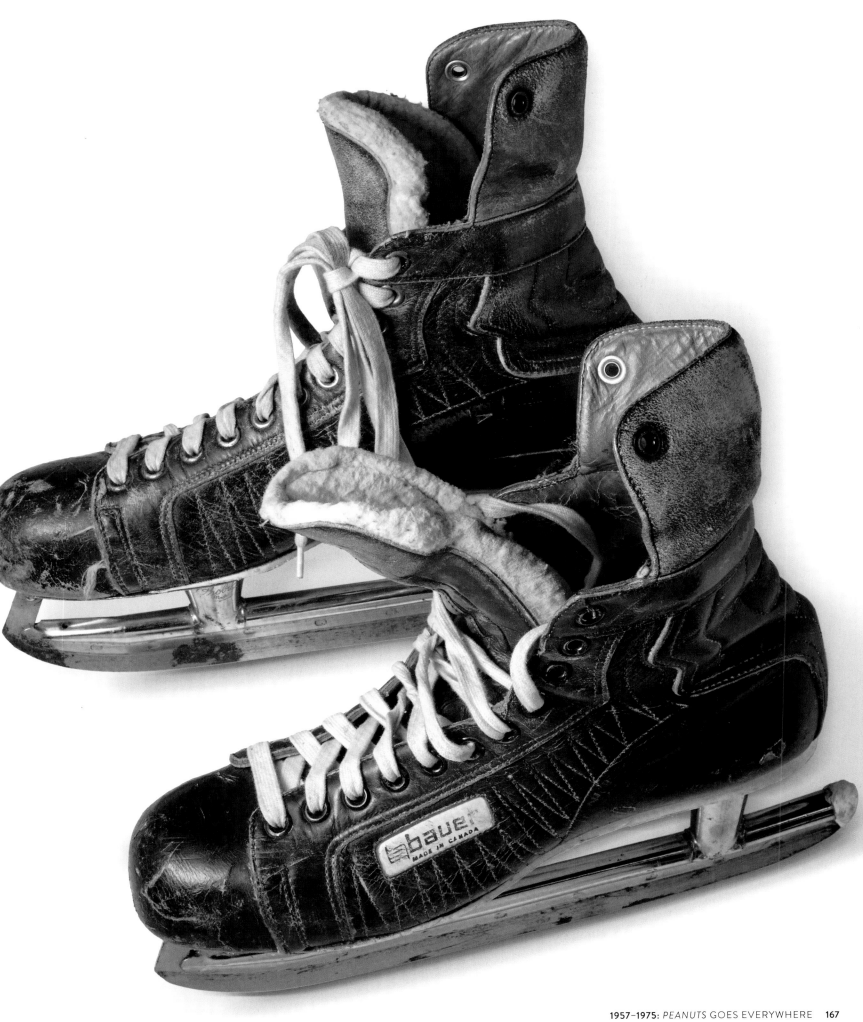

PEANUTS
featuring
"Good ol' Charlie Brown"
by Schulz

IS LOVE A 'NOW' KIND OF THING, CHUCK, OR IS IT MOSTLY HOPE AND MEMORIES?

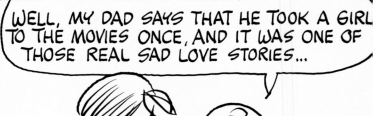

WELL, MY DAD SAYS THAT HE TOOK A GIRL TO THE MOVIES ONCE, AND IT WAS ONE OF THOSE REAL SAD LOVE STORIES...

HE NEVER FORGOT THAT GIRL BECAUSE EVERY TIME HE SAW ANNE BAXTER, IT WOULD REMIND HIM OF HER...

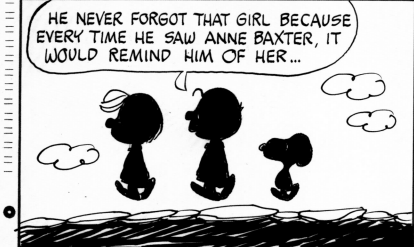

THEN, ONE NIGHT ON THE LATE, LATE SHOW THAT SAME MOVIE CAME ON, BUT IT TURNED OUT THAT HE HAD BEEN WRONG ALL THOSE YEARS... IT WASN'T ANNE BAXTER... IT WAS SUSAN HAYWARD!

By 1972, Sparky's relationship with his wife, Joyce, was troubled. Even during the best of times, Sparky could look back on old slights and failed romances and draw on them for the strip, such as in his stories about the Little Red-Haired Girl. In this May 1972 Sunday strip, Schulz offers one of his rare purposeful pieces of using the *Peanuts* strip "as the instrument for my own recollections." He has taken his own tale of a failed romance and the painfulness of memories and ascribed them to Charlie Brown's dad.

Joyce Schulz filed for divorce later that year.

The "Little Red-Haired Girl" that Charlie Brown is obsessed with is a character drawn from Sparky's Art Instruction days. Donna Mae Johnson, a petite redhead who worked in the accounting department, caught Sparky's attention, and he, hers. They dated for a while, and Sparky fell hard. He sought her hand in marriage, but she, after consideration, chose to marry a family friend who attended her church, breaking Sparky's heart more than a little. She was his one-that-got-away. But Sparky had at least been braver than Charlie Brown, who had never gathered up the courage to approach the girl of his dreams. Schulz tended to carry the pains of his past with him and to use them in his work, and Miss Johnson was no exception.

Snoopy's Senior World Hockey Tournament - 1998
Worlds First 75 Yr. Old Division

77 | SENIOR HOCKEY TOURNAMENT

When Schulz's Santa Rosa hockey team started participating in the Senior Olympics Hockey Tournament in 1973, was the beginning of a tradition, and Schulz would participate in the tournament almost every year up to and including the last year of his life. At first, participating required a 400-mile trip down to Burbank, in Southern California, but at the 1974 tournament, Schulz was asked if he might like to start hosting the event at his Redwood Empire arena. The tournament at the arena was part of the Senior Olympics until 1982, when the event was renamed Snoopy's Senior World Hockey Tournament, the name it still uses today. Beyond just playing with his team the Diamond Icers, Schulz would show up for pickup games almost every Tuesday, stopped only by his final hospitalization in November 1999, at the age of seventy-seven.

The hockey jersey in the Museum's collection bears the number 9, his preferred jersey number.

Hockey, for me, is the greatest game going. There's just nothing comparable to the exhilarating feeling of breaking down the ice with the puck, heading in on the goal. You really have a chance to go. I've also played baseball, tennis, and golf, but there's just nothing quite like ice hockey.

—Charles M. Schulz

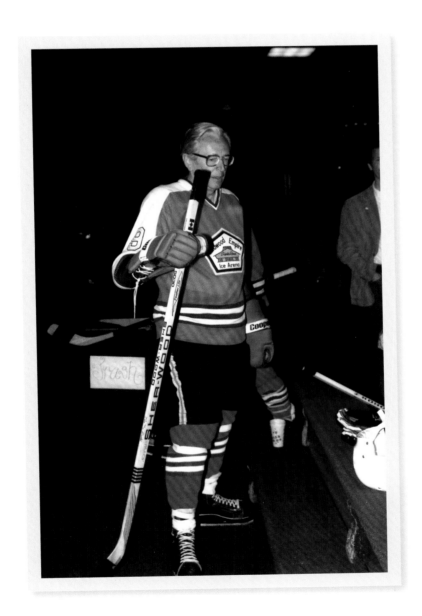

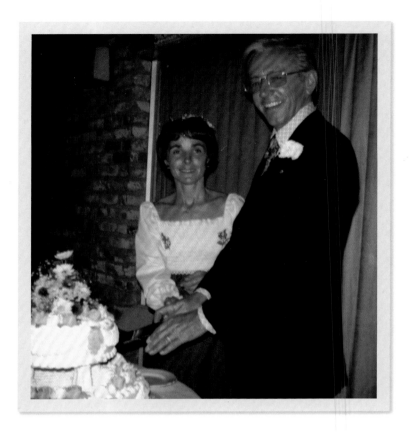

The woman who had had a friend secure a Snoopy drawing on a napkin for her eventually started encountering the cartoonist. Jean Forsyth Clyde would see Sparky in the Warm Puppy Café at his reserved table (it is still reserved for him to this day) as she was dropping off or picking up her children from their skating sessions in 1972, the year that Sparky's marriage to Joyce came to an end. Sparky and Jean eventually fell into conversations and found each other fascinating.

On September 22, 1973, they married, a union that would last the rest of Sparky's life. Jean's wedding present to him was this desk. It served as both his place for doing business and for his just-inked comic strips to dry for the remainder of his career. It now sits in the Schulz Museum, in a re-creation of his office space, letting all see the environment in which he worked.

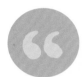

This reproduction of Sparky's office reveals a number of important aspects of a very complex man. As a family man and a man of the world, we see photographs of family, friends, and associates. His love of cartooning and art in general is hinted at by the art tools and cartoon book at the right side of the desk, which is appropriately large, handsome, and practical for an astute businessman. Finally, the world globe in the background symbolizes Sparky's magnanimous philanthropy. A small brass plaque on the mounting indicates one of the many thousands of worthy organizations that Sparky has supported. As a thank-you for his unfailing financial, intellectual, and heartfelt sponsorship, it reads, 'For Sparky / We think the world of you / Cartoon Art Museum.'

—M.K. Whyte, founder, Cartoon Art Museum

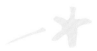

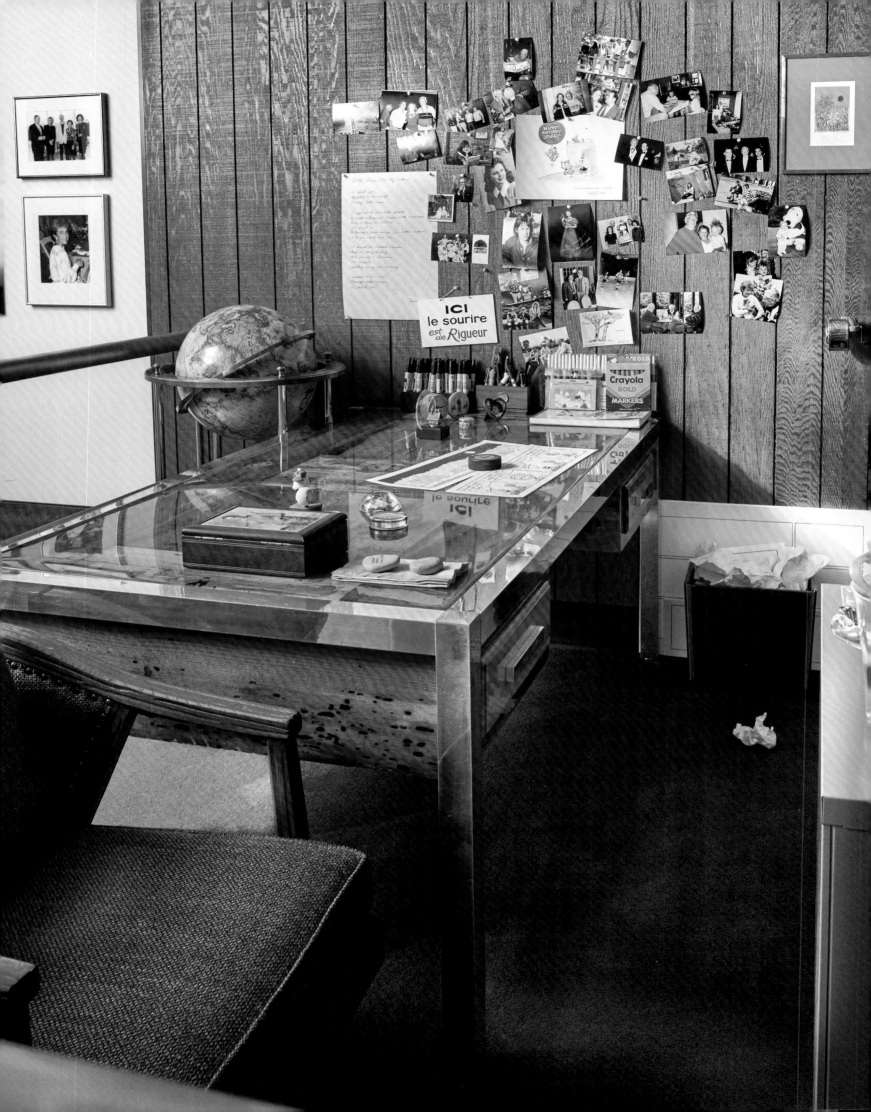

79 | THE TOURNAMENT OF ROSES PARADE

The Tournament of Roses Parade is one of America's great New Year's Day traditions. Each year's parade has a special theme for the floats and a celebrity grand marshal toward the front of the parade. In 1974, over a million people lined the streets of Pasadena, California, to watch the annual parade of floats decorated solely with flowers and other organic materials, with millions more watching on television. Charles Schulz was the grand marshal and "Happiness is …" was, appropriately enough, the theme. Schulz was accompanied on this ride by his daughter Amy and a large, familiar-looking beagle.

The top prizes in the parade went to the "Happiness is … a Snowflake" float by the city of St. Louis and the "Happiness is … Love" float by the Eastman Kodak Company.

I am frequently asked, 'What was it like to grow up with a famous father?' The question is difficult for me to answer, because I was not aware that my dad was as famous as he was; all I knew was that he drew cartoons during the weekdays and played with his kids the rest of the time. The few times that he had an event honoring him as a 'world famous cartoonist,' he was always good to invite his kids to come along if they wanted to. I am grateful that, when I was just 17 years old, I accepted his invitation to ride in this parade with him. On each one of these occasions where he was the celebrity focus, I witnessed his humility. He consistently showed respect for all those around him, never once making anyone feel like they were less important than he was. To be able to see my dad, the most humble of all men, in these situations is something I will forever cherish.

—Amy Schulz Johnson

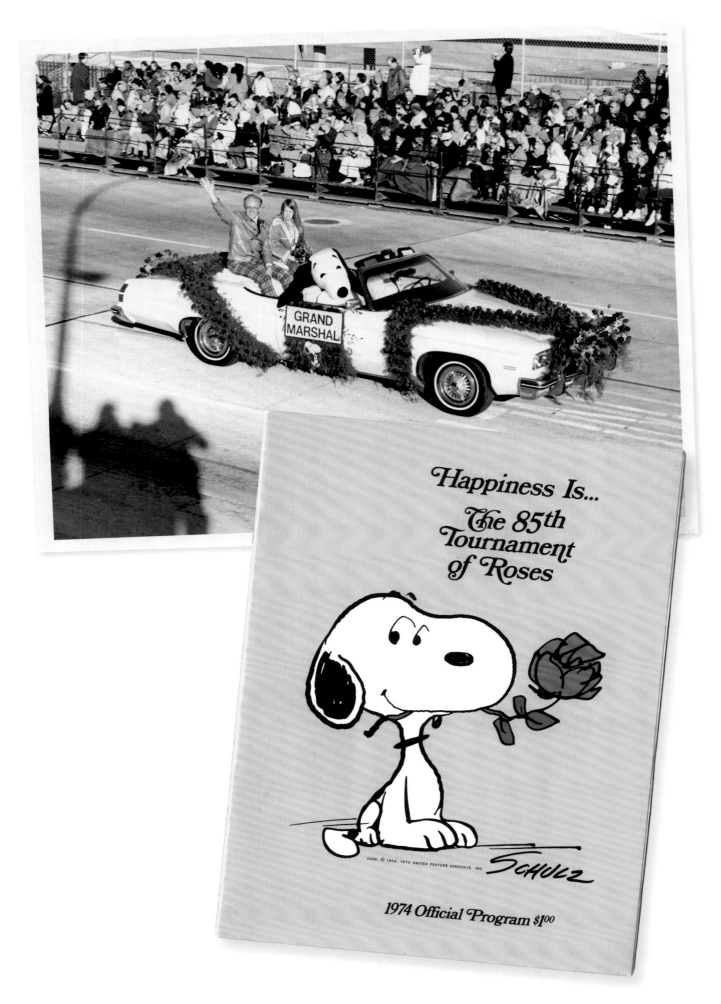

Happiness Is...
The 85th
Tournament
of Roses

COPR. © 1958, 1973 UNITED FEATURE SYNDICATE, INC.

Schulz

1974 Official Program $1⁰⁰

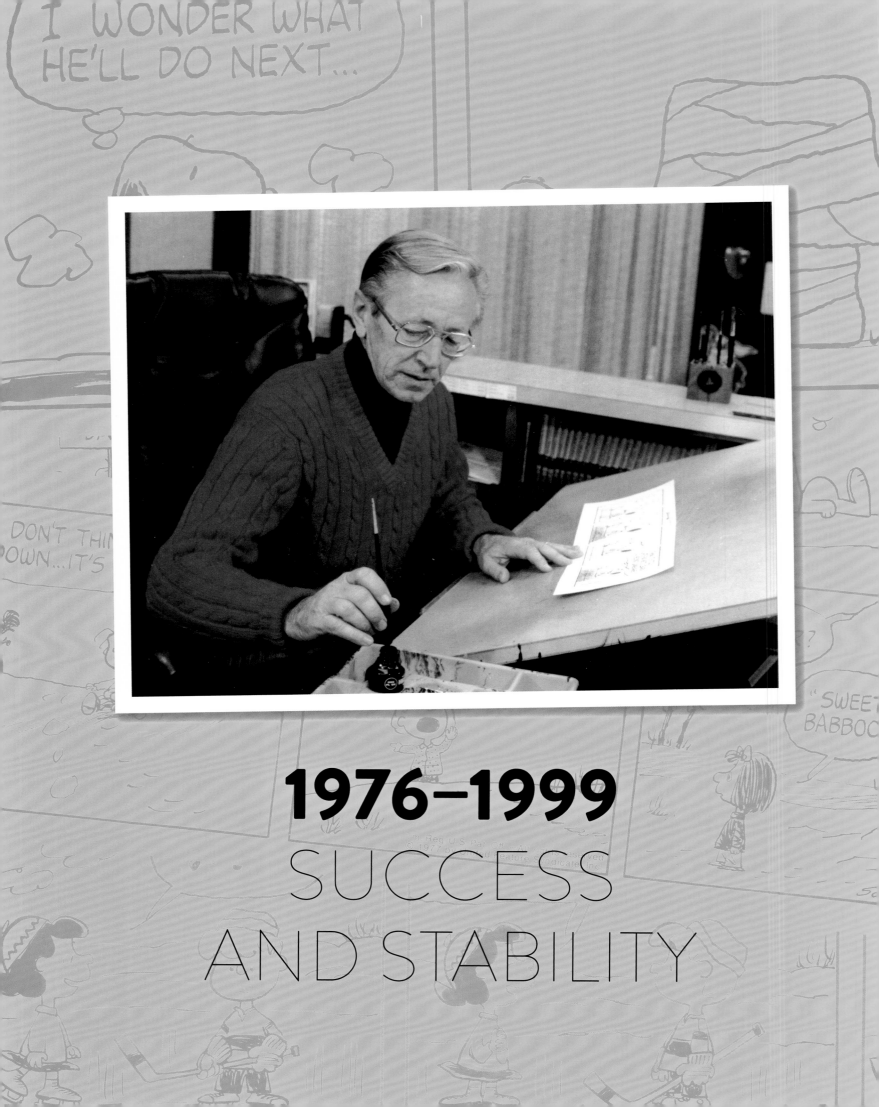

1976–1999
SUCCESS AND STABILITY

The second half of the *Peanuts* run was a stable time for Sparky. He had settled into a happy marriage. His work maintained international popularity. He had creative outlets of his own making, and thanks to some negotiations with his syndicate, he had more control over *Peanuts* licensing than he had in the early days.

The time was not without its troubles, however. He required heart bypass surgery in 1981, and he developed an essential tremor that kept him from drawing the clean, smooth lines of earlier times. But he found a way to make it work, and the shaky line gave the strip a wistful quality while still retaining the *Peanuts* essence.

80 | "SWEET BABBOO"

In this January 27, 1977, strip, Schulz introduces the term "sweet babboo." It was not a term he had invented but rather one that he had stolen from his wife, Jean. It was her expression of affection for Sparky. It appeared in the strip dozens of times over the years. Sally would call Linus by it, with Linus always denying his babboo status. Few Valentine's Days would pass without Sally calling him her sweet babboo, only to be shunned for it. But unlike the unrequited love that so much of *Peanuts* is built on, Jean's love for Sparky was fully returned, as you can see displayed in this engagement photo.

Sweet babboo would end up being one of the terms that *Peanuts* popularized in the real world, along with security blanket, fussbudget, and blockhead.

ABOVE: Panel detail from daily strip, January 27, 1977. OPPOSITE: Engagement photo, 1973.

The entry of "sweet babboo" into the lexicon was not the only or even the biggest impact that *Peanuts* has had on the language. While Schulz did not invent the term "security blanket," he was key in changing its common definition from an enforced veil of secrecy (as in "the Pentagon maintained a security blanket over troop movements") to a comforting personal item. Perhaps the biggest impact the strip had is not from a phrase, but from an image: Lucy pulling the football away just as Charlie Brown was about to kick it has become an allegory for those who are trusting the word of someone who has repeatedly proven themselves untrustworthy. That someone is about to or has already yanked the football away gets invoked constantly in political discussion, speeches, and editorial cartoons.

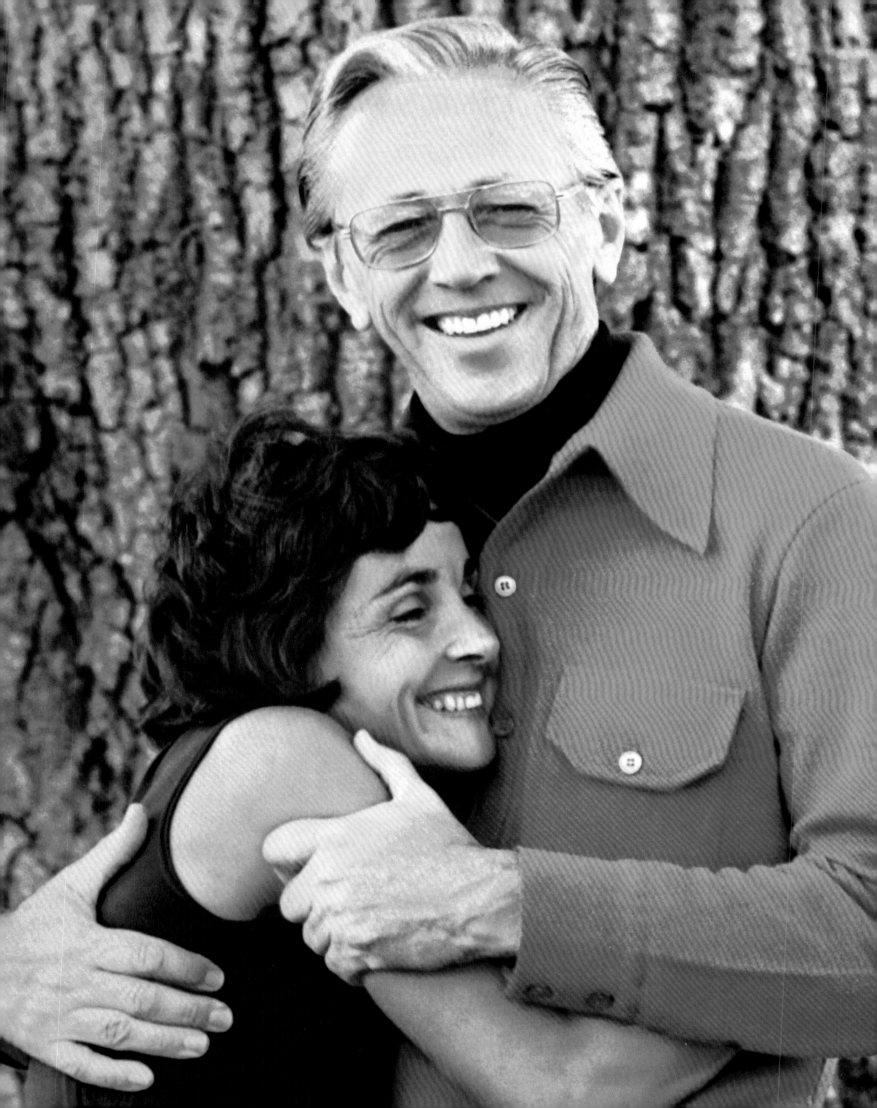

Schulz captures some of the beauty of Yosemite National Park in this 1974 marker sketch.

81 | LANDSCAPE AND TRAVEL SKETCHES

Schulz was not a frequent traveler. The life of a newspaper cartoonist is one of perpetual deadlines, and with the *Peanuts* empire growing, there were always more things to be done in the studio beyond the strip. When he did get ahead of deadlines and was able to get away for an extended period, however, he took pleasure in exercising his art skills to capture the sights he saw.

On a 1978 trip to participate in a documentary, Schulz made this drawing of Paris's famed Notre Dame Cathedral.

| *WRAPPED SNOOPY HOUSE*

The story of the *Wrapped Snoopy House* begins in 1978 and finishes a quarter century later. The artistic duo of Christo and Jeanne-Claude gained their reputation by creating art installations using large amounts of cloth. They wrapped the Reichstag in Berlin, draped vinyl gates in New York's Central Park, and hung a curtain across a state highway in Colorado. Their 1976 installation *Running Fence*, which consisted of a nylon-covered fence extending along over 24 miles of the California landscape, caught the eye of many Californians, including Sparky.

One special piece was very directly inspired by the strip. In 1978, Schulz showed Snoopy expressing admiration for the artist Christo's work and wondering what he'd do next, only to find his own doghouse had been wrapped in cloth. In 2003, Christo and Jeanne-Claude presented the museum with *Wrapped Snoopy House*, bringing life to Schulz's cartoon vision of their work.

 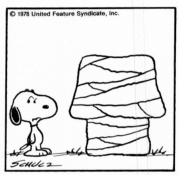

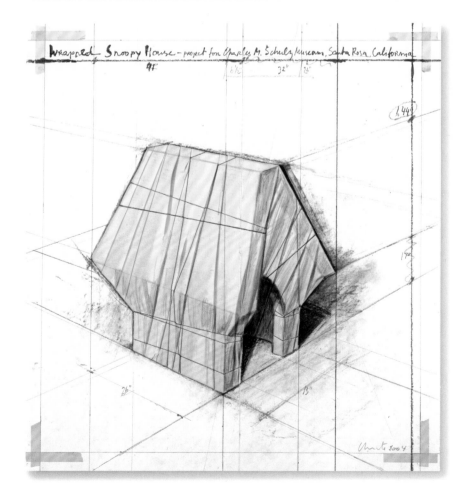

What's more important: Christo's *Wrapped L'Arc de Triomphe* or Christo's *Wrapped Snoopy House*? The answer is obviously the Snoopy house; especially if you're reading this book. Very few people know this, but Snoopy and Woodstock were playing cards in the basement the evening that his house was being wrapped.

—Peter Guren, creator, *Ask Shagg*

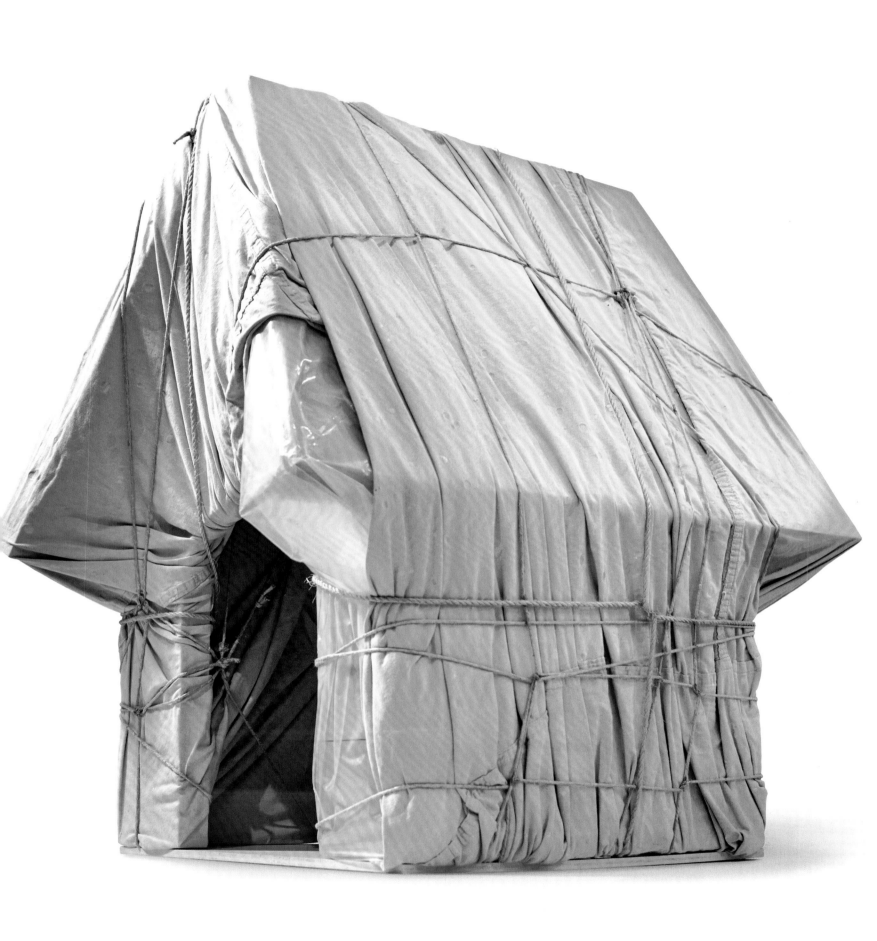

83 | WOMEN'S SPORTS FOUNDATION POSTER

In *Peanuts*, the girls always played sports alongside the boys. At first, they did it somewhat reluctantly, but as time went on, they could be as committed as their male counterparts. So it made sense when Schulz was asked to join the board of trustees for the Women's Sports Foundation, an organization supporting female participation in athletics founded by Schulz's friend and tennis great Billie Jean King. In 1979, he was named vice president of the group. Along with his behind-the-scenes managerial efforts, he helped the group in some visible ways, whether it was participating in a pro-celebrity exhibition tennis match in 1977 or providing art for some of the group's promotional materials, like this poster. His illustrations for the 1983 *Women's Sports Foundation's Cookbook* included his own recipe for the front cover: a guide to making yourself a bowl of cold cereal.

Sparky was a champion for women and women's sports. And as this Women's Sports Foundation poster shows, he believed in and supported strong, confident women in 1952, when he introduced Lucy, and in 1976, when we printed this poster. What's important is his message still resonates today. We loved having Sparky on the board of trustees at the WSF, and when we invited him to join our board, he said yes before we finished asking him. He was there for us when Title IX was being challenged, and the power of his pen and the influence of the *Peanuts* comic strip was one of the most important gifts the foundation ever received. For me, many of Sparky's strips and drawings often had special hidden meanings. Lucy, with her tongue sticking out in this image, showed us she could do anything a boy could do. Showing her feet off the ground showed us her strength. Those things are important because in those days, and even still today, girls are taught not to trust their bodies. Sparky showed us we could be athletic, we could be strong and confident, and we could win.

—Billie Jean King, tennis champion and founder of the Women's Sports Foundation

Although best known for its Reuben Award, the National Cartoonists Society has a number of other awards it grants at its annual conventions. In 1980, over a decade after he had won the second of his two Reuben Awards for Outstanding Cartoonist of the Year, Sparky took home a different trophy: the Elzie Segar Award. Named for the creator of the comic strip *Thimble Theatre* featuring Popeye, the award was created to recognize people who "have made a unique and outstanding contribution to the profession of cartooning."

Schulz had grown up fascinated by Segar's work, and as a child, he would draw Popeye on his classmates' schoolbooks.

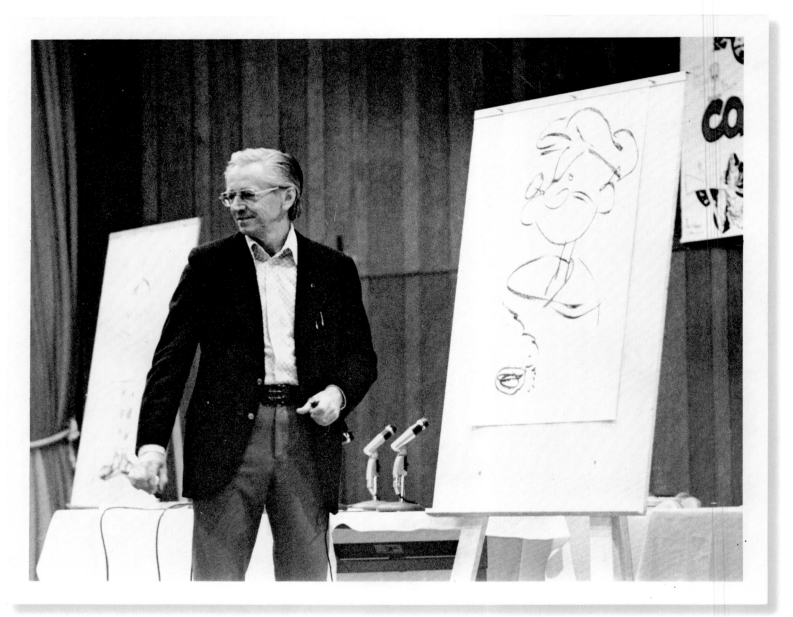

Charles Schulz draws Elsie Segar's most famous creation at the 1974 San Diego Comic Con.

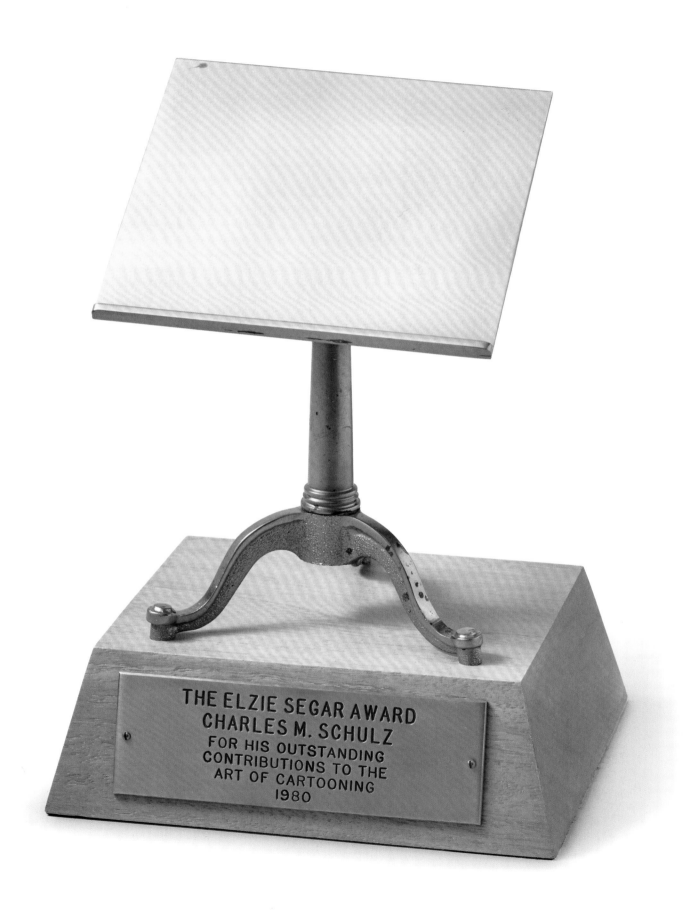

Charles Schulz valued his friendships for the usual reasons, but he also found they helped him with his work. Many of the character names from Charlie Brown on were borrowed, in whole or in part, from people Schulz knew. And when he wanted to delve deeper into something in the strip, he had people who could give him accurate details, whether it was the proper technical term for childhood loss of eyesight (amblyopia ex anopsia) or how to write "good grief" (⌒ ⌣) in shorthand. Snoopy's guise as the World Famous Attorney was inspired by Schulz's pal Ed Anderson, who helped him with the relevant legal details, as in this 1982 strip.

As a gift, Schulz presented Anderson with the same sort of leather briefcase that the World Famous Attorney carries, with Anderson's initials inscribed.

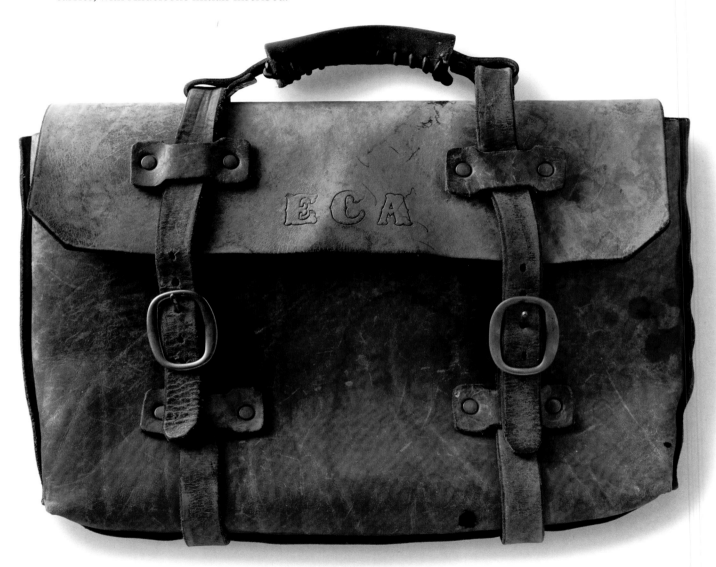

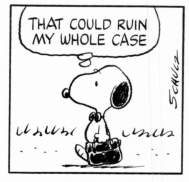

I was Ed Anderson's law partner and worked with him for almost 40 years until his retirement in 2015. For many meetings Ed and I attended together, some of which were related to legal matters for Sparky, Ed always had the briefcase with him. Sparky would call Ed (and later me) every once in a while and ask about a legal term or process so he could reference it accurately in the comic strip. For example, Sparky was working on a strip to be published on March 18, 1996, that begins with Linus asking Snoopy, who was decked out with his hat, bow tie, and briefcase, 'As a world famous attorney, do you serve many subpoenas?' Sparky wanted to be sure he was spelling 'subpoena' the way lawyers spell it in their legal documents, even though many people spell it 'subpena.' Sparky was genuinely fascinated by the law, and he liked discussing legal issues and how they played out in the courtroom and the philosophy of justice, which may explain why a significant number of strips deal with the law or attorneys. He also enjoyed discussing legal dramas on TV or in the movies, and we both laughed at the movie *My Cousin Vinny*. Ed's briefcase seems to me to be the same one Snoopy carries as Snoopy the World Famous Attorney or the 'legal beagle.' I always wondered if Sparky intended Ed's briefcase to be the same as Snoopy's or if he intended Snoopy's briefcase to be the same as Ed's.

—Barbara D. Gallagher, Spaulding McCullough & Tansil LLP

The success of *Peanuts* and the prestige it brought him allowed Sparky to share his lifelong love of sport. Beyond the hockey tournaments and the other events at the ice arena, he sponsored or hosted golf tournaments, tennis tournaments, and an annual fun run. He himself would run in the Young at Heart Run (as it came to be called), which raised money for cardiac health programs in Sonoma County. This shirt for the 1984 run features Snoopy jogging, an activity that the beagle had been doing in the comic strip since 1968.

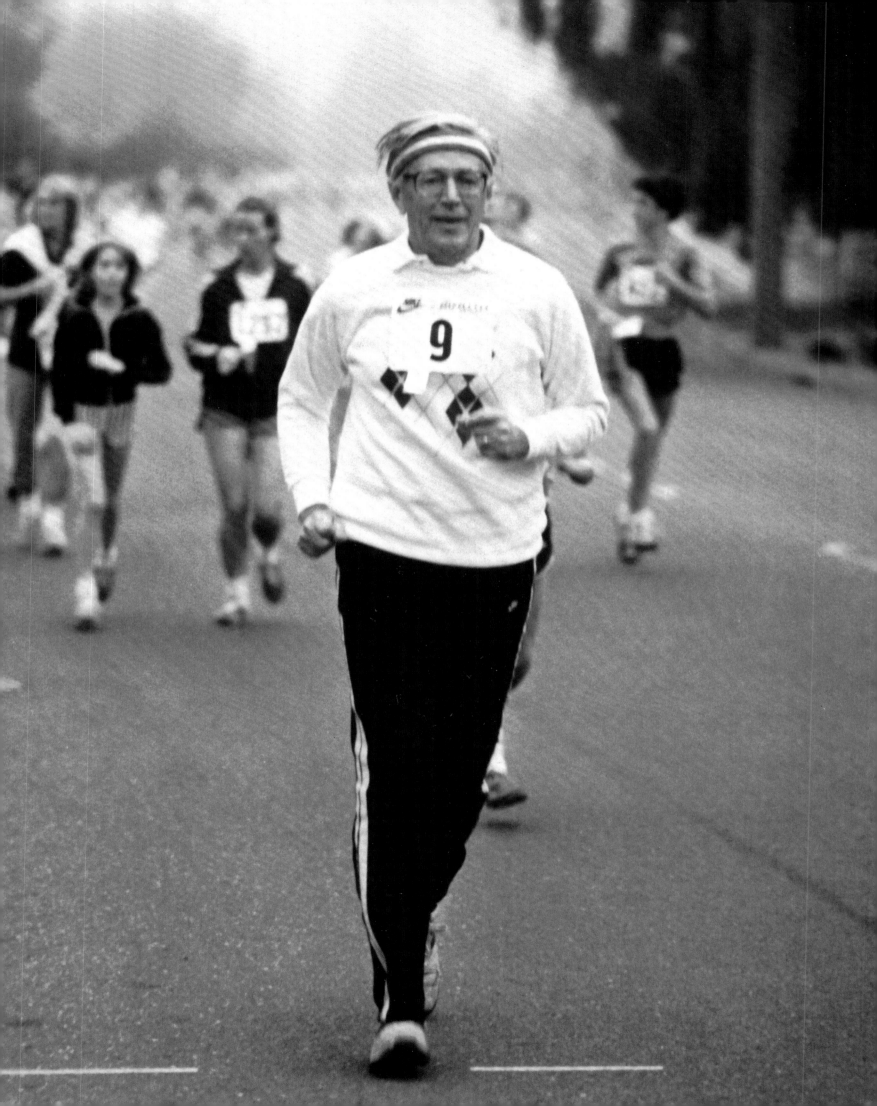

87 | ICE SHOWS

Starting in 1986, the Redwood Empire Ice Arena became the home for an annual Christmas ice show, with Sparky as a very hands-on producer. That first year's show, titled *Snoopy's Wonderful Magical Christmas*, featured Olympic gold medalist Scott Hamilton as a special guest star. (This was not Hamilton's first time at the arena. Just the year before, he had skated in the show *Flashbeagle*.) Skating in the Christmas show with Scott was Jill Schulz, Sparky's youngest daughter, as well as dozens of other skaters. All sixteen performances sold out every seat in the arena.

Title character Snoopy had a little help. Inside the Snoopy suit was Judy Sladky, who spent decades getting under that dog's skin. A five-time US national champion skater, Judy had become a friend of Sparky's, who had noticed the Snoopy in her. She first appeared as the beloved beagle in the 1978 television special *Snoopy's Musical on Ice* and has continued portraying Snoopy on ice and off for decades, appearing at everything from the annual White House Easter Egg Roll to Sparky's funeral.

 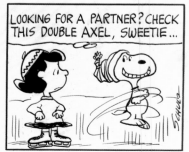

Charles Schulz became a grandfather for the first time in 1974, when his eldest daughter, Meredith, gave birth to a girl, Dena, named for Schulz's mother. His grandfather status grew rapidly in the 1980s, with his son Craig becoming a father in 1981 and his daughter Amy giving birth in 1983 to the first of nine children she'd have during the 1980s and 1990s.

The impact of being a grandfather could be seen in the strip by way of the character Rerun Van Pelt, the youngest regular member of the *Peanuts* crew. The little brother of Lucy and Linus, Rerun had been introduced in the strip in the early 1970s, courtesy of Jean Schulz's stories of her adventures, and had largely been confined to gags about riding on the back of his mom's bicycle. Schulz had even expressed regret about having introduced the character at all, though he knew he couldn't write out a Van Pelt. But Sparky, energized by exposure to his grandkids, started making new use of Rerun in 1987, and as a character he grew in import continuously through the end of the strip. In many ways, Rerun became the most realistic of the cast, dreaming not of success as a concert pianist or of pitching perfect baseball games but of very normal kid things: having a dog and a bicycle. (The fact that he doesn't get what he wants is what makes him a *Peanuts* character.)

" I have countless fond memories of visiting my Grandpa Schulz in Santa Rosa throughout my entire childhood. I was blessed to spend 16 years with him, doing such things as taking walks down to a small lake near his house and hanging out by the pool while eating our favorite Round Table pepperoni pizza. Some days, we would just sit around the dining room table talking and drawing together. I always felt such love from him; he made me feel so special. I remember the time he gave me a beautiful set of porcelain *Peanuts* characters; it meant so much to me. I still have that set today, and it is one of my most precious possessions. These experiences showed me that he really loved being a grandpa and that it made him very happy and proud! Family was very important to Grandpa, and I am so grateful for the time we had together. "

—Stephanie Revelli

This picture is what I imagine in my head when I think back on the memories I had with my grandpa. Some of my best childhood memories are from visiting Santa Rosa, not only because that is where I got to visit with all my cousins and extended family but because I knew we were going to go visit Grandpa. We would always stop by the studio where he would immediately greet us, no matter what he was doing. One thing I always admired about him was that he always made time for us and made me feel like I was the most important kid in the room. He hung out with us a lot, helping us figure out Power Wheels, cheering us on while we jumped off the diving board into his pool (if we were brave enough), and even teaching me how to shoot a BB gun. Now that he has passed, I am left with only good memories. To me he wasn't the 'most famous cartoonist in the world' but just my humble, caring, and devoted grandfather who loved spending time with his family and especially with his grandchildren.

—Charles Johnson

In 1990, Schulz was named a Commandeur of the Ordre des Artes et Lettres (commander of the Order of Arts and Letters), the highest honor in the arts granted by the government of France. This medal was presented to him by Jack Lang, the French minister of culture, in Paris. (Fellow Commandeurs include such notable creatives as Alfred Hitchcock, Audrey Hepburn, and Bob Dylan.)

Two years later, the government of Italy would also honor Schulz. It bestowed upon him the title of Commendatore in the Ordine al Merito della Repubblica Italiana (Order of Merit of the Italian Republic). The Order of Merit, a knighthood order, is the highest-ranking honor awarded by the Italian government.

Sparky wore this Italian medal the night he presented me with a Reuben Award in 1993. He was also wearing his 'Charles Schulz' name badge—as if everyone in the room didn't know who he was. As if one of the most famous people on the planet needed an introduction—especially to a group of cartoonists to whom he was the Cartooning God.

Sparky always wore his humble name badge as proudly as he wore his huge honors. I remember being so touched that night, as I always was, by his humility. He loved and supported all cartoonists with incredible graciousness and generosity. He talked and laughed with us as one of us—not as the grand master. Sometimes he called me on the phone and almost knocked me to the floor with his greeting: 'Hi, this is Sparky. I can't think of any jokes today. Can you think of anything?'

Sparky was proud of the honors he received, and he looked like a king wearing his Order of Merit of the Italian Republic medal on Reuben night in 1993. But it seemed he was always, at heart, a boy with a blank page and a bottle of ink who just wanted to draw cartoons and to support anyone else who wanted to draw cartoons. Even with all his fame, he never presumed anyone would know who he was. And so, along with his medals, he always wore his name badge: Charles Schulz.

—Cathy Guisewite, creator, *Cathy*

CHARLES M. SCHULZ
AT THE LOUVRE

PEANUTS Characters ©1950, 1951, 1952, 1958, 1960, 1965, 1966 United Feature Syndicate, Inc. 1990, 40 Years of Happiness

90 | LOUVRE POSTER

The presentation of Schulz's French medal in January 1990 was done as part of an honor that had never before been given to a cartoonist. If you were stopping by the Louvre to catch the smile of the *Mona Lisa* or the disarming charms of the *Venus de Milo*, you could also see a certain round-headed blockhead and a lot of his beloved beagle. The famed Paris museum's Musée des Arts Décoratifs, located in its northwest wing, presented a collection of dozens of pieces of Schulz's original art and related items along with "Snoopy in Fashion," an exhibition of over one hundred fashion designers' custom outfits on Snoopy and Belle plush dolls. The show ran at the Louvre from January 23 to April 22, and then the stuffed figures were sent off on a tour of other museums and cultural sites across the globe.

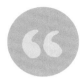

This photo stirs up such deep memories. I began selling cartoons regularly at a young age. Because of that, I developed great friendships with many great cartoonists, including the close friendship I shared with Schulz. I never understood how this King of the Cartooning World would be friends with me or even care to be but he was and I never asked. He seemed genuinely interested in me and we spoke freely about most things other than art every time we met. He took delight in teasing me like I was a younger brother. He called me by different names, anything starting with an R, and immediately put on a big grin. That scenario plays on my strips involving Curtis and his barber Gunther, who never gets his name right. It's always a name that starts with C. It let me know he was reading my strip. He found time to speak to me whenever I called for advice. The advice I sought was never about cartooning but about life's problems: things I was going through in relationships, navigating alone in NY, those sorts of things. Since I grew up in a dysfunctional family and couldn't speak to my own father, I adopted Schulz as a father figure. He gave me insight, jokes, and chastised me if I needed it. I appreciated it all. He did something that I will always consider Very Special, and it's right on his desk: he gave me the dimensions of his *Peanuts* Sunday page. He even made a template to follow, which I still use. I'll never part with it. No one knows that the size and dimensions to a *Curtis* Sunday is exactly the same as *Peanuts*. No one until now.

—Ray Billingsley, creator, *Curtis*

91 | A BOY AND HIS DOG

Snoopy, who had evolved from being a normal (if somewhat playful) dog in the early 1950s to being a walks-on-two-legs, rooftop-sleeping combination flying ace, author, and skating coach, took a turn back to normality in the late 1980s. While not abandoning those activities, he began sleeping on the lap of Charlie Brown and others, and even chasing a ball occasionally. The cause of this change was simple: Charles Schulz had a new dog in his life. Andy, a wire-haired terrier, gave Schulz the sorts of interactions he had not had with a dog in a long time, and those were reflected in the strip.

Although Snoopy is the most famous beagle of all time, there is an actual real life rescue dog that stole my dad's heart. He had grown up with the love of dogs, and we had many dogs, cats, and horses when we lived in Sebastopol.

Andy, became one of the many siblings from the Daisy Hill Puppy Farm who was not only a character in the strip, he was a special dog in real life, and best friend to my dad. If I remember correctly, my dad and Jeannie were told that it might be a good idea to get a dog to have around the house for protection. In visiting the local shelter, they came across a rather old, scruffy, sort of sad looking small dog and felt like they needed to take him home and give him a good life for his remaining years. In some ways I feel this speaks of how my dad was always thinking of others, and very generous to many, as he was always so grateful for being able to do what he loved his entire life, and for it to become successful beyond what he could have ever imagined.

Andy became a source of comfort and best friend to my dad. At the end of the day, I could always find him with Andy in his lap watching TV, reading a book, or just plain hanging out. My dad spoke of Andy constantly, and was always happy when he was home with Andy. I am not sure 'who rescued who' as the saying goes. But I do know that he had a very special place in my dad's heart. Andy was not much of a watch dog after all But then again, that was not what he was meant to be.

—Jill Schulz

While Jean Schulz was traveling in the summer of 1990, Sparky made this marker drawing to fax her, showing that he had been doing one of his favorite things: relaxing in a recliner with Andy on his lap. Just as many decades before he had submitted drawings to his yearbook only to have them not appear, the fax he sent his wife never reached her.

Andy's impact on the strip wasn't seen only in the changes in Snoopy. He became part of the *Peanuts* cast as Snoopy's more fuzzy-faced brother. In fact, he was the only character to appear in the animated *Peanuts* (specifically *Snoopy's Reunion*) before showing up in the strip.

Sparky wrote lovingly about his canine friend in his introduction to the anniversary strip collection *Around the World in 45 Years*, which was produced around the time of Andy's death.

One Sunday in October 1988, my wife, Jeannie, picked up this eight-year-old scruffy little dog who had been found wandering on a nearby beach. Jeannie apologized for his odd looks and mangy coat but said she was afraid no one else would take him. 'Andy' was scratched into the inside of his leather collar as if a child had written it. Once Andy's hair grew, and we left it alone, he turned out to be soft, fluffy, and cuddly. Andy brought some new truths into my life. He taught me the wonderful love that a person can have for a dog. He would always lie on the couch next to me in the evening. Now and then, he might wake up and lean over and stretch his paw out and kind of bump my arm and ask me for the first of several doggie cookies.

—Charles M. Schulz

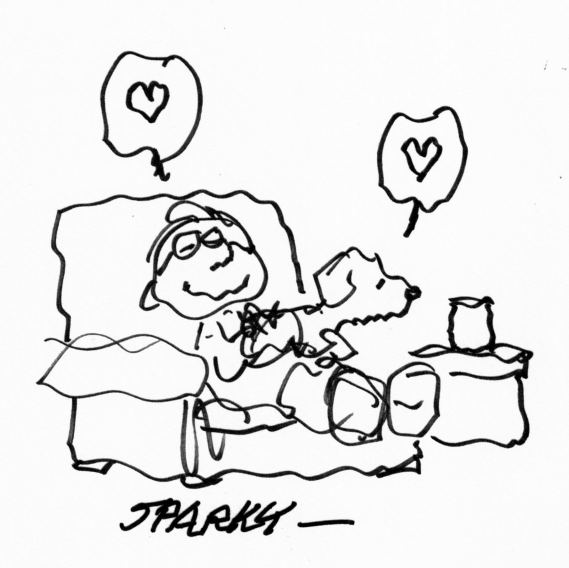

Jean, Sparky, and a Canine Companion dog in uniform.

93 | CANINE COMPANIONS

When it comes to dogs, Sparky was more than the creator of a World Famous Dog and the appreciator of a wire-haired terrier. Moved by seeing an example of a trained service dog helping a boy in a wheelchair, he and Jean became big supporters of Canine Companions for Independence (CCI), a locally based charity that trains service dogs. Canine Companions dogs will go on to help with day-to-day activities for people with a range of physical or cognitive disabilities, or act as hearing dogs, alerting their deaf or hard-of-hearing human partners to important sounds. Some serve as facility dogs, taken by professionals to hospitals, schools, and the like.

Jean Schulz served as president of the Canine Companions board for fifteen years and continues to advocate for the group.

Sparky clearly had a great love of dogs,
which I do as well, and every time I see a dog
with a blue vest on, I think of him and my time at Canine
Companions for Independence. I had the privilege to
volunteer at CCI during my senior year of high school,
just a few years after the Schulz Campus was opened in
1996. The idea came from Sparky and Jeannie, which
at first I was hesitant about because I had no idea what
Canine Companions for Independence even was. After
they explained a bit about what they do, I knew I had
to do it. Every day after school I would drive the twenty
minutes across town to start my shift. While it was not
glamorous work, cleaning the crates and the stalls, it was
very rewarding because I understood the impact these
highly trained dogs could play in someone's life. There
were other perks to the work of course, like getting to play
in stalls full of spirited puppies running about! There's not
much better in the world than that, though my shoes paid
the price as a substitute chew toy. I was able to attend
a graduation ceremony at the end of my time there and
what a special day that is for all the many people that
helped in the process to get those dogs to the finish line.
Seeing the graduate's leash being handed over to their new
partner is something that I will never forget. To this day I
still have the work badge from my time there because of
what it meant to me.

—Bryan Schulz

On June 6, 1993, the *Peanuts* strip commemorated the D-Day invasion, a deadly but vital part of the World War II campaign, on its forty-ninth anniversary. Although Schulz himself was not part of the invasion, some of the young men he was drafted with were. The strip touched a lot of people, including Richard Burrows, the director of the National D-Day Memorial Foundation, which was working toward creating a memorial in Bedford, Virginia, the town with the highest per-capita loss of life in the invasion. Burrows reached out to Schulz to see if he might help raise funds for the memorial. Schulz responded by offering his time, his reputation, and his money, donating a million dollars and serving as the chairman of the fundraising campaign. The campaign was a success, and the memorial was dedicated on June 6, 2001.

This statue, in the collection of the Schulz Museum, is a miniature of one of the sculptures by Jim Brothers that are part of the memorial, where they are scaled to larger-than-life size in order to emphasize the heroism of the action. The piece, originally titled *Across the Beach*, has since been retitled *Valor, Fidelity, Sacrifice*.

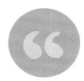

Snoopy was my favorite *Peanuts* character. The fictional aerial battles with Baron Von Richtofen captured my imagination. Being the son of a 23-year Army veteran, I grew up playing soldier on our family trek from base to base, from the US mainland to Asia to Europe and back again. My father served two tours in Vietnam and one in Korea. It gave me great insight into and respect for the service of our military and their families, because I saw the sacrifices made firsthand.

I was surprised to learn of Sparky's service. I first noticed it when I read his D-Day tribute. It gave me a different perspective on the man behind the *Peanuts* strip. His commemoration of the Normandy invasion highlighted the service of those dedicated to freedom, and the beginning of the liberation of Europe from Nazi Germany. It struck close to home. I read about his service in the army during WWII and his deployment to France and Germany, and the liberation of Dachau. My father and I loved the strip but appreciated it even more because of Schulz's D-Day commemorations, the various dedications to soldiers and veterans, his personal military service, and his role in funding the National D-Day Memorial.

So, I was delighted when I finally got to meet Sparky. It was hard to imagine this mild-mannered, genteel comic genius behind a 50-caliber machine gun, but it was easy to see his patriotism, his respect for humanity, and his love for America.

—Michael Ramirez, two-time Pulitzer Prize–winning
editorial cartoonist, *Las Vegas Review-Journal*

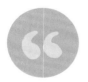

When Mark Cohen and I entered his studio, Schulz was at the drawing board, inking that D-Day strip. It riveted my attention immediately, because it was so unusual for a *Peanuts* Sunday installment. Although it featured Snoopy in a war setting, it was nothing like his light-hearted escapades as the World War I ace. It was dark and somber, dominated by a large panel depicting Snoopy slogging through the mud of Omaha Beach. There were no word balloons, simply a single caption at the bottom: "June 6, 1944, 'To Remember.'" It was very powerful. Clearly, this 49th anniversary of one of the most memorable dates in American history held great significance for Schulz, like my own father a World War II veteran. I stared in awe at the strip and the man who created it.

—Sam Viviano, caricaturist and former art director of *Mad*

In a 1990 strip, Charlie Brown says to the World Famous Golfer, "I find it strange that the golfing gods have never allowed you to make a hole-in-one … I wonder what that means?" "It means we need some new golfing gods," thinks Snoopy in reply.

On August 12, 1995, Charles Schulz got some new golfing gods. The sixth hole of the Bodega Harbour Golf Links in Bodega Bay, California, was a 136-yard, par 3 hole, and Sparky and his 7 iron did it in one. In his seventies, he had finally achieved something he had been striving for since his teens, and this trophy marks the event.

Sparky had provided support and cartoons to various golf organizations over the years, but his longest association was with the annual Pebble Beach pro-am tournament that crooner Bing Crosby had founded in 1937. Cartoonist Hank Ketcham started as art director of the tournament's program book even before the launch of his famed newspaper feature *Dennis the Menace*, and he had gotten many respected cartoonists to work on the program. Schulz cartoons appeared every year from 1957 to 1990, with the finale being a full-color wraparound Schulz/Ketcham cover collaboration in which Charlie Brown and his friends played golf alongside Dennis and his.

Panel detail from daily strip, June 25, 1952.

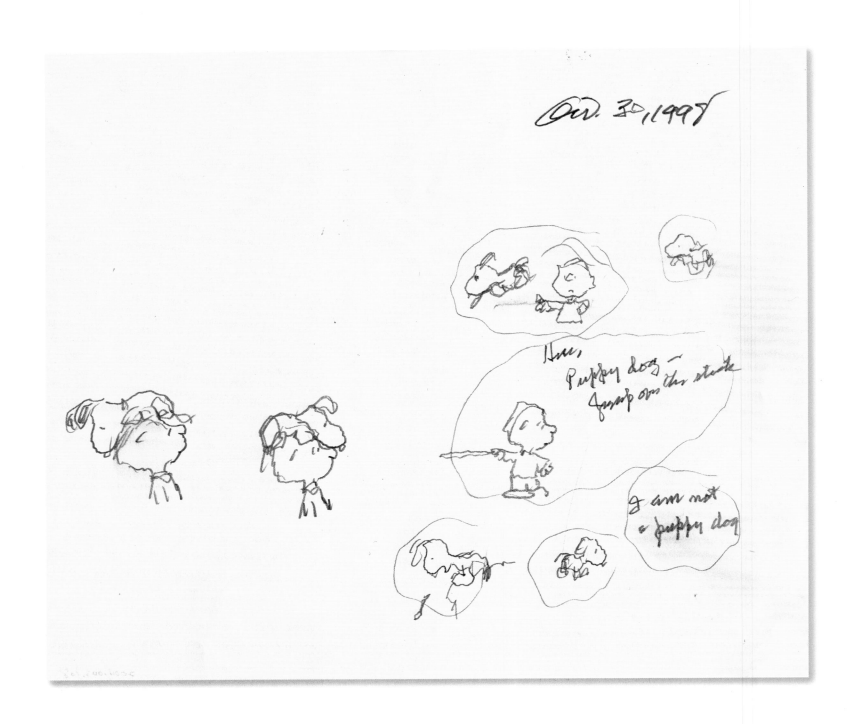

96 | LATE SKETCHES AND DOODLES

C harles Schulz was sometimes dismissive of his own work, whether he was minimizing the importance of comics as an art form (saying that "art has to pass the test of time") and crumpling up the sketches he made while working on the strip. Luckily, Edna Poehner, his administrative assistant, took to rescuing these papers that document Schulz's process, letting us see all the effort that went into making his work look effortless, as in this example for the January 24, 1999 strip.

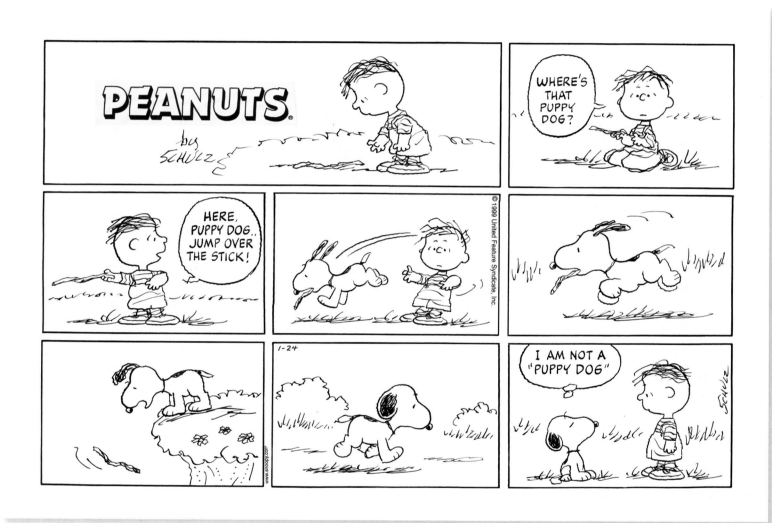

2000–TODAY
AFTER SPARKY

Beset by colon cancer, Charles Schulz announced his retirement in December 1999. He passed away in his sleep on the night of February 12, 2000.

Many assumed that with Schulz gone and with his wishes that no other cartoonist take over the *Peanuts* newspaper strip, his work would quickly fade into memory. Time has proven that to be untrue. A series of books reprinted the complete run of the *Peanuts* newspaper strip for the first time, with other books doing the same thing for *Li'l Folks* and *It's Only a Game*. New adventures for the characters appeared as storybooks and comic books, on television, and in cinemas. A plan to reprint Schulz strips in the newspapers just in 2000, so the strip could reach its fiftieth anniversary, proved so popular that the reruns still appear decades later. Sparky's work continues to be recognized the world over.

While Charles Schulz was hospitalized to treat his cancer, his wife, Jean, called Paige Braddock, the studio's creative director, at home. Sparky was unable to speak, but Jean conveyed to Paige a message to his fans that he wanted included in the final strip. Using images from previous strips, Braddock assembled two strips. The final weekday strip appeared on January 3, 2000. Due to the longer lead time involved in producing Sunday comics, the final *Peanuts* strip appeared in newspapers on Sunday, February 13, 2000, the morning after Charles Schulz passed away.

Paige Braddock's notepad transcription of Schulz's message

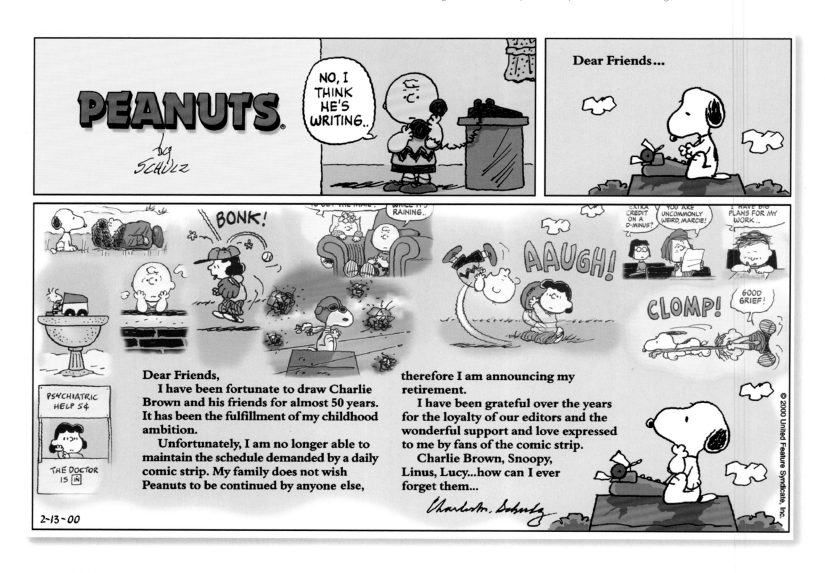

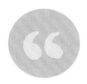

Millions of *Peanuts* fans and who knows how many cartoonists—including me—awaited Sparky's last comic strip with bittersweet anticipation. *Peanuts* was to end on February 13, 2000, in the Sunday comics. How would the *Peanuts* gang ride into the sunset? I'd met Sparky eight years earlier. [He'd invited me] to attend the famous ice show he produced every year at the Redwood Empire Ice Arena in Santa Rosa.

Occasionally, I'd call him. Not often, because, I mean—he was Charles Schulz, for crying out loud. He had a cartooning empire to run and strips to draw! We had a few conversations about gags and chocolate chip cookies and dogs.

After Sparky announced his retirement, and the daily strips had already ended, I called him on a Friday in February 2000. I don't remember the upcoming final strip being on my mind when I picked up the phone, only that I wondered how he was doing. We talked for a few minutes. He was as excited as a little boy. Not just excited, he was giddy. 'I skated!' he said. He'd been out on the rink skating for the first time since his surgery. He was so happy. Sparky was back! I couldn't wait to tell my wife, Sukey, the great news. The prospect of the last *Peanuts* strip appearing on Sunday didn't feel so sad now. Sparky skated. He sounded great. 'Happiness is getting back on your skates.'

Sunday morning, I headed for the newspaper to see the last strip. My wife had already heard the news. She told me that Sparky had passed away overnight. 'No. He couldn't have. I just spoke ... he skated ... ' I went into my studio and wept at my drawing table.

—Rick Kirkman, cartoonist, *Baby Blues*

Charles M. Schulz gave the Nation a unique sense of optimism, purpose, and pride. Whether through the Great Pumpkin Patch, the Kite Eating Tree, Lucy's Psychiatric Help Stand, or Snoopy's adventures with the Red Baron, *Peanuts* embodied human vulnerabilities, emotions, and potential.

—Congressman Mike Thompson, United States Representative for California's fifth congressional district

The Congressional Gold Medal in honor of Charles M. Schulz is not only about honoring a cartoonist who made us laugh and think but also about honoring a lifetime of work that has transcended generations of Americans and has become the fabric of our national culture. Sparky inspired generations of Americans with his cartoons and led an active life in service to our community in Northern California. Introducing the legislation to present Sparky with the Congressional Gold Medal was a tremendous honor for me because he truly deserved the recognition. Sparky Schulz transformed our culture and demonstrated that art can transcend lifetimes—and his legacy will carry on for generations.

—Public Law 106–225

The Congressional Gold Medal is the highest honor that the legislative branch of the US government can bestow on a civilian. Continuing the Gold Medal series the Second Continental Congress had begun in 1776, the US Congress began issuing the medals in 1800, at an average rate of fewer than one per year. Each Gold Medal requires the creation of a separate act of Congress, beginning with sponsorship by at least two-thirds of the members of both the Senate and the House of Representatives.

An act to create the Congressional Gold Medal honoring Charles Schulz was drafted in the wake of his retirement and introduced in the House of Representatives by Congressman Mike Thompson on February 10, 2000, two days before Schulz's death. The House passed it on February 15, and the Senate on May 2. Voting was nearly unanimous, with the sole vote against being from a representative who objected not to Schulz but to the Gold Medal program.

The bill was signed into law by President Bill Clinton on June 20, 2000.The ¼-inch-thick, 2 ¾-inches-across medal was then designed and minted, and was presented to the Schulz family at a June 7, 2001, ceremony.

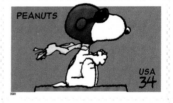 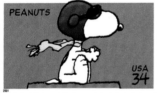 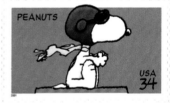

 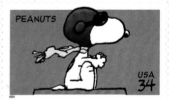 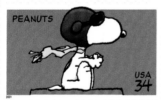

 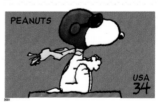

I n 2001, the US Postal Service released the first US stamp featuring a *Peanuts* character. Some 125 million stamps bearing a picture of Snoopy as the World War I Flying Ace were printed, each worth thirty-four cents in postage (the cost of sending a first-class letter at the time). The stamp was released on May 17 in Santa Rosa, California, and was available throughout the rest of the country the following day.

This would not be the last time the art of Charles Schulz would appear on a US stamp. *Peanuts* returned to postage in 2015 with a set of eight stamps featuring scenes from *A Charlie Brown Christmas*. The release event for the set was held at the Charles M. Schulz Museum. Then, in 2022, in order to join us all in celebrating the Schulz centennial, the USPS came back to *Peanuts* again. This set features eleven characters over ten stamps (Snoopy and Woodstock had to share).

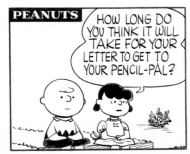
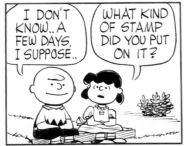
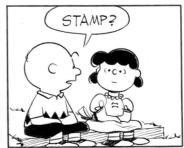

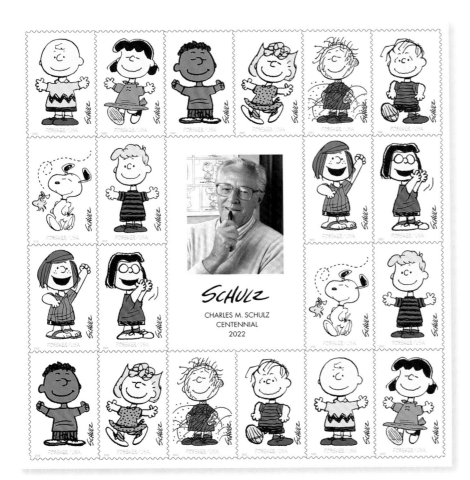

Posing for a postage stamp is far from the only work that the *Peanuts* characters have done for the US government. In addition to their extensive efforts with NASA, Charlie Brown and friends have appeared in government-published booklets on topics as diverse as the American economy and the sight disorder commonly known as "lazy eye." The Bureau of Land Management had Snoopy and Woodstock promote their Johnny Horizon anti-littering campaign, the Department of Agriculture's Forest Service had Snoopy don Smokey Bear's hat to encourage fire safety, and the Environmental Protection Agency helped fund the short anti-pollution film *Charlie Brown Clears the Air*.

100 | THE CHARLES M. SCHULZ MUSEUM AND RESEARCH CENTER

Charles Schulz was, at first, unenthusiastic about there being a museum dedicated to him and his work; he was, after all, still creating his work and, as all of us are, always a work in progress. His wife, Jean; his friend and attorney Ed Anderson; and cartoon historian Mark Cohen won him over.

Ground was broken for the museum on June 29, 2000, and the 27,384-square-foot building designed by the architectural firm of C. David Robinson Architects opened to the public on August 17, 2002. Over a million people have come to see its galleries lined with original Schulz art, with regularly updated displays chosen from the roughly 7,000 original strips that the museum holds in its archives, as well as key items from Schulz's life and career. The museum has an educational space and a theater and hosts a wide variety of events. The research center, which houses a broad range of records about Schulz and *Peanuts*, is used by historians and other curious and interested visitors.

This book celebrates both the 100th anniversary of the birth of Charles Monroe Schulz in Minneapolis, Minnesota, on November 26, 1922, and the 20th anniversary of the Charles M. Schulz Museum and Research Center in Santa Rosa, California, on August 17, 2002.

In celebrating my husband Sparky's 100th anniversary we selected 100 notable items from the museum's collection—a museum which, ironically, Sparky never saw. Planning for the museum began in 1997. Although at first he did not support the *idea* of a museum, once convinced, Sparky was fully on board. He listened carefully and expressed opinions on the information I brought back from our meetings and travels to other 'one person' museums.

Sparky was happy that the museum would hold the many things he had saved over the years, things like his treasured 'page of threes,' and the war-time photo album and sketchbooks, which he frequently shared with interviewers and friends. He was convinced that the museum should not rely on the appeal of fascinating technological 'playthings,' but rather be grounded in pencil and paper, and provide a place for people to explore their own ideas and storytelling. We have maintained this vision. In this ever more hectic world, the museum remains a quiet and contemplative space where visitors can explore their own creativity.

Neither of us knew what surprises the creative imaginations and hard work of our staff would bring. The Museum has hosted everyone from the astronauts aboard the *Peanuts*-themed Apollo 10 mission to some of today's most popular cartoonists, drawing crowds of children and adults alike.

The Museum will continue to inform, entertain, and preserve the history of Sparky and his creations for generations to come. Now that you've enjoyed this book, come and see the rest of what we have to offer!

—Jean Schulz, President,
The Charles M. Schulz Museum and Research Center

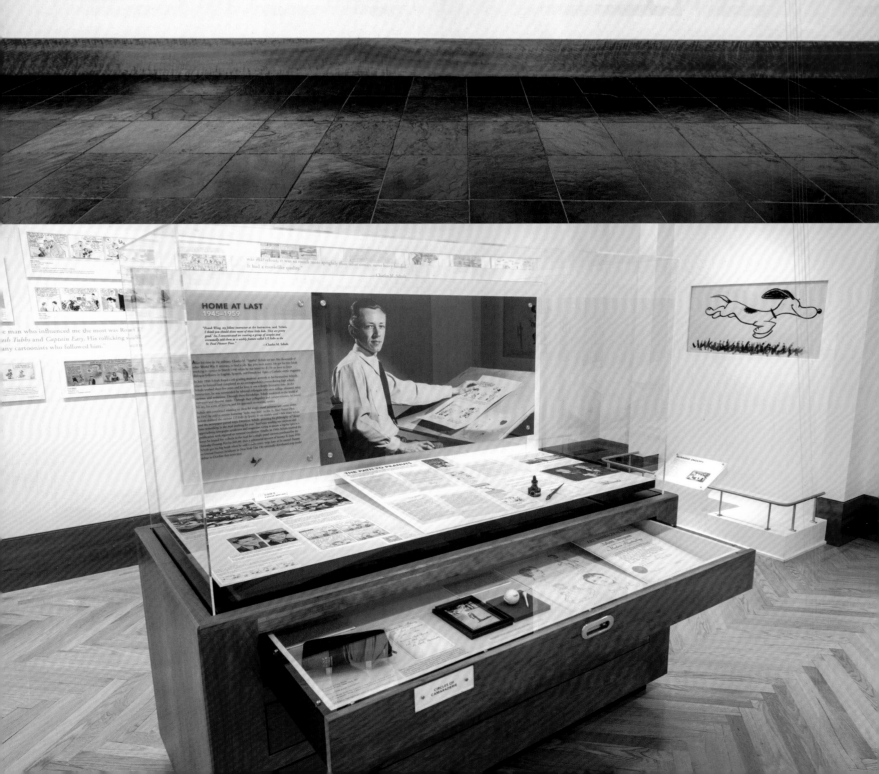

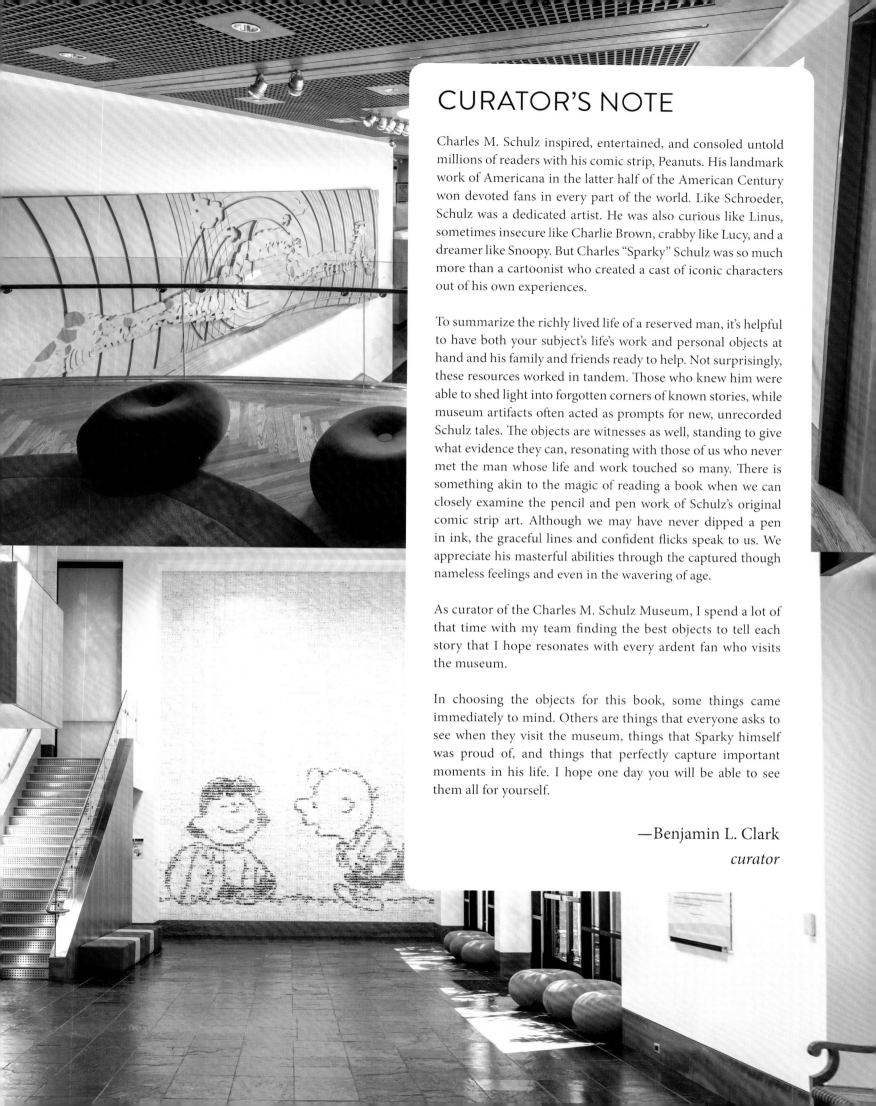

CURATOR'S NOTE

Charles M. Schulz inspired, entertained, and consoled untold millions of readers with his comic strip, Peanuts. His landmark work of Americana in the latter half of the American Century won devoted fans in every part of the world. Like Schroeder, Schulz was a dedicated artist. He was also curious like Linus, sometimes insecure like Charlie Brown, crabby like Lucy, and a dreamer like Snoopy. But Charles "Sparky" Schulz was so much more than a cartoonist who created a cast of iconic characters out of his own experiences.

To summarize the richly lived life of a reserved man, it's helpful to have both your subject's life's work and personal objects at hand and his family and friends ready to help. Not surprisingly, these resources worked in tandem. Those who knew him were able to shed light into forgotten corners of known stories, while museum artifacts often acted as prompts for new, unrecorded Schulz tales. The objects are witnesses as well, standing to give what evidence they can, resonating with those of us who never met the man whose life and work touched so many. There is something akin to the magic of reading a book when we can closely examine the pencil and pen work of Schulz's original comic strip art. Although we may have never dipped a pen in ink, the graceful lines and confident flicks speak to us. We appreciate his masterful abilities through the captured though nameless feelings and even in the wavering of age.

As curator of the Charles M. Schulz Museum, I spend a lot of that time with my team finding the best objects to tell each story that I hope resonates with every ardent fan who visits the museum.

In choosing the objects for this book, some things came immediately to mind. Others are things that everyone asks to see when they visit the museum, things that Sparky himself was proud of, and things that perfectly capture important moments in his life. I hope one day you will be able to see them all for yourself.

—Benjamin L. Clark
curator

Published by The Charles M. Schulz Museum
and Research Center, 2301 Hardies Lane,
Santa Rosa California 95403, USA

THE CHARLES M. SCHULZ MUSEUM
AND RESEARCH CENTER

President of the Board Jean F. Schulz
Treasurer Randy Pennington
Museum Director Gina Huntsinger
Curator Benjamin L. Clark
Archives, Collections & Research Sarah Breaux, Kelly Schulz,
Dinah Houghtaling, Ashley Reclite, Natasha Cochran
Legal Barbara Gallagher, Terry Sterling
Administration Jackie Rader, Faith Yazel, Jean Bevier
Communications Stephanie King, Daniel Campoverde
Additional thanks to board members: Ed Anderson, Rose Marie
McDaniel, Karen O'Connell, Dee Richardson, Michael Schwager,
Roland Thibault, and Laura Whiting
Additional thanks to staff members: Misty Adams, Krista Bickerton,
Toma Day, Renee Donmon, Rosemary Giacomini, Reese Griffin,
Jisung Heo, Amanda Kelly, Sara Merrick, Jessica Ruskin, Som Sao,
Rachel Veramay, Megan Widener, and Stephanie Wilson

THE CHARLES M. SCHULZ MUSEUM AND RESEARCH
CENTER STAFF

Misty Adams, Krista Bickerton, Toma Day, Renee Donmon,
Rosemary Giacomini, Reese Griffin, Jisung Heo, Amanda Kelly, Sara
Merrick, Jessica Ruskin, Som Sao, Rachel Veramay, Megan Widener,
and Stephanie Wilson

PEANUTS WORLDWIDE
Global Brand Experiences & Publishing Craig Herman
Legal Carrie J. Dumont
Marketing & Communications Melissa Menta, Alison Hill
Charles M. Schulz Creative Associates, Editorial Alexis E. Fajardo

CONTRIBUTORS

Robb Armstrong, Ray Billingsley, Jim Borgman, Sandra Boynton,
Paige Braddock, Jenny Campbell, Lucy Shelton Caswell, Michael
Cavna, Brooke Clyde, Lisa Clyde, Pete Docter, Greg Evans, Tom
Everhart, Kevin Fagan, Barbara Gallagher, Cathy Guisewite, Peter
Guren, Scott Hamilton, Meredith Hodges, Amy Schulz Johnson,
Brian Johnson, Charles Johnson, Lynn Johnston, Billie Jean King,
Rick Kirkman, Mike Luckovich, Patrick McDonnell, Jason and Glenn
Mendelson, Yoshi Otani, Stephan Pastis, Mike Ramirez, John Reiner,
Stephanie Revelli, Rob Rogers, Al Roker, Bryan Schulz, Craig Schulz,
Jean Schulz, Jill Schulz, Monte Schulz, Jerry Scott, Judy Sladky, Jeff
Smith, Jeff Stahler, Congressman Mike Thompson, Adrian Tomine,
Sam Viviano, Brian Walker, and M. K. Whyte

In association with Weldon Owen International

weldon**owen**
An imprint of Insight Editions

CEO Raoul Goff
VP Publisher Roger Shaw
Associate Publisher Amy Marr
Editorial Assistant Jourdan Plautz
VP Creative Chrissy Kwasnik
Art Director Allister Fein
Editorial Director Katie Killebrew
VP Manufacturing Alix Nicholaeff
Production Manager Joshua Smith

Weldon Owen wishes to thank the following people for their
generous support in producing this book: Ellen Espinoza-Hale,
Rachel Markowitz, Ted Thomas, Sharon Silva, and Amani Wade.

Produced by Weldon Owen
P.O. Box 3088
San Rafael, CA 94912
www.weldonowen.com

Library of Congress Cataloging in Publication data is available.

ISBN: 978-1-68188-860-6

10 9 8 7 6 5 4 3 2 1

2022 2023 2024 2025 2026

Printed in China

PHOTO CREDITS

All images © 2022 by Peanuts Worldwide LLC
Except the following, courtesy of Alamy page 52; Associated Press page 157; Brian Myers
page 193; Christo 2003 pages 7, 182–183; Charles M. Schulz Museum and Research
Center pages 4, 6, 10–11, 12, 15-16, 18-19, 23, 25 (top), 28 (top), 29, 31, 37 (© Yoshiteru
Ohtani), 40, 41, 42, 45, 64, 70 (bottom), 71 (bottom), 72, 73, 74 (top), 77 (bottom right),
79, 80, 81 (top), 90, 117 (top), 118, 161, 220, 222 (top right), 222 (bottom right), 223 (top
left), 223 (bottom left); Columbia Records page 88 (top right); Dave Fleming page 176;
Gerald Mugele page 179; Giovanni Trimboli page 200 (bottom); Harriet Glickman page
154 (top left); J. Allen Hawkins page 175 (top); Kenneth C. Kelly page 154 (bottom right);
King Features pages 14-15, 187; Mendelson–Melendez Productions pages 138 (top),
138 (bottom), 145 (top), 145 (bottom), MGM page 88 (bottom); Minnesota Historical
Society page 17; National Academy of Television Arts and Sciences page 141; National
Cartoonists Society page 116; National D-Day Memorial Foundation page 206 (bottom);
National Museum of the United States Army page 53; Peabody Awards, Grady College
of Journalism and Mass Communication, University of Georgia page 142 (top); Saturday
Evening Post pages 84 (top), 85; Schulz Family Intellectual Property Trust pages 2, 3, 8,
10, 13, 16 (top left), 20 (bottom), 21, 23 (top), 25 (bottom left), 30, 32, 33, 38, 46, 47, 48,
51 (left), 51 (right), 54 (top), 54 (bottom), 55 (bottom), 55 (top), 56, 58 (top), 58 (bottom),
59, 60 (top), 61 (top), 60–61, 62 (bottom left), 62 (bottom right), 63, 65 (left), 65 (right) ,
66, 68 (top), 69, 70, 82, 83, 84 (bottom), 86, 87, 94–95, 103, 104–105, 111 (bottom), 114,
115 (top), 115 (bottom), 117 (bottom left), 117 (bottom right), 122 (top), 122 (bottom),
123, 124 (top), 125, 127 (top), 142–143 (spread; text © Bill Adler); 149, 154 (top right),
154 (bottom left), 160 (bottom), 171, 172, 180, 181, 186, 191, 194 (top), 194 (bottom),
195, 203, 206 (top); R. Smith Kiliper page 140; RCA page 88 (top left); Redwood Empire
Ice Arena pages 160 (top), 170, 192 (top); Ripley's Believe It or Not page 36 (top); Timm
Eubanks page 204; Tribune Content Agency/Penguin Random House pages 26, 27 (top);
United Press Associations page 93 (top); United Feature Syndicate page 93 (bottom right);
Charles M. Schulz Centennial 2022" © 2022 United States Postal Service®. All Rights
Reserved. Used with Permission. pages 218, 219 (bottom); Weldon Owen pages 16 (top
left), 22, 24, 25 (bottom), 35 (top), 68 (top), 69, 74 (bottom), 74–75, 124 (bottom), 164,
167, 173, 188 (top), 196 (bottom left), 196 (bottom right), 208, 217.